Picture Duluth

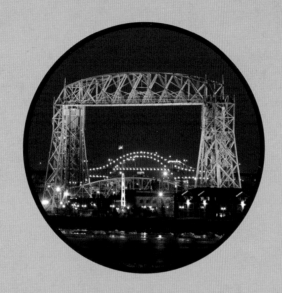

Photographs of the Zenith City

Dennis O'Hara

X-comm

Duluth, Minnesota

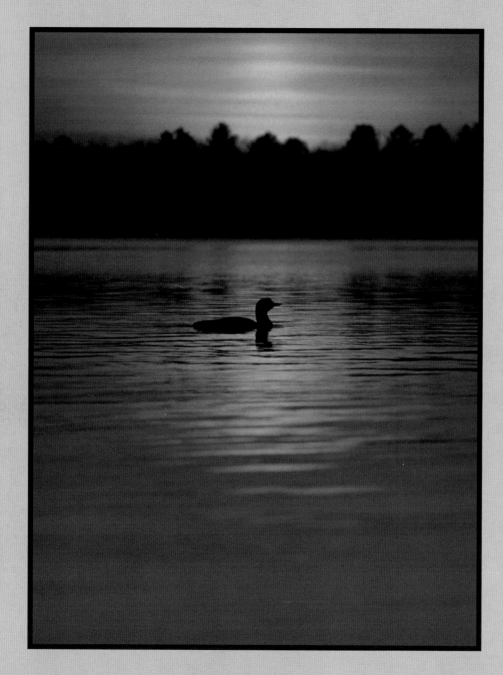

X-communication
Duluth, Minnesota
218-310-6541
www.x-communication.org

Picture Duluth:
photographs of the zenith city

Photographs by Dennis O'Hara
Copyediting by Scott Pearson
Proofreading by Suzanne Rauvola
Research by Maryanne Norton & Kris Aho
Text, maps, and design by Tony Dierckins

First Edition, 2010
10 11 12 13 14 • 5 4 3 2 1

Library of Congress Control Number: 2009938348
Soft cover ISBNs: 1-887317-36-8; 978-1-887317-36-8
Hard cover ISBNs: 1-887317-37-6; 978-1-887317-37-5

Printed in China by Four Colour Imports
of Louisville, Kentucky, U.S.A.

Discover more photos by Dennis O'Hara
at www.northernimages.com

Title page photo: Aerial Lift Bridge framing the Blatnik Bridge.
At left: A Common Loon, the Minnesota State Bird.
Opposite: Duluth Ship Canal and lighthouses at dawn.
Contents: Northern Lights (*aurora borealis*) outside Duluth.
Foreword: The *Mesabi Miner* enters Duluth's Ship Canal.
Preface: The Duluth Rose Garden at Leif Erikson Park.

For my wife Debby—who shares my fondness for the city of Duluth and for Lake Superior and has spent countless hours accompanying me on my photographic journeys—and for our children, Molly, Keely, and Brady, and our grandchildren, present and future. I hope this book will serve as a reminder of the beauty we have the privilege to enjoy as a family. And also for my mother, Kathryn, for passing down to me her love of the "big lake" and the city in which she grew up, and the memory of my father, Willard, who was always a proud Duluthian.

Special acknowledgment and appreciation needs to be given to our Zenith City predecessors, men such as Chester Congdon, Bert Enger, Guilford Hartley, Rodney F. Paine, William K. Rogers, Bernard Silberstein, Samuel Snively, and the many others who spent much of their time (and, some of them, their fortunes) setting aside beautiful parks and green-spaces throughout Duluth for use by the generations who would follow them.

— D.O.

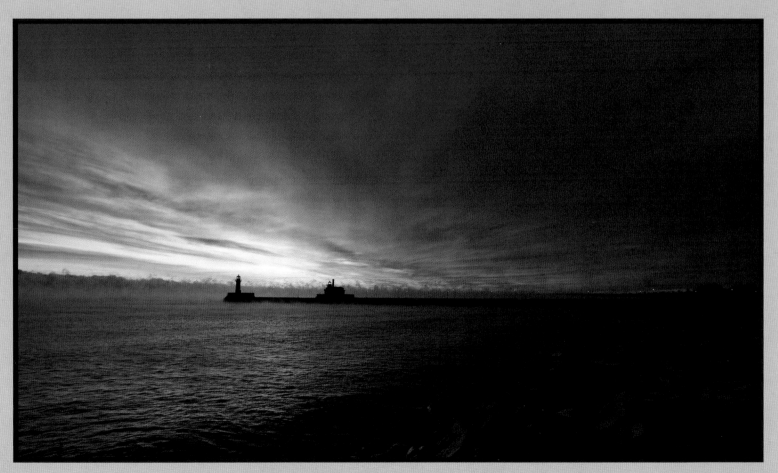

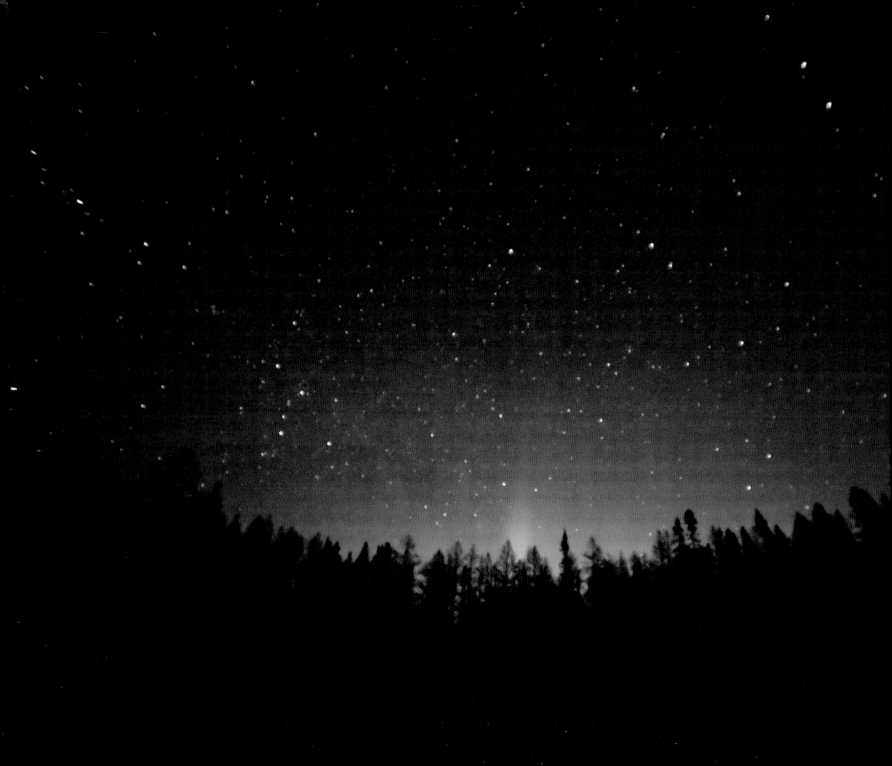

Contents

Scenic Highway 61 to 21st Avenue East

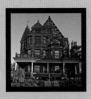

21st Avenue East to Mesaba Avenue

Including Park Point, Bayfront Park, and the Canal Park Business District

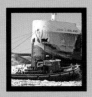

Mesaba Avenue to the Ore Docks

The Ore Docks to Fond du Lac Park

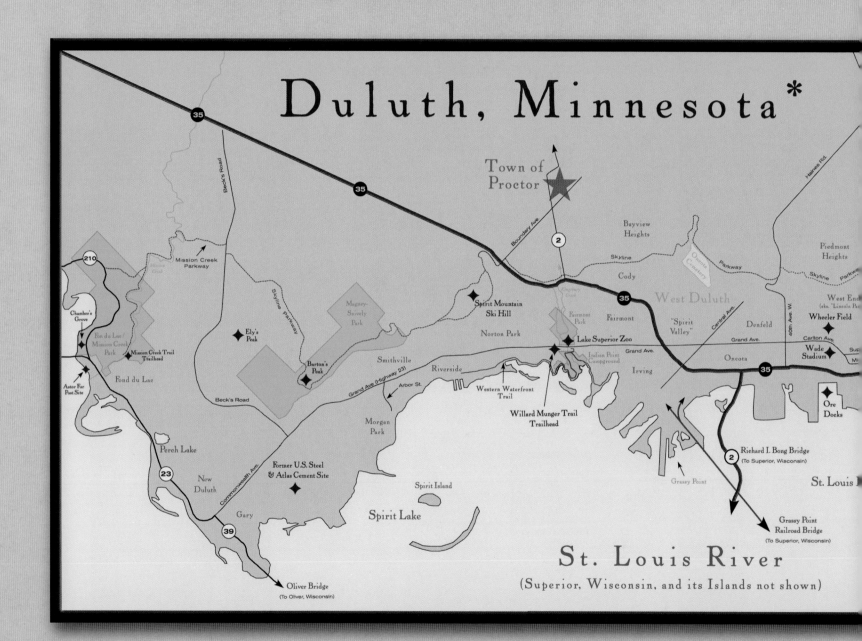

Duluth, Minnesota*

St. Louis River

(Superior, Wisconsin, and its Islands not shown)

Town of Proctor

Bayview Heights

Piedmont Heights

West End (aka. "Lincoln Park")

West Duluth

Cody

Skyline

Oneota Cemetery

Parkway

Skyline Parkway

Mission Creek Parkway

Skyline Parkway

Chamber's Grove

Fon du Lac / Mission Creek Park

Mission Creek Trail Trailhead

Astor Fur Post Site

Fond du Lac

Ely's Peak

Barton's Peak

Magney-Snively Park

Spirit Mountain Ski Hill

Norton Park

Fairmont Park

Fairmont

"Spirit Valley"

Denfeld

Wheeler Field

Lake Superior Zoo

Smithville

Riverside

Western Waterfront Trail

Indian Point Campground

Willard Munger Trail Trailhead

Grand Ave.

Oneota

Irving

Wade Stadium

Beck's Road

Grand Ave. (Highway 23)

Arbor St.

Morgan Park

Perch Lake

New Duluth

Commonwealth Ave.

Former U.S. Steel & Atlas Cement Site

Gary

Spirit Island

Spirit Lake

Grassy Point

Richard I. Bong Bridge
(To Superior, Wisconsin)

St. Louis

Ore Docks

Grassy Point Railroad Bridge
(To Superior, Wisconsin)

Oliver Bridge
(To Oliver, Wisconsin)

Boundary Ave.

Haines Rd.

Central Ave.

Carlton Ave.

40th Ave. W.

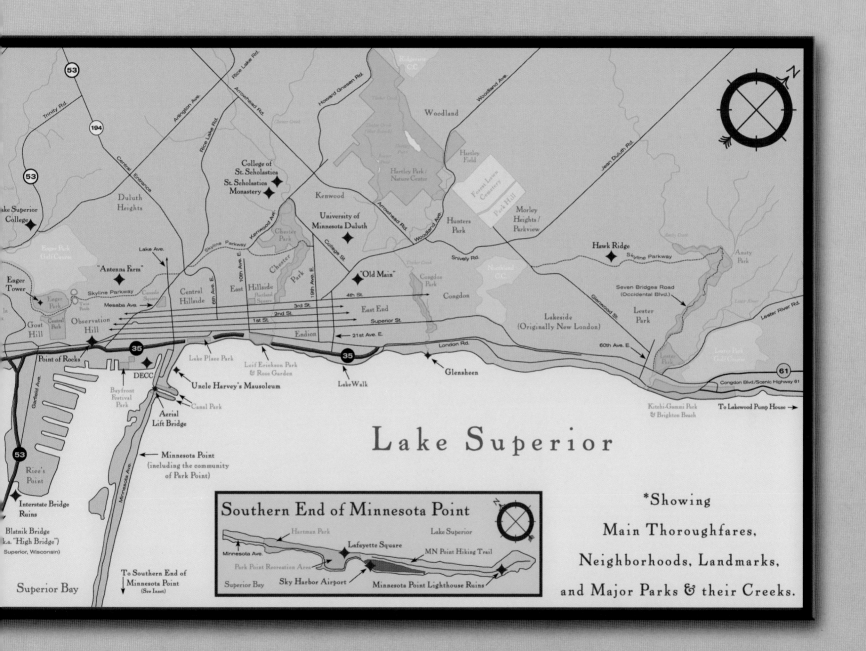

Lake Superior

53

53

53

194

Trinity Rd.

Arlington Ave.

Rice Lake Rd.

Rice Lake Rd.

Howard Gnesen Rd.

Woodland Ave.

Woodland

Hartley Field

Jean Duluth Rd.

Central Entrance

College of St. Scholastica
St. Scholastica Monastery

Kenwood

Hartley Park / Nature Center

Forest Lawn Cemetery

Park Hill

Morley Heights / Parkview

Duluth Heights

Lake Superior College

University of Minnesota Duluth

Arrowhead Rd.

Hunters Park

Hawk Ridge

Skyline Parkway

Amity Park

Kenwood Ave.

Chester Park

Woodland Ave.

"Antenna Farm"

Lake Ave.

Skyline Parkway

Chester Park

"Old Main"

Snively Rd.

Northland C.C.

Seven Bridges Road (Occidental Blvd.)

Enger Tower

Enger Park

Skyline Parkway

Central Hillside

East Hillside

Bethel Square

4th St.

Congdon Park

Congdon

Lester Park

Glenwood St.

Lester River Rd.

Goat Hill

Observation Hill

Mesaba Ave.

6th Ave. E.

10th Ave. E.

3rd St.

2nd St.

1st St.

19th Ave. E.

East End

Endion

Superior St.

21st Ave. E.

Lakeside (Originally New London)

60th Ave. E.

61

Garfield Ave.

35

Point of Rocks

DECC

Lake Place Park

Uncle Harvey's Mausoleum

Leif Erickson Park & Rose Garden

35

LakeWalk

London Rd.

Glensheen

Congdon Blvd./Scenic Highway 61

Bayfront Festival Park

Canal Park

Aerial Lift Bridge

Minnesota Point (including the community of Park Point)

Kitchi-Gammi Park & Brighton Beach

To Lakewood Pump House

53

Rice's Point

Lake Superior

Interstate Bridge Ruins

Blatnik Bridge a.k.a. "High Bridge"
Superior, Wisconsin)

Minnesota Ave.

To Southern End of Minnesota Point (See Inset)

Southern End of Minnesota Point

N

Hartman Park

Lake Superior

Lafayette Square

MN Point Hiking Trail

Minnesota Ave.

Park Point Recreation Area

Superior Bay

Sky Harbor Airport

Minnesota Point Lighthouse Ruins

Superior Bay

*Showing

Main Thoroughfares,

Neighborhoods, Landmarks,

and Major Parks & their Creeks.

Duluth, Minnesota: The "Zenith City"

When Dr. Thomas Foster first called Duluth the "Zenith City of the Unsalted Seas" in 1866, it was a then-hopeful nickname. The township, little more than Minnesota Point and portions of today's downtown, would not even become a city until 1870. That same year Duluth began construction on a ship canal that brought the city its fortune—eventually. The Panic of 1873 bankrupted Duluth's creditors, and the fledgling city lost its charter.

By the time of this early fall from grace, the region already had a long history. The Ojibwe, the Dakota before them, and other earlier peoples had established a native habitation stretching back three millennia. In fact, the township of Duluth was centered on a spot along the isthmus the Ojibwe called *Onigamiinsing*, or "Little Portage." This is the very site the city's namesake, French explorer Daniel Greysolon Sieur du Luht, crossed in 1679. After many French explorers and fur-trapping Voyageurs, and wars between and with the native cultures, the 1854 Treaty of La Pointe ceded northeastern Minnesota from the Ojibwe to the United States. Two years later, Duluth township was born.

Duluth sits at the "Head of the Lakes," the very southwestern tip of Lake Superior—the planet's largest freshwater lake by surface area. The fourth-largest city in Minnesota with a population of approximately 87,000, Duluth is also the seat of St. Louis County, the second largest county in the nation. Minnesota Point, the world's largest naturally formed sandbar, stretches across the bay toward Duluth's neighboring city of Superior, Wisconsin.

Competition between these "Twin Ports"—the furthest inland ports in the world—made the digging of the canal inevitable. The ship canal lifted Duluth back on its feet following the 1873 financial panic, helping to turn it into a major shipping center for the grain trade. Its economy was further helped by the timber industry, and by 1887 Duluth had paid off its debts and became a city once again. It then invited neighboring townships from Lester Park to Fond du Lac to join the Zenith City, and by 1896 those townships had become neighborhoods in a metropolis just three miles wide but twenty-eight miles long, curving along the Lake Superior and St. Louis River shores, giving rise to the short-lived nickname "Crescent City" (a moniker far more associated with New Orleans).

Shipping iron ore mined in the newly opened Mesabi Iron Range helped Duluth ride out the financial panic of 1893, and by the turn of the century Duluth was said to have more millionaires per capita than any other U.S. City. Duluth's wealthy—lumber barons, mining executives, shipping magnates, grain traders, and the like—built majestic homes in the city's east end, many of which still stand today. The City's wealth also made Duluth a place rich in architecture executed in a wide variety of styles and faced in brick, granite, and locally mined sandstone. In 1907 Duluth surpassed New York as the busiest port in the U.S., and the Twin Ports remain the world's largest inland ports.

Along the way Duluth has had other nicknames, including the "Air-conditioned City," a term used since the 1930s to promote the lake-cooled town as a getaway from the often oppressive humidity of summers in the Midwest. City fathers were long aware of Duluth's other natural features, setting aside land for a parks system as early as 1887. The initial plan was to center parks along the City's creeks; Skyline Parkway (originally Boulevard Drive) would connect these vertical parks, and Lakeshore Park (now Leif Erikson Park) would anchor them along Superior's shore. This plan evolved over the years, and today Duluth boasts 129 municipal parks, playgrounds, and public spaces, and Skyline Parkway stretches the length of the city.

Duluth has changed considerably since its boomtown days, but much of its glory remains—the abundance of greenspaces, many of the grand buildings and homes, and of course its working waterfront—maintaining Duluth's status as the Zenith City of the Unsalted Seas.

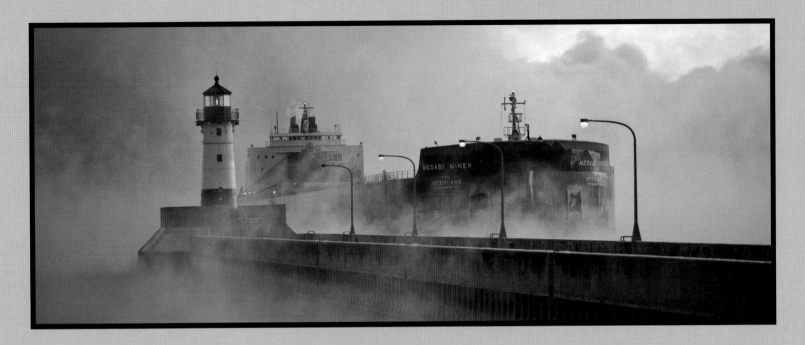

Foreword

Duluth is one of a kind, there is no doubt about that. Somehow no city is like it, although it is like other cities. Perched on San Francisco–like hills it enjoys the rain and fog of numerous ports, but, just to make things interesting, it has winters that can freeze the great inland sea it overlooks. In spite of these extremes, or perhaps because of them, Duluth has a magnetism that seems to pull people in; sometimes it doesn't let them leave, as happened to me. Once hooked, we want to show it off to everybody and are proud to boast of her wherever we go. The glorious beauty of this community glistens three hundred sixty-five days a year.

Denny O'Hara is committed to leading us on a pictorial journey through this glorious city. Within his photography is a love for Duluth and its all-encompassing, four-season beauty. *National Geographic* photographer Sam Abell says of a photograph that "the moment is held until someone sees it. Then it is ours." Denny gives us these images—these moments—and they are ours. We have them to share with family and friends, near and far, and we will have them to look at thirty years from now.

But striking imagery doesn't just appear on the viewfinder. "F-8 and be there," photographers say, and Denny is there, early and late, in weather fair or foul, waiting and watching for those moments. These are times to reflect, be quiet and still, to listen to the world without and within. To let the eye and heart examine the subject and allow it to touch our emotions. These are the delicate ingredients of a fine photograph.

When we look past our everyday surroundings and forget to appreciate Duluth's many facets—the diverse neighborhoods, the city parks, the hidden places, the people, and the crown jewel, Lake Superior—these fine photographs bring them all back into focus.

Now begin the journey, travel through the pages of Denny's work. Whether lifelong resident, summer vacationer, or new to the city, you will find yourself agreeing it really is breathtaking, this Zenith City of ours.

– Photographer Jay Steinke, November 2009

Photographer's Preface

In a way, this book has been twenty years in the making. Like a stained-glass window, the pictures are a collection of pieces that tell a story of what Duluth is and what it means to those who live here, have lived here, and who often visit the Zenith City.

Duluth is a unique place where land, sea, and sky meet together on a stage of ever interacting climate, commerce, and people. From a photographer's perspective, there is rarely a day that there isn't something to photograph in this city, whether natural beauty, man-made or a combination of both.

There is a draw to Lake Superior and the harbor that cannot be explained, it's something a person simply feels. It is part habit, part curiosity, and part just plain joy in knowing that although the location doesn't change, the hand of God has crafted the elements into another beautiful scene for our enjoyment. Like visiting an old friend, you may have done it a hundred times before, but each time is special.

Special thanks to Tony Dierckins of X-Communication for his vision for this book. I am grateful for his encouragement of my work and his skill and dedication in putting this book together and getting it to print. His zeal for this project became contagious. Tony is a true Duluthian at heart.

For some this will be a book of memories, for others a tour guide, and for others a visual record of the place they call home. It is also a response to the countless visitors and acquaintances who have expressed their appreciation to me for sharing the beauty of the region with them through my galleries at northernimages.com. Much of the correspondence I receive is from former Duluthians who have an empty place in their heart for the things of Duluth. I hope, in a small way, the images within these pages will fill that longing with fond memories. For current Duluthians, may these pictures remind you of the blessings of living in a place such as this; for those who are drawn to our city from far and near, or to those for whom this book will be as close as you get; enjoy your visit as you "Picture Duluth."

— Dennis O'Hara, December, 2009

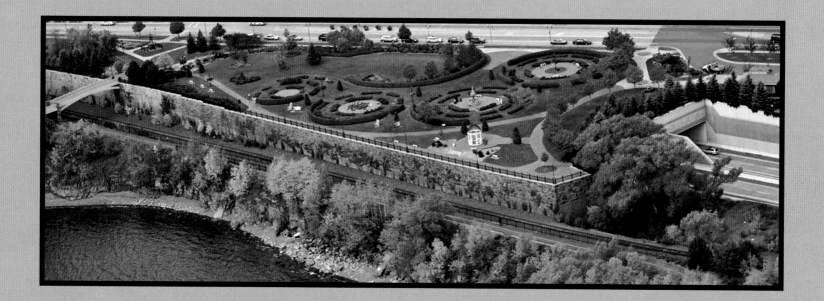

1. Eastern Environs

Scenic Highway 61 to 21st Avenue East

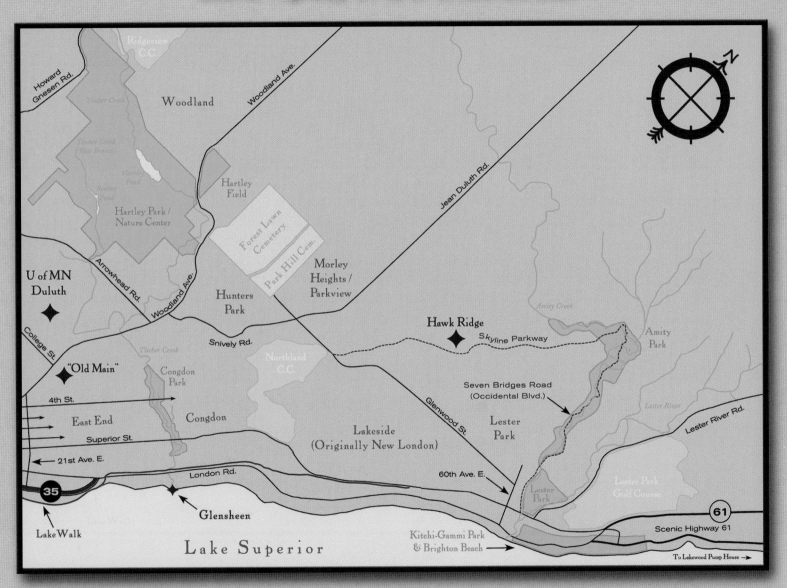

Howard Gnesen Rd.

Ridgeview C.C.

Woodland

Woodland Ave.

Tischer Creek

Tischer Creek (West Branch)

Hartley Pond

Rustler Pond

Hartley Field

Hartley Park / Nature Center

Forest Lawn Cemetery

Park Hill Cem.

Jean Duluth Rd.

Arrowhead Rd.

U of MN Duluth

Woodland Ave.

Hunters Park

Morley Heights / Parkview

Amity Creek

Hawk Ridge

Skyline Parkway

Amity Park

College St.

Snively Rd.

"Old Main"

Tischer Creek

Congdon Park

Northland C.C.

Seven Bridges Road (Occidental Blvd.)

Lester River

4th St.

East End

Congdon

Lakeside (Originally New London)

Glenwood St.

Lester Park

Lester River Rd.

Superior St.

21st Ave. E.

London Rd.

60th Ave. E.

Lester Park

Lester Park Golf Course

35

Glensheen

61

Lake Walk

Kitchi-Gammi Park & Brighton Beach

Scenic Highway 61

Lake Superior

To Lakewood Pump House

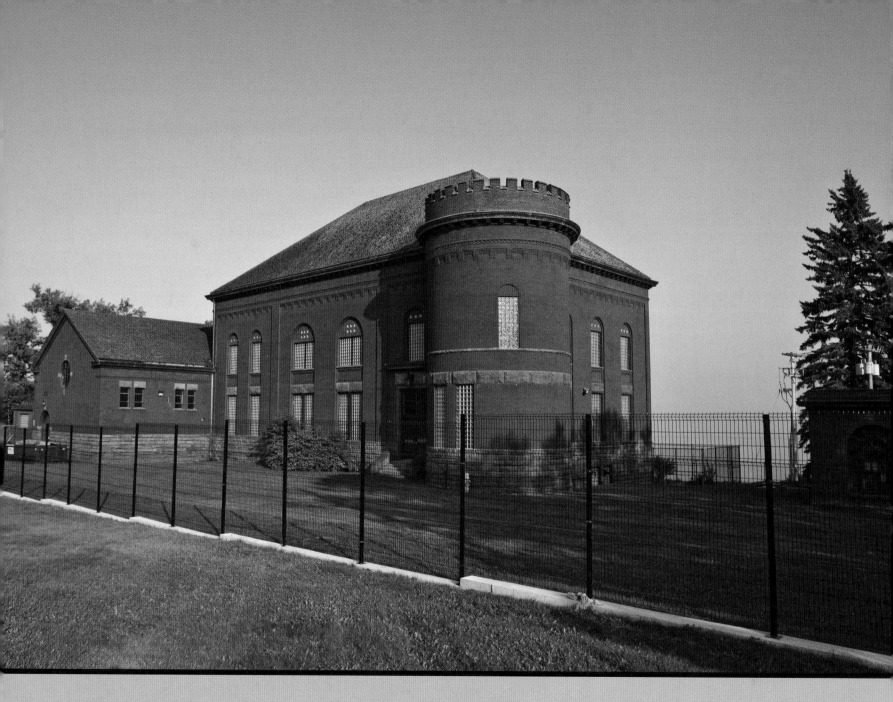

2. The Lakewood Pump House, 8120 Congdon Boulevard (b. 1897; architect unknown).
The pump house supplies Duluth with its fresh water; before it was built, Duluth suffered several typhoid epidemics.

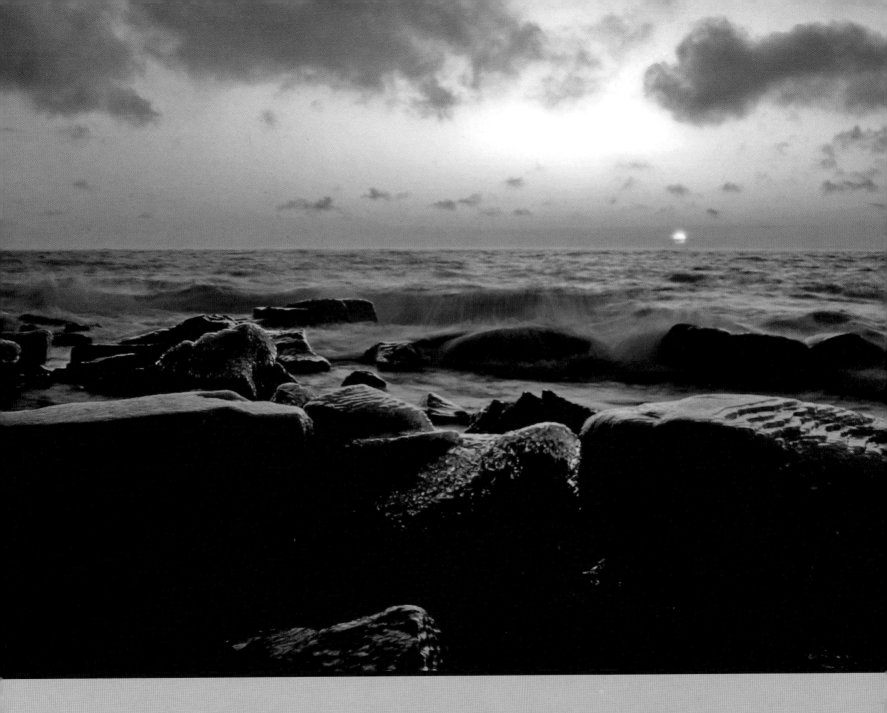

3. Shoreline rocks at Kitchi Gammi Park's Brighton Beach at dawn, winter.

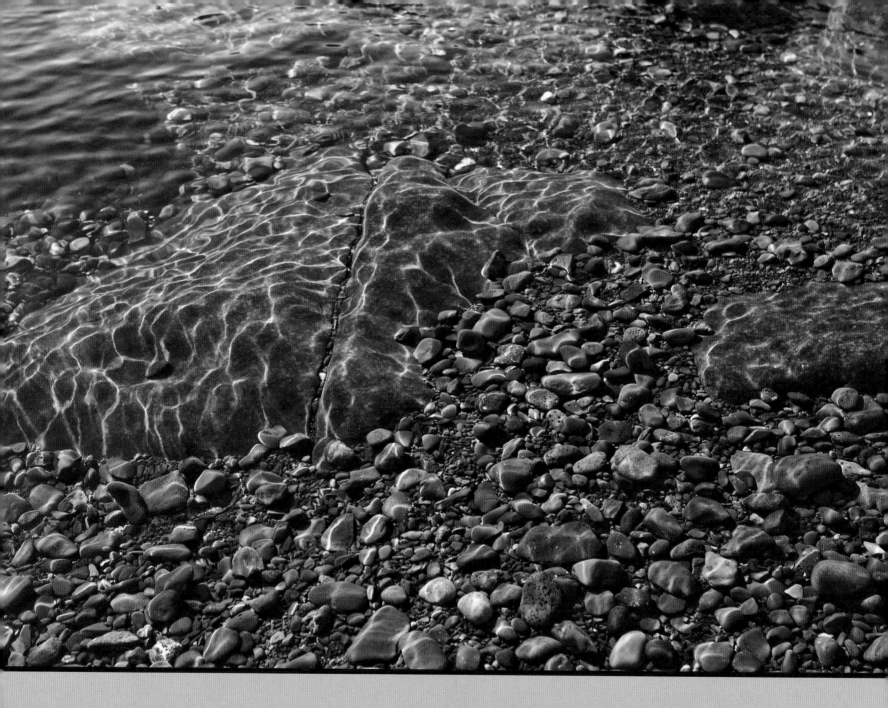

4. Sunlight plays off submerged rocks along the Lake Superior Shore at Kitchi Gammi Park's Brighton Beach, summer.

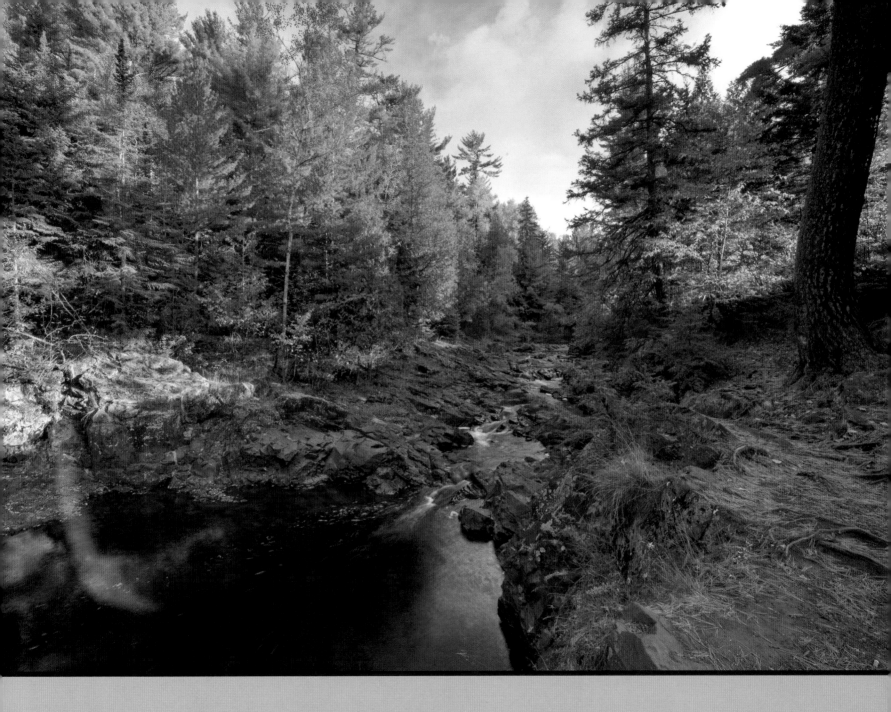

5. The Lester River flowing through Lester Park, summer.

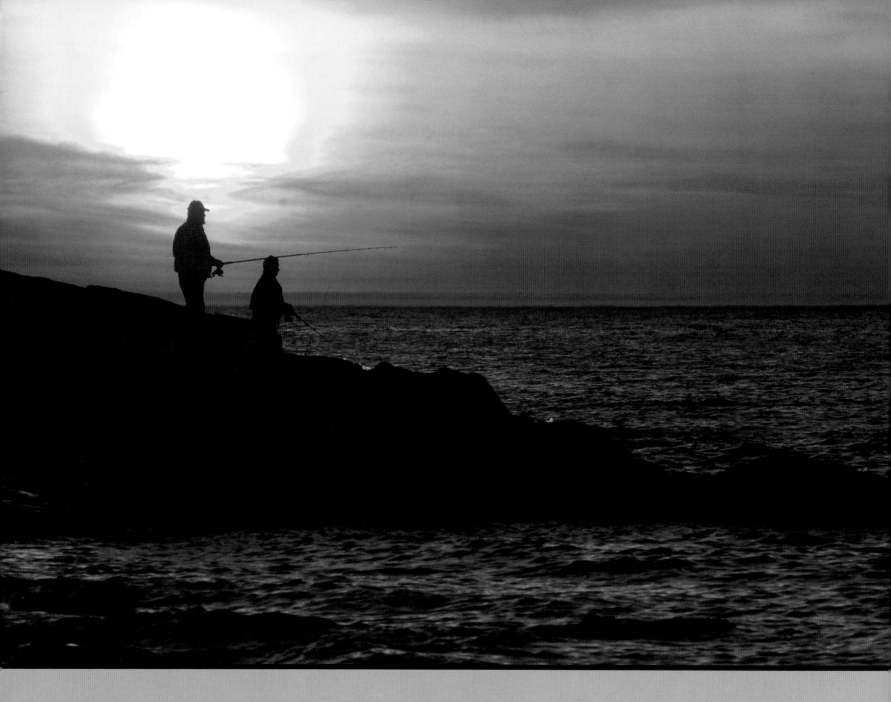

6. Fly fishing at the mouth of the Lester River, summer.

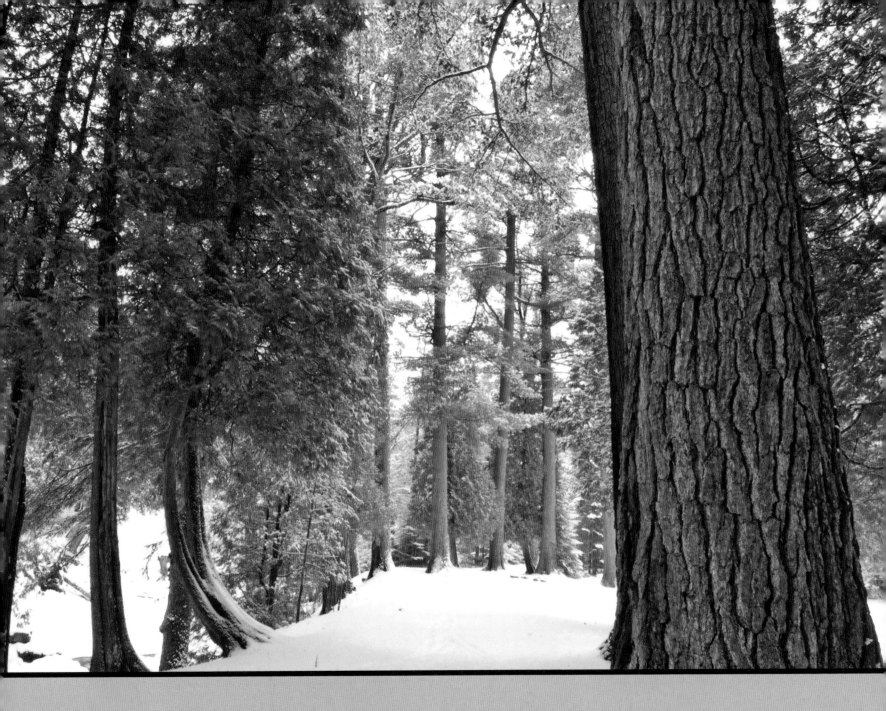

7. Pines and cedars, Lester Park, winter.

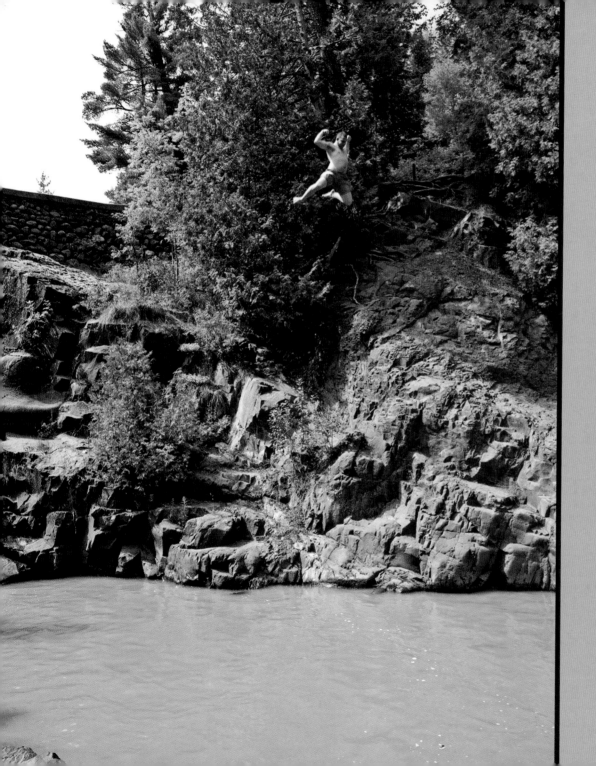

8.
Cliff diving into
"The Deeps"
at Amity Creek
as it runs through
Lester Park,
summer.

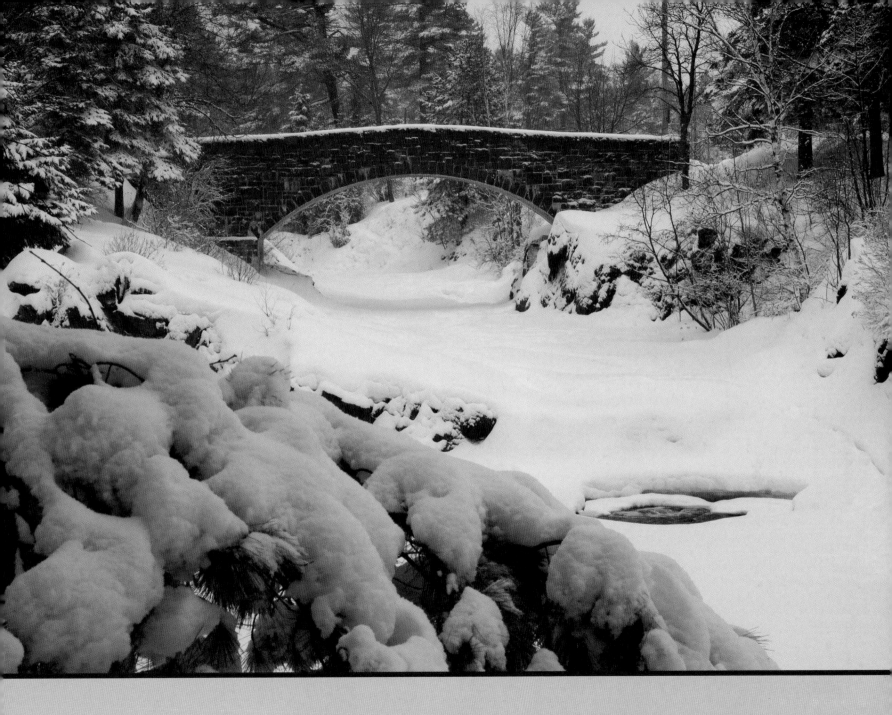

9. The foot bridge over Lester River near the picnic grounds, winter.

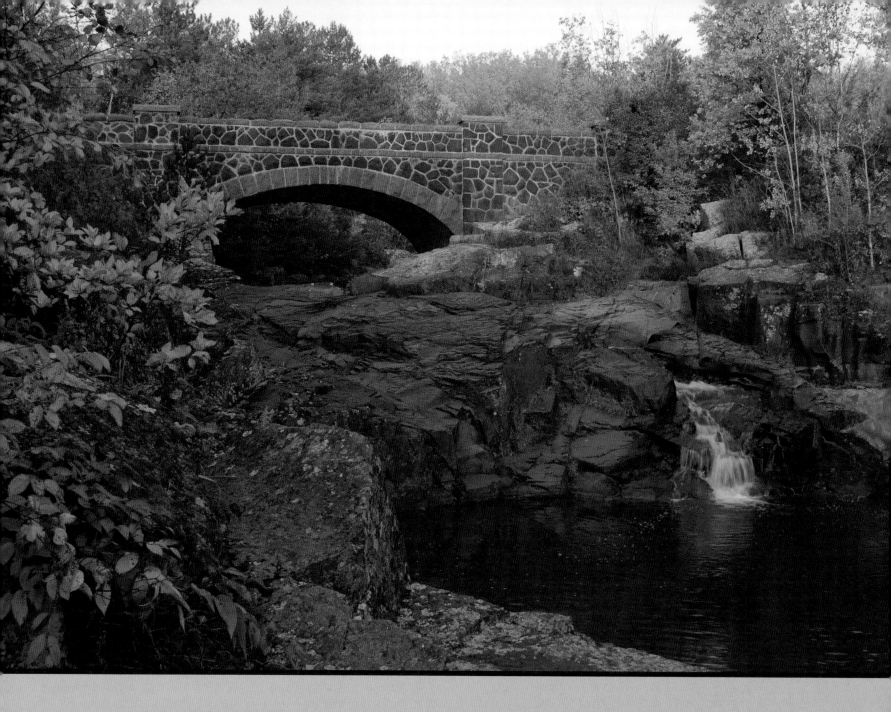

10. Seven Bridges Road bridge number six over Amity Creek, Amity Park, autumn.

11. Seven Bridges Road bridge number five over Amity Creek, Amity Park, summer.

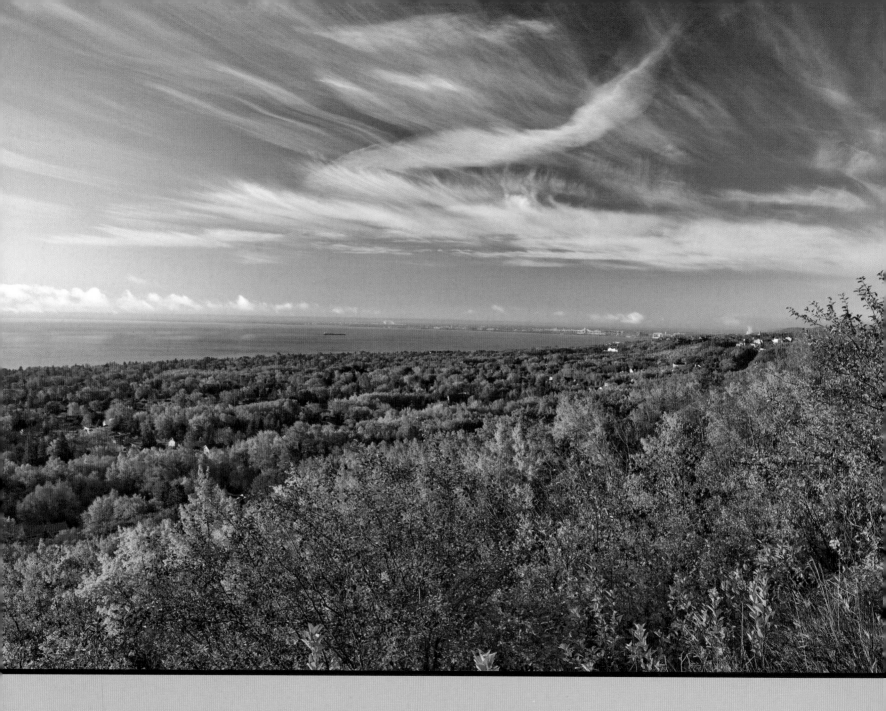

12. The view from Hawk Ridge above Skyline Parkway, autumn.

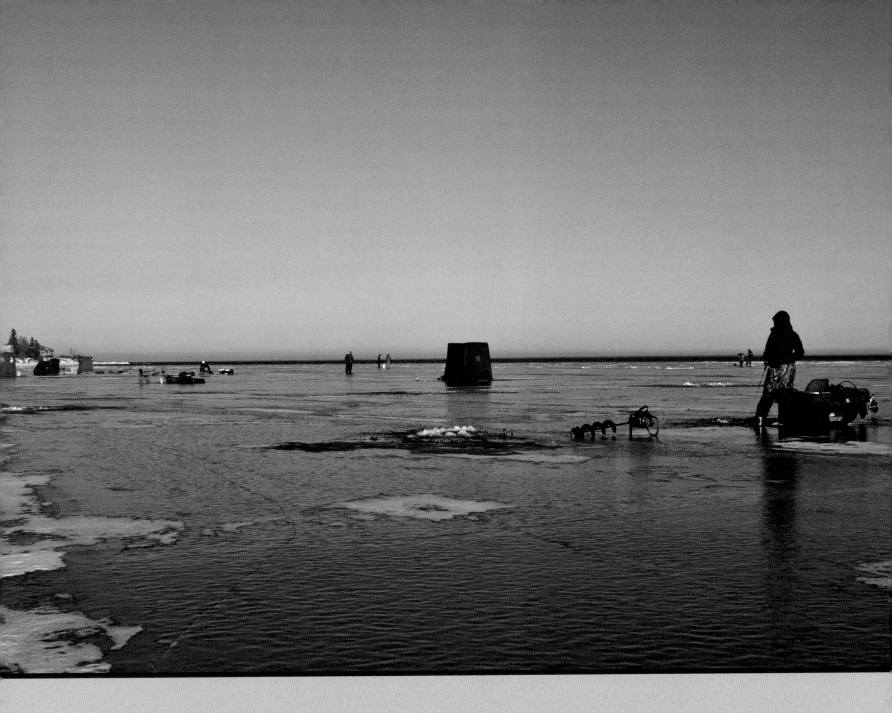

13. Ice fishing on Lake Superior near Duluth's Lakeside neighborhood, winter.

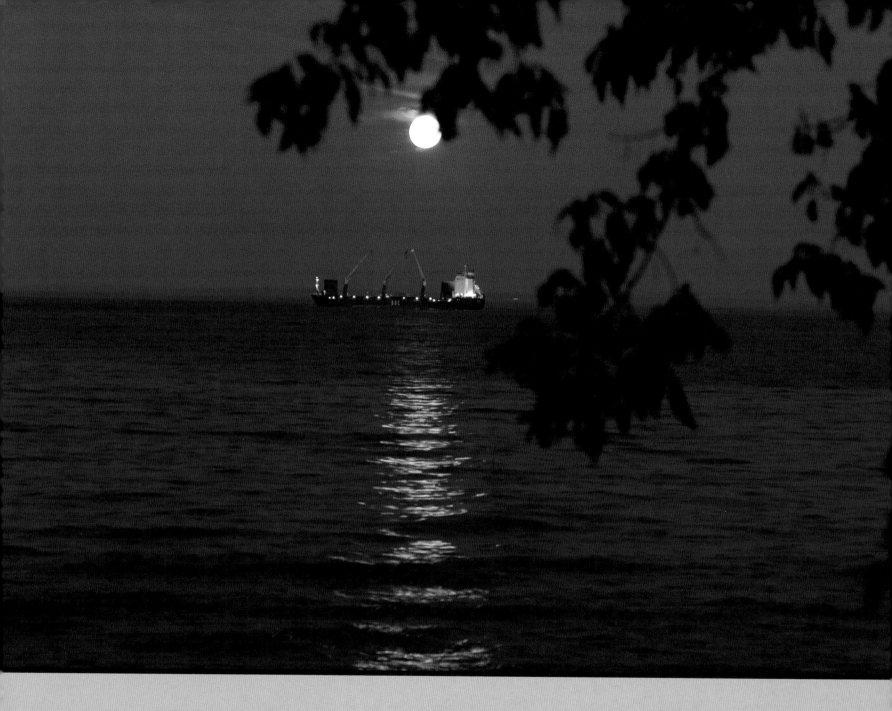

14. Ocean-going vessel or "saltie" anchored off the Lake Superior shore seen from Lakeside, summer.

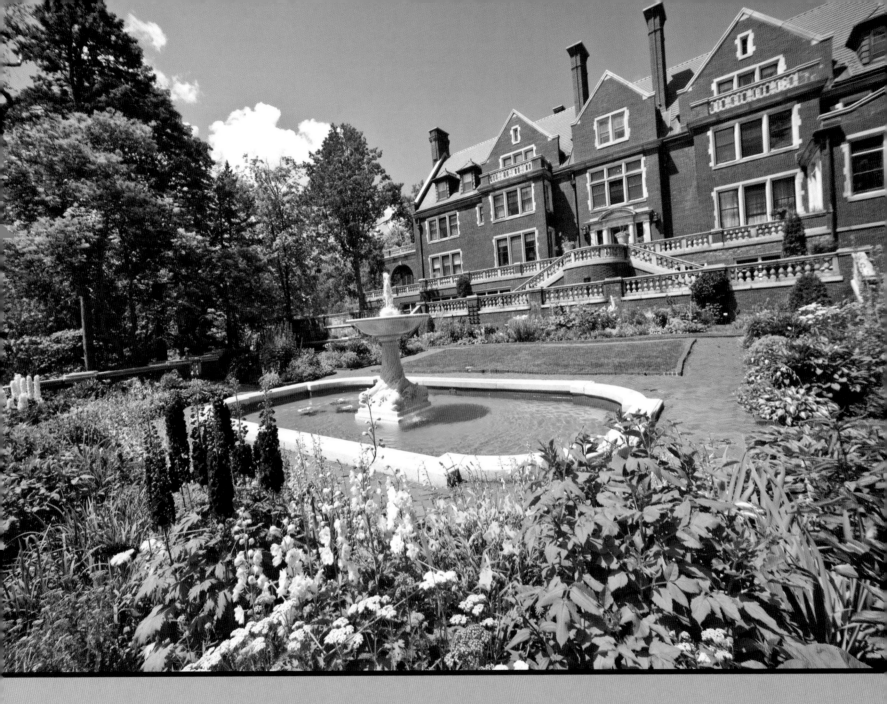

15. Glensheen, the Chester and Clara Congdon Family Estate, 3300 London Road (b. 1909; Clarence H. Johnston, architect).
Placed on the National Register of Historic Places in 1991.

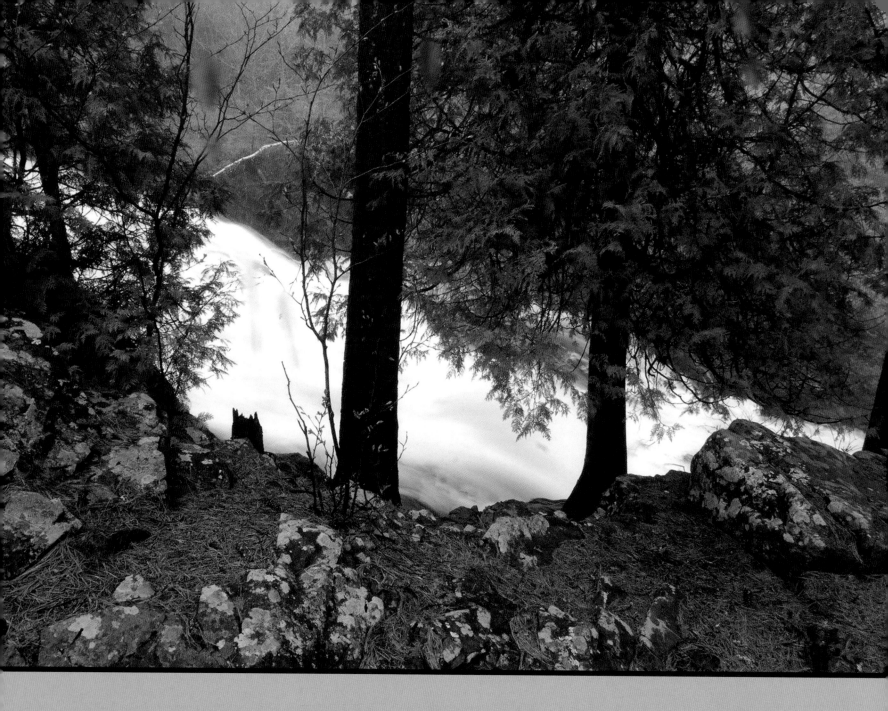

16. Tischer Creek in Congdon Park after a rain, summer.

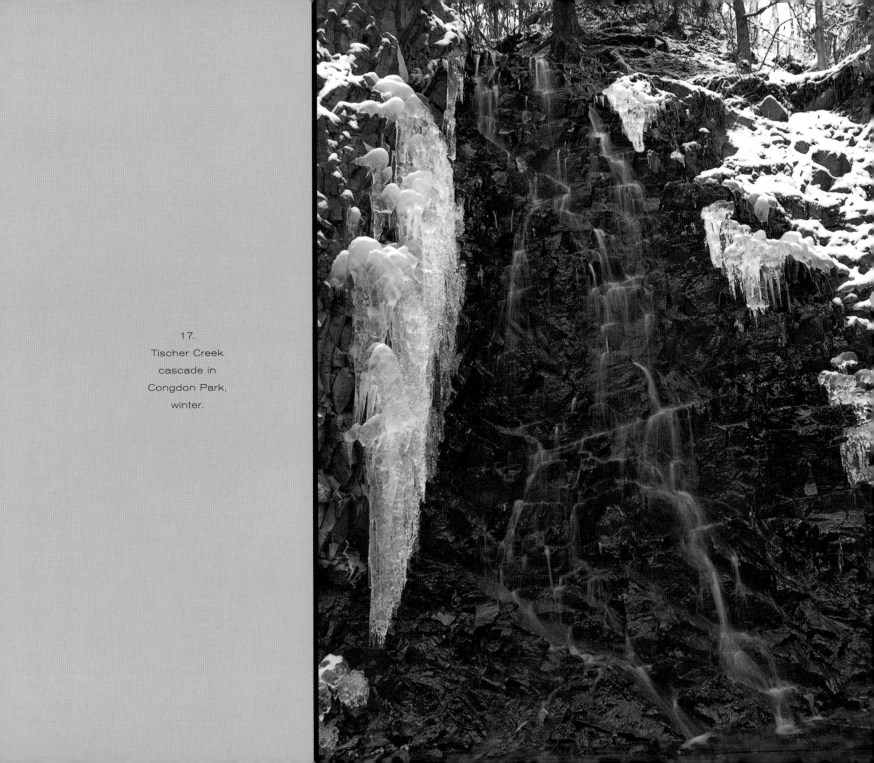

17.
Tischer Creek
cascade in
Congdon Park,
winter.

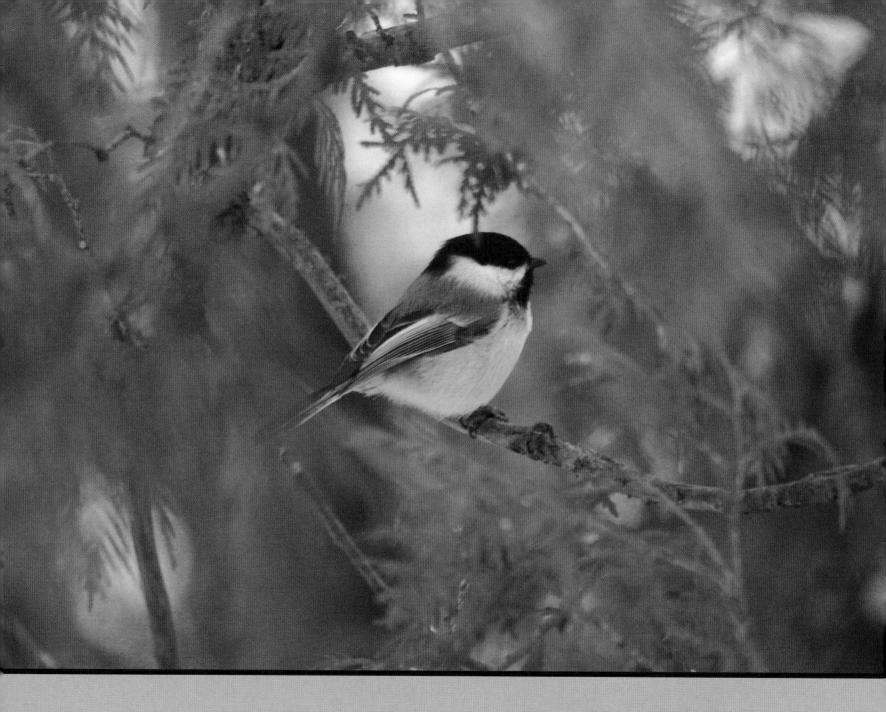

18. A black-capped chickadee perched on a cedar tree in Congdon Park, summer.

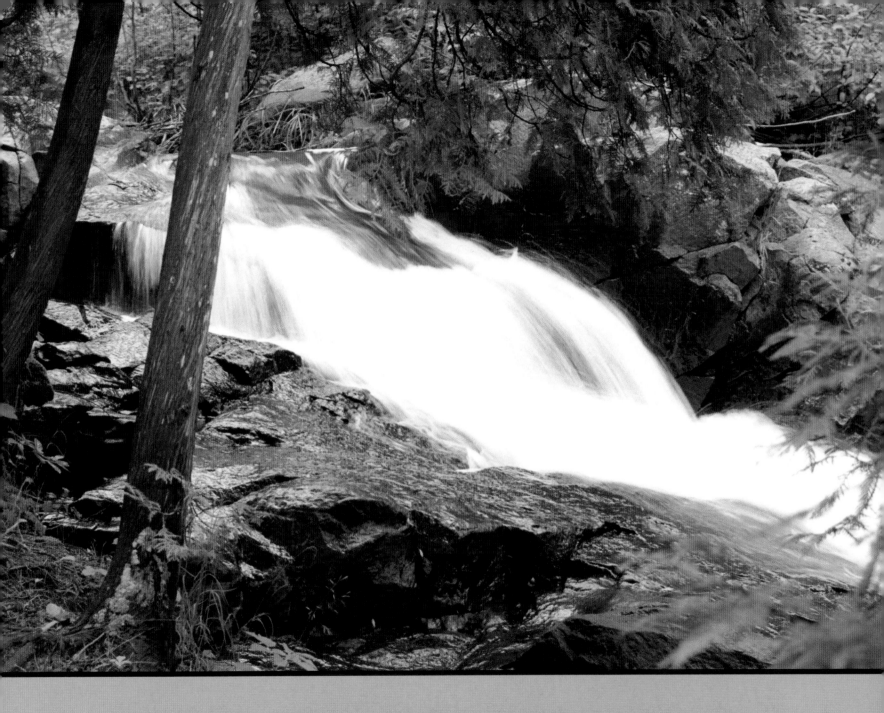

19. Tischer Creek rushing through Congdon Park, spring.

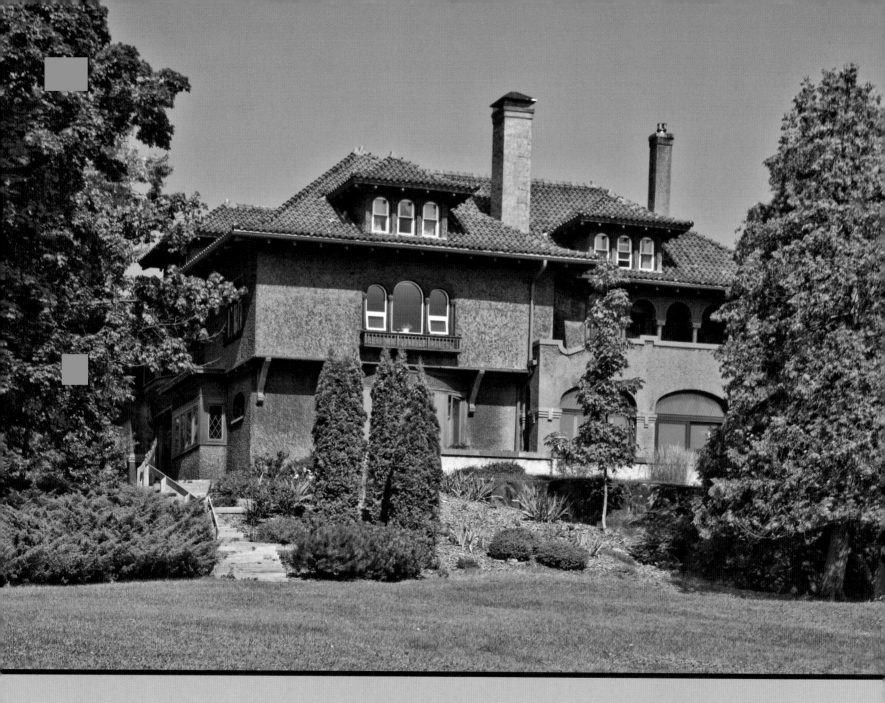

20. The William and Mina Prindle House, 2211 Greysolon Road (b. 1905; William A. Hunt, architect).
The house later became the John Duss Music Conservatory.

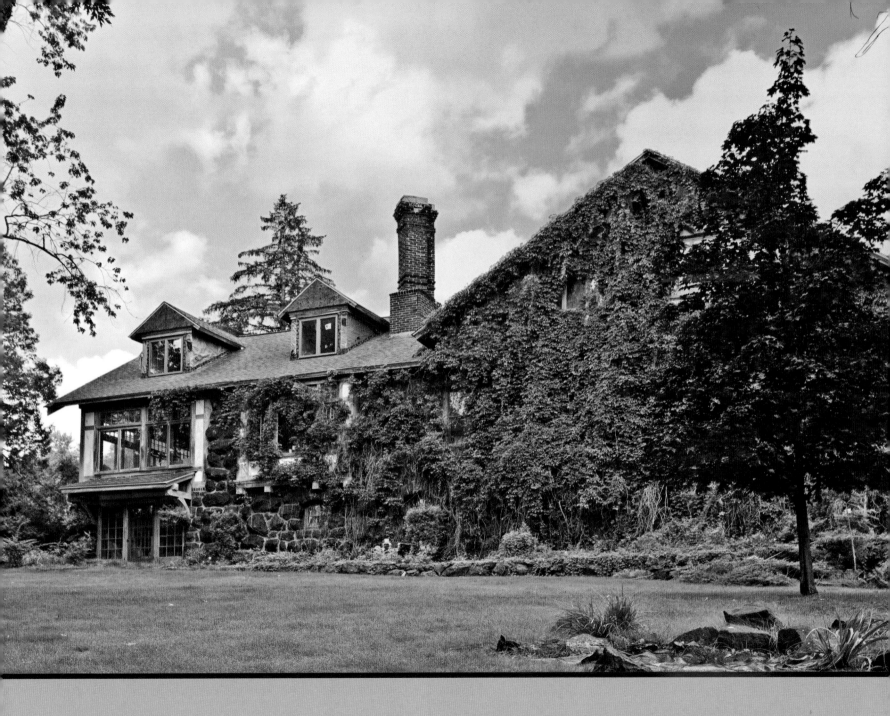

21. 2301 Greysolon Road, original owners unknown (b. 1901; architect unknown).

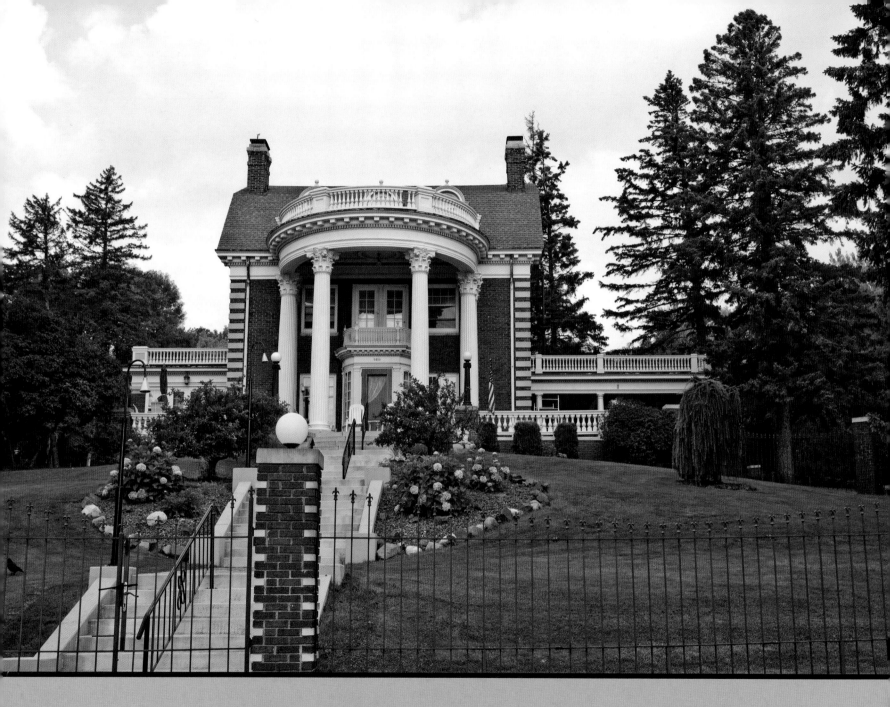

22. The Linna Pattison House, 2429 Greysolon Road (b. 1914; William A. Hunt, architect).
Linna Pattison was the widow of William Pattison, a lumber and mining executive.

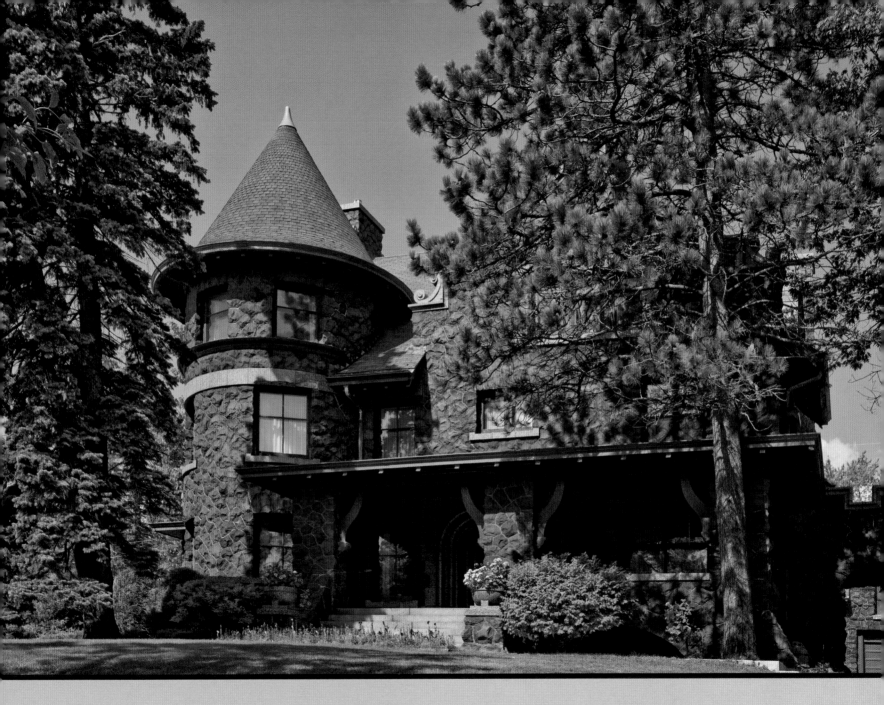

23. The Henry and Lucy Meyers House, 2505 East 1st Street (b. 1910; William T. Bray and Carl Nystrom, architects).
The basalt stone that faces the house was taken from material blasted from the earth while building 24th Avenue East.

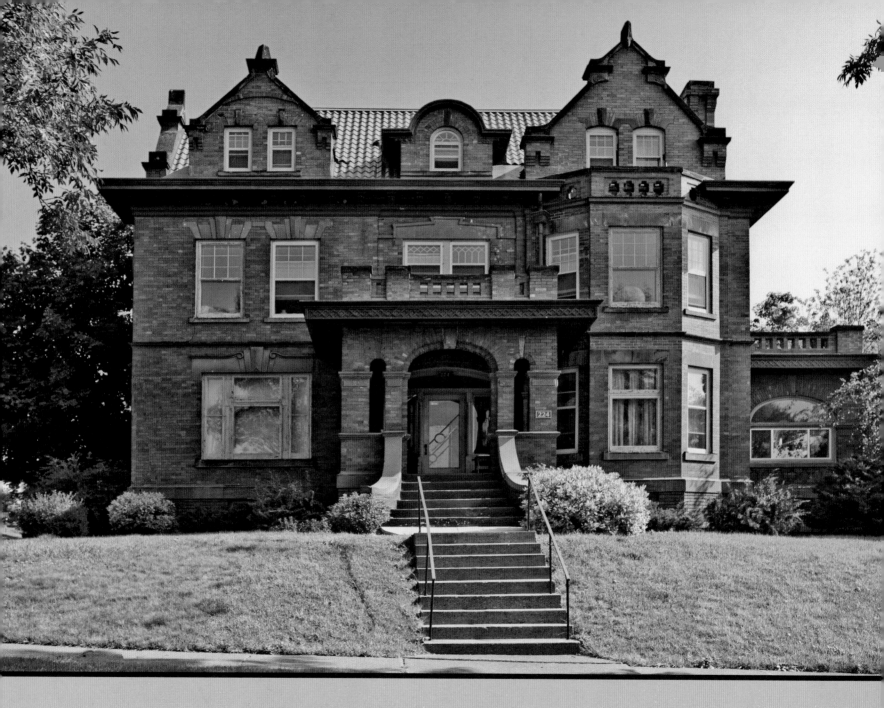

24. The Dr. J. J. Eklund House, 224 24th Avenue East (b. 1908; John J. Wangenstein, architect).

A surgeon, Dr. Eklund was shot and killed in 1922 in his office by John Magnuson, who then turned the gun on himself.

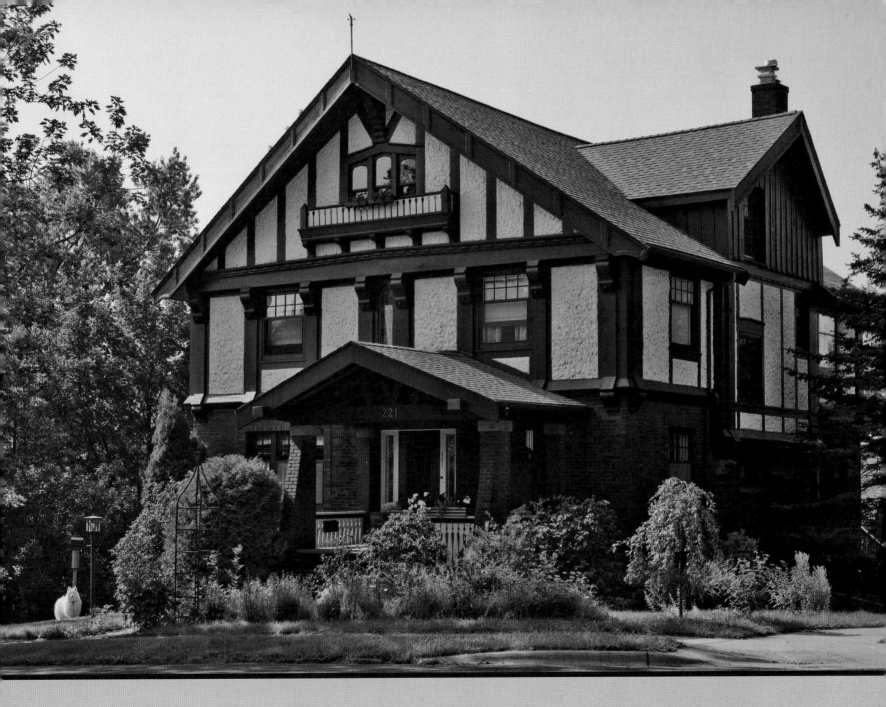

25. The Alice Florada House, 221 23rd Avenue East (b. 1908; William A. Hunt, architect).
Alice Florada was the widow of Edward Florada, a mining executive.

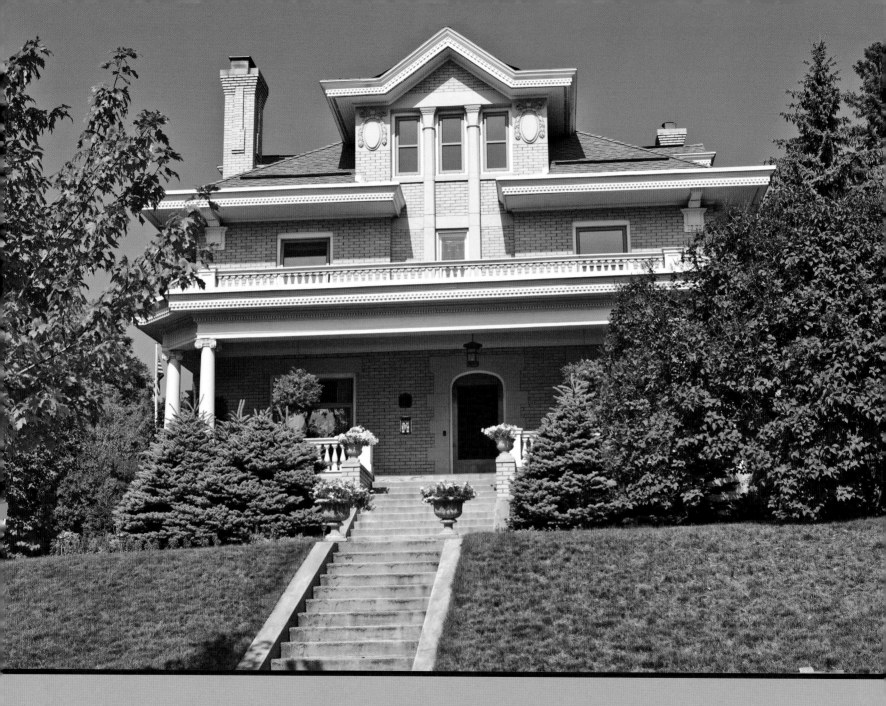

26. The Alexander McDougall House, 2201 East 1st Street (b. 1910; William T. Bray & Carl E. Nystrom, architects).
McDougall was a shipbuilder and the creator of the whaleback steamer ore carrier.

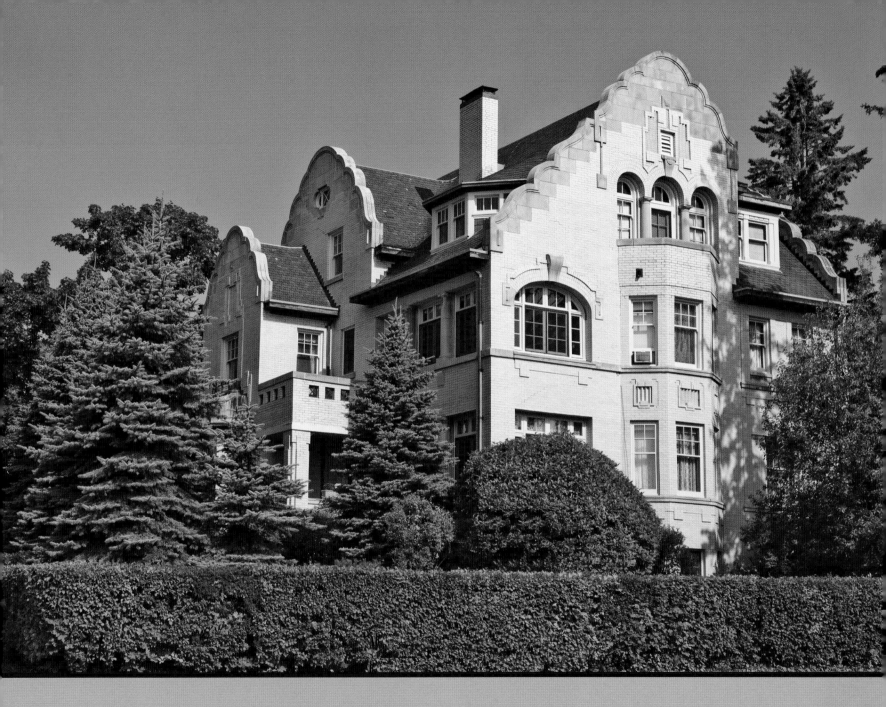

27. The Gust and Hanna Carlson House, 202 24th Avenue East (b. 1910; A. Werner Lignell, architect).
Gust Carlson was a copper mining executive and a developer of taconite.

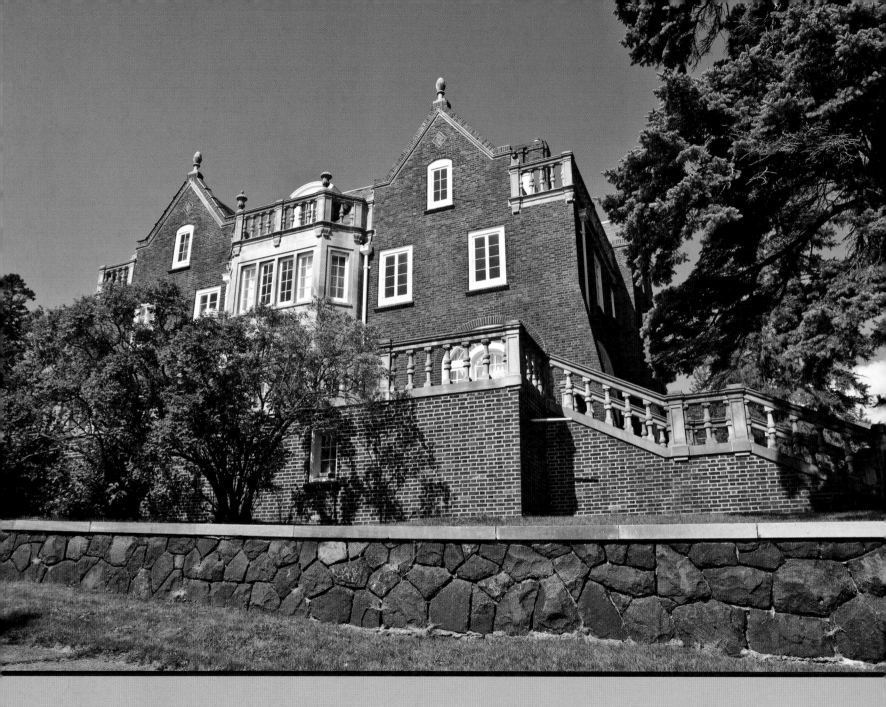

28. The John and Julia Williams House, 2601 East 2nd Street (b. 1913; Frederick W. Perkins, architect).
John Williams was an attorney; author Sinclair Lewis lived in this house between 1944 and 1946.

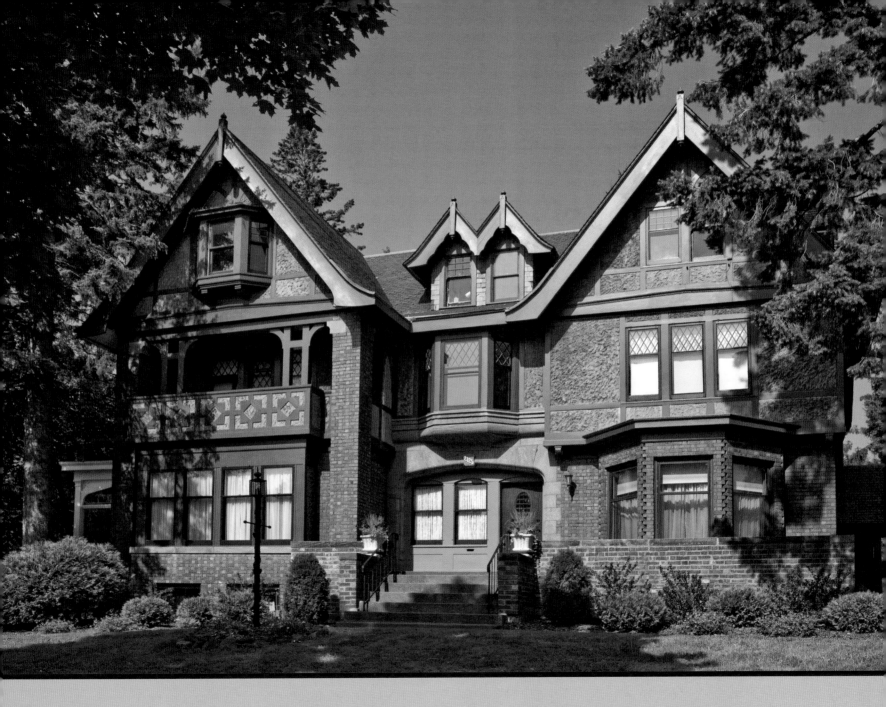

29. The Zar and Frances Scott House, 2125 East 1st Street (b. 1907; William A. Hunt, architect).
Zar Scott co-owned Duluth's Scott-Graff Lumber Company and was a leader in Minnesota's reforestation movement.

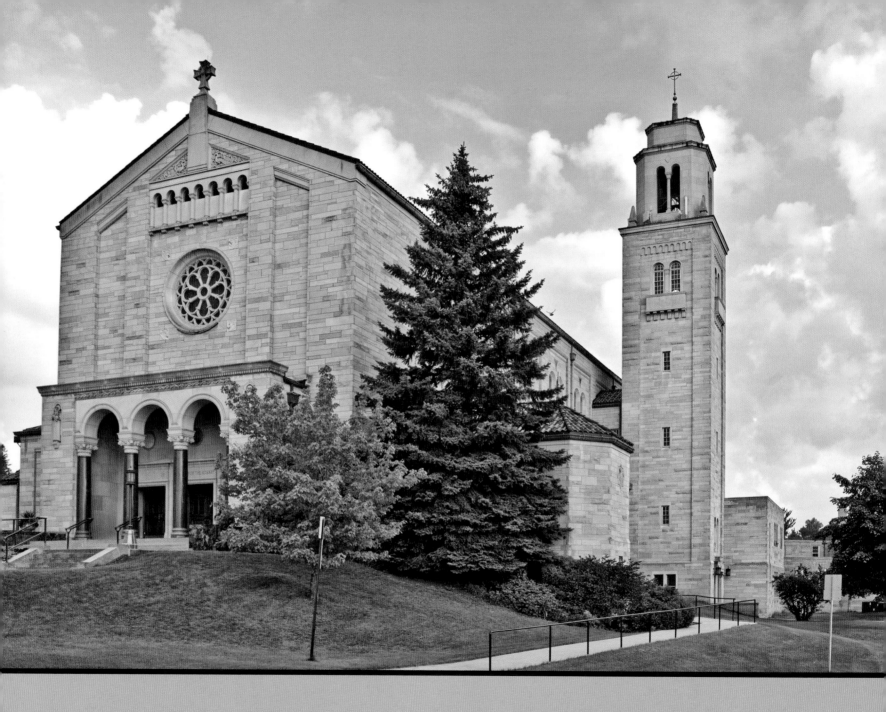

30. Cathedral of Our Lady of the Rosary, 2802 East 4th Street (b. 1957; Margulo and Quick, architects).

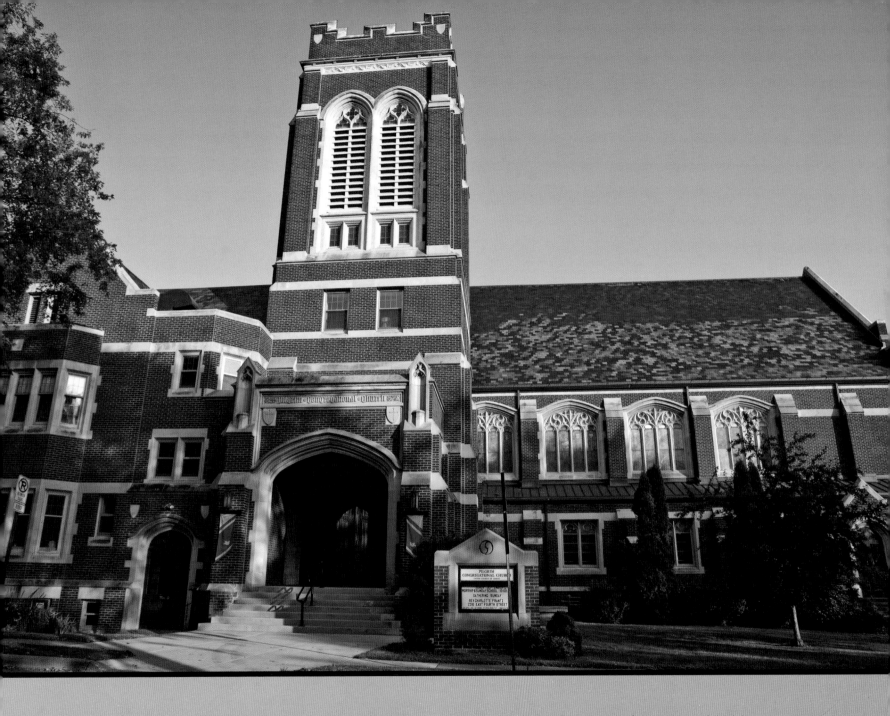

31. Pilgrim Congregational Church, 2310 East 4th Street (b. 1917; Frederick German & Leif Jennsen, architects).

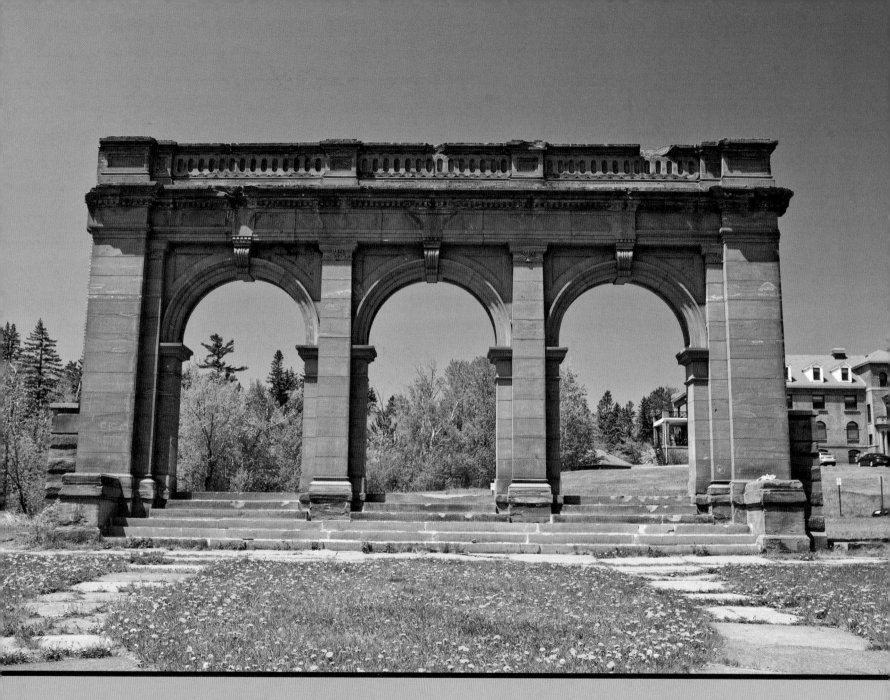

32. Ruins of "Old Main," on the former University of Minnesota Duluth campus, 2205 East 5th Street (b. 1898; Palmer, Hall, & Hunt, architects). Originally the Normal School at Duluth and later the Duluth State Teacher's College, it became UMD in 1947. It was destroyed by fire in 1992. The entire old campus was placed on the National Register of Historic Places in 1985.

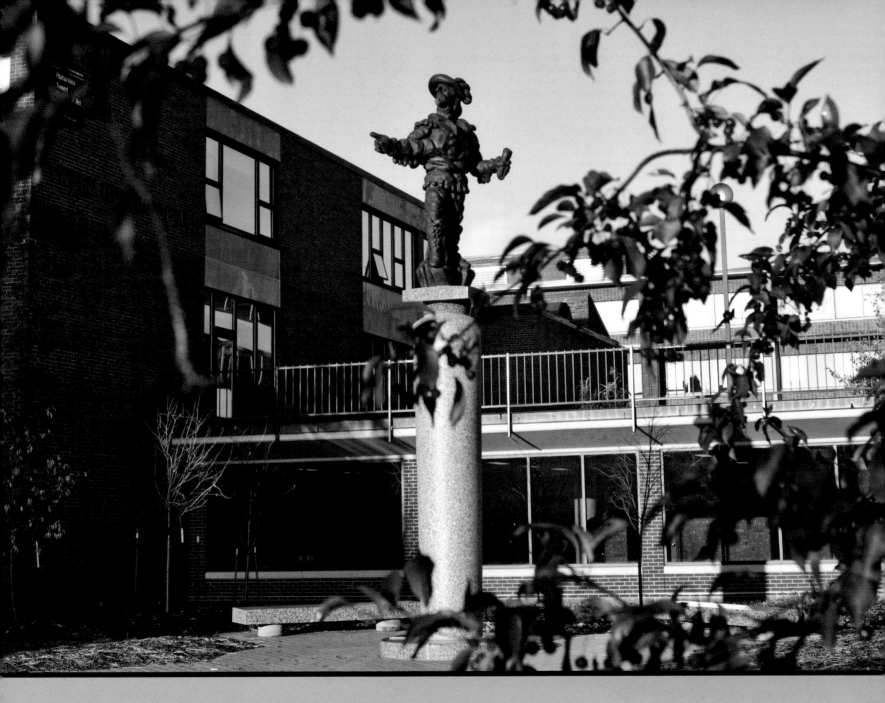

33. Statue of Duluth namesake Daniel Greysolon Sieur du Lhut by French artist Jacques Lipschitz.
The statue stands in Ordean Court outside the Tweed Museum of Art on the University of Minnesota Duluth campus.

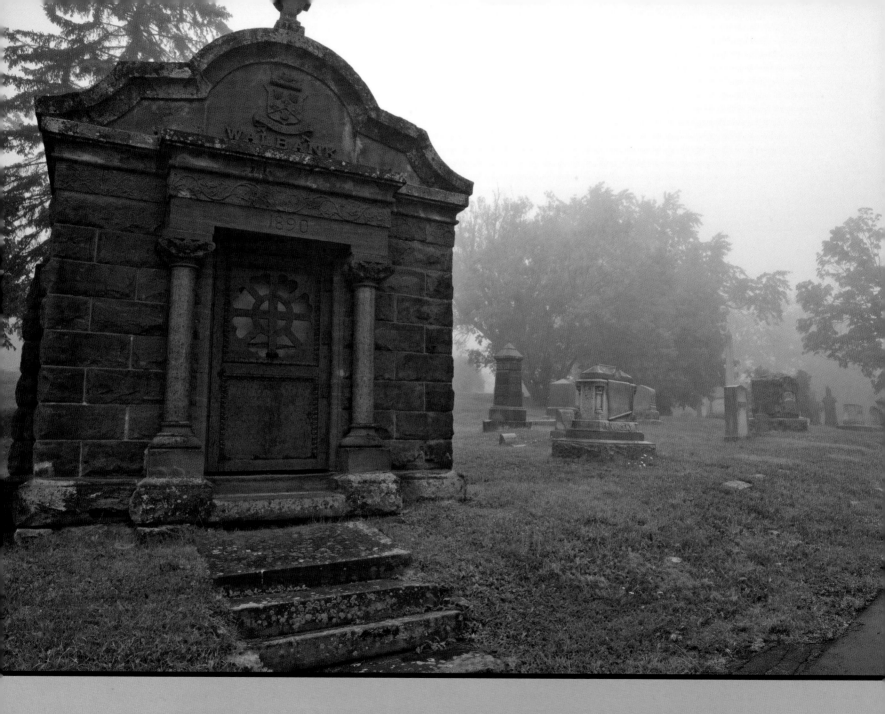

34. The Walbank family mausoleum at Forest Hill Cemetery; Dr. Samuel S. Walbank was a physician and a Duluth pioneer.

35. Hartley Pond, Hartley Park, late summer.

36. Great Grey Owl, Hartley Park, winter.

37. View from Hartley Park's Rock Knob looking south, autumn.

38. Tischer Creek as it flows through Hartley Park, spring.

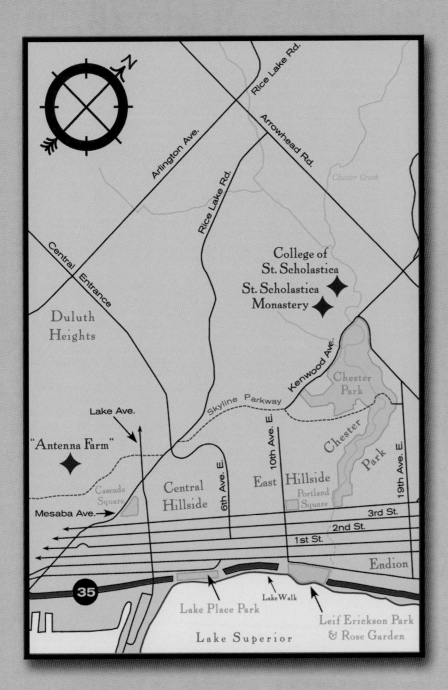

2.
Downtown and The Hillside

21st Avenue East to Mesaba Avenue

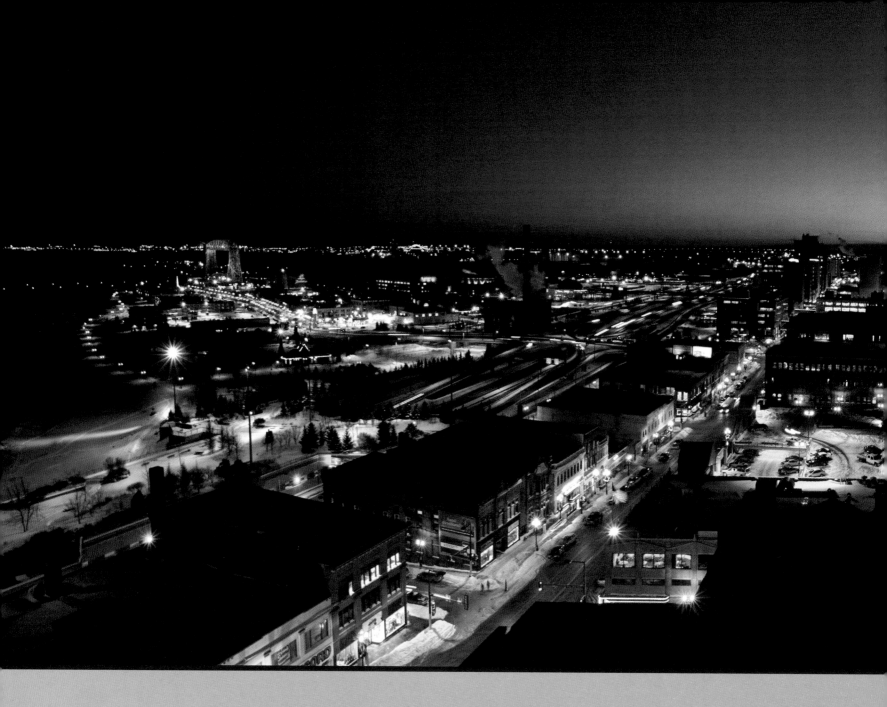

40–41. Downtown Duluth from the east, winter.

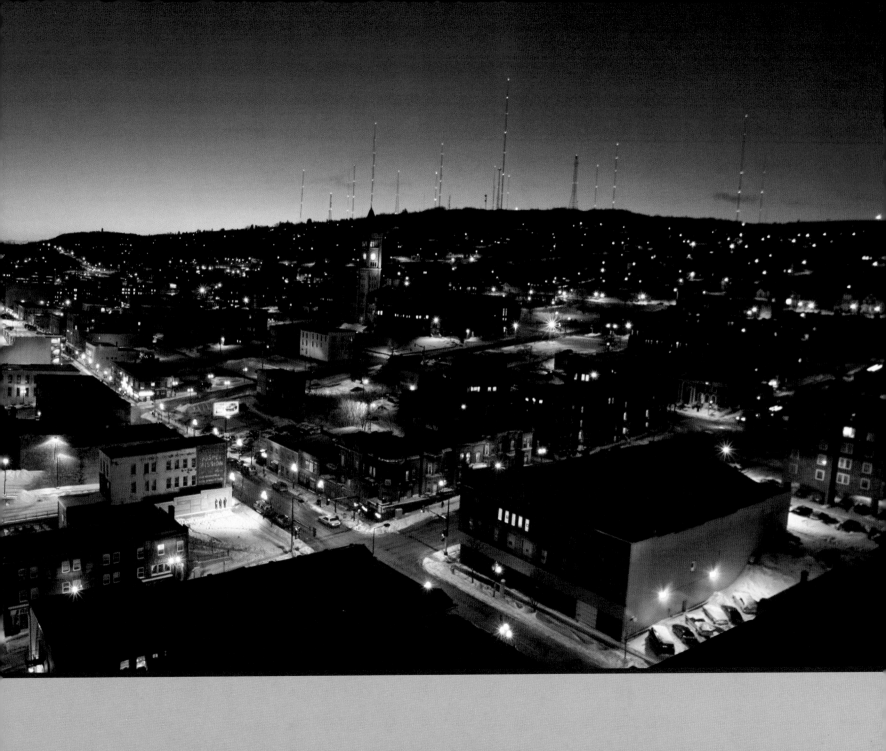

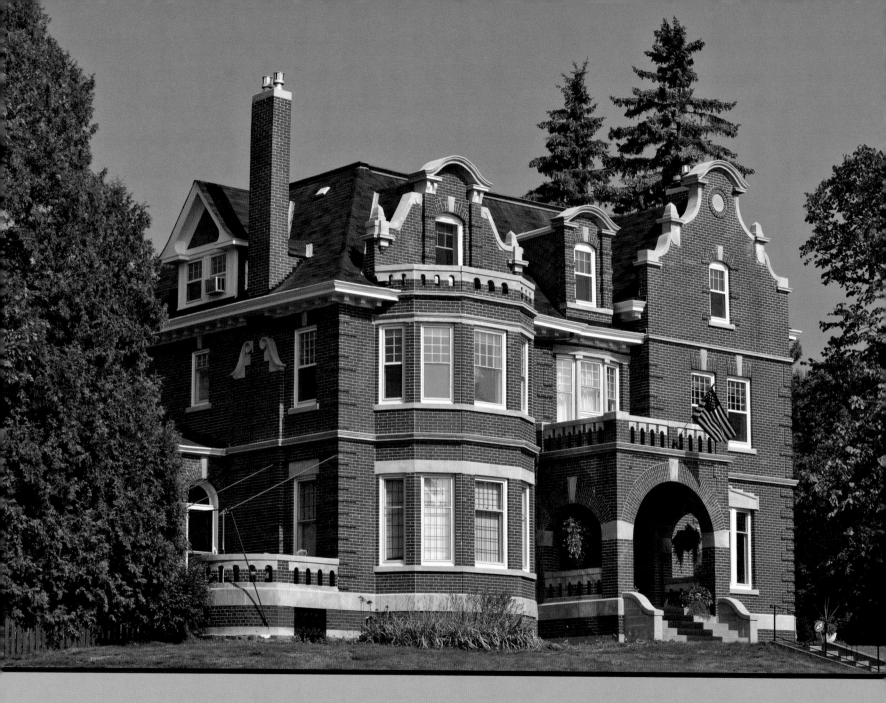

42. The E. Milie and Elizabeth Bunnell House, 2017 East Superior Street (b. 1899; John J. Wangenstein, architect).

E. Milie Bunnell founded the *Duluth Herald* and was later the publisher of the *Duluth News Tribune*.

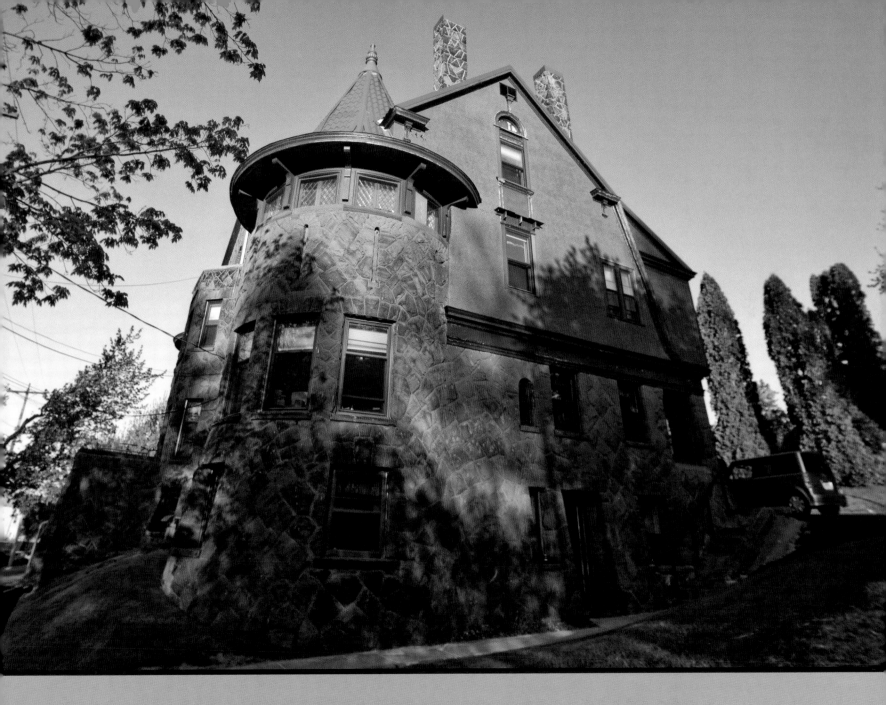

43. The Sellwood/Leithead House, 16 South 18th Avenue East (b. 1902; William A. Hunt, architect).
Mining executive Joseph Sellwood built this house as a wedding gift for his daughter Ophelia and her husband, Leslie Leithead.

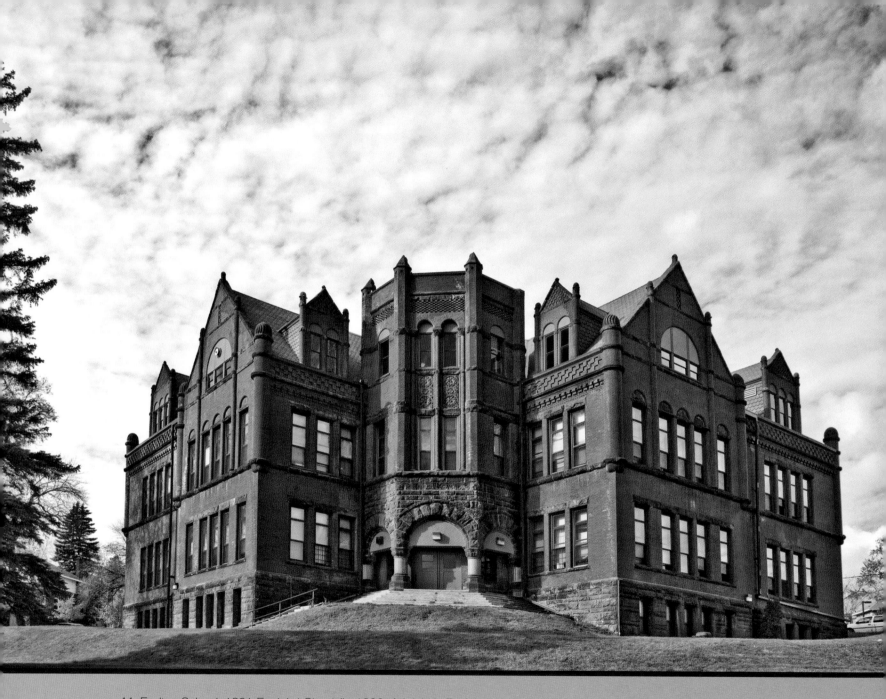

44. Endion School, 1801 East 1st Street (b. 1890; Adolph A. Rudolph, architect). The building's belfry was removed after vandals damaged it in 1970; the school closed in 1977 and the building's classrooms were later converted to apartments. Placed on the National Register of Historic Places in 1983.

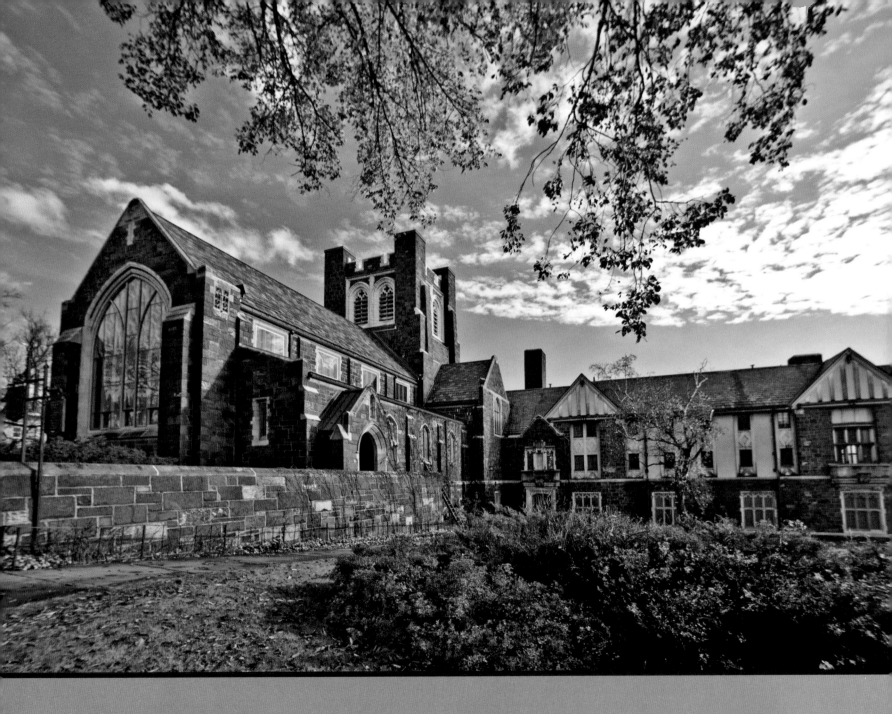

45. St. Paul's Episcopal Church, 1710 East Superior Street (b. 1913; Bertram Goodhue, architect).

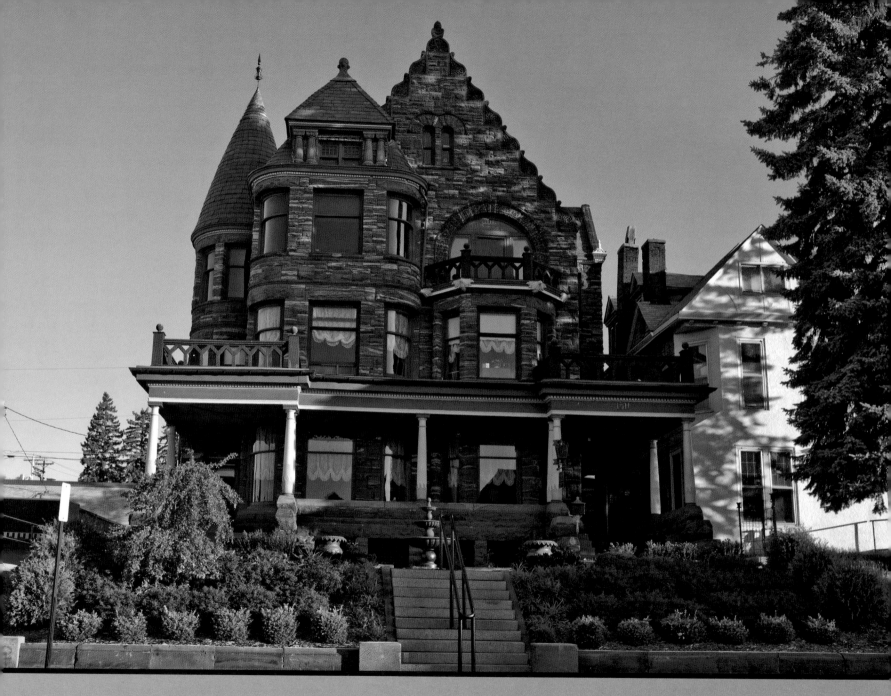

46. "The Redstone," 1511 East Superior Street (b. 1892; Oliver G. Traphagen, architect).

Architect Oliver G. Traphagen built this as his family home; the Chester and Clara Congdon family resided here until Glensheen was built.

Placed on the National Register of Historic Places in 1975.

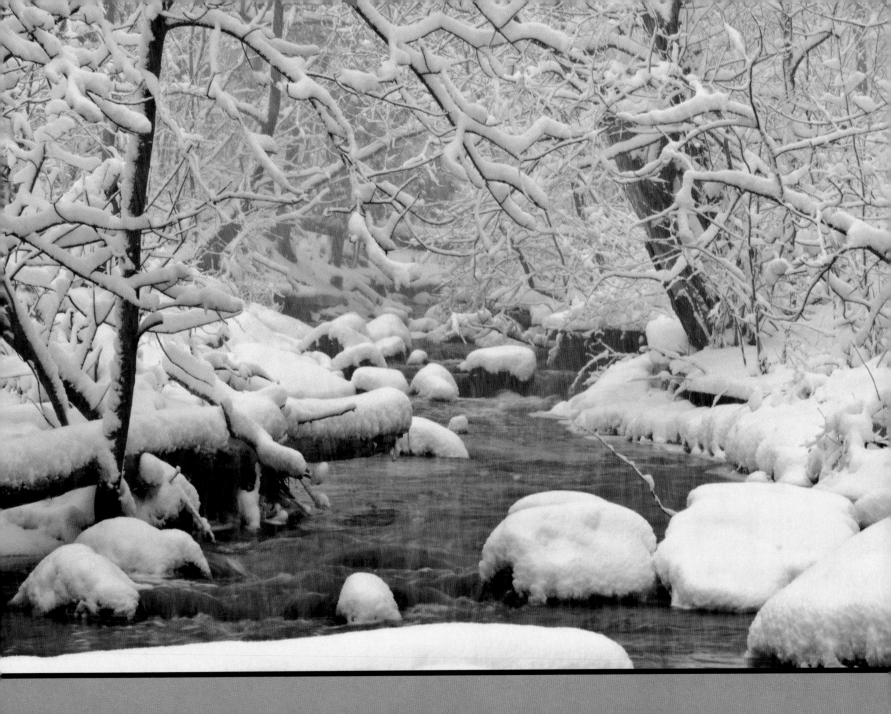

47. Chester Creek during a snowfall, Chester Park, winter.

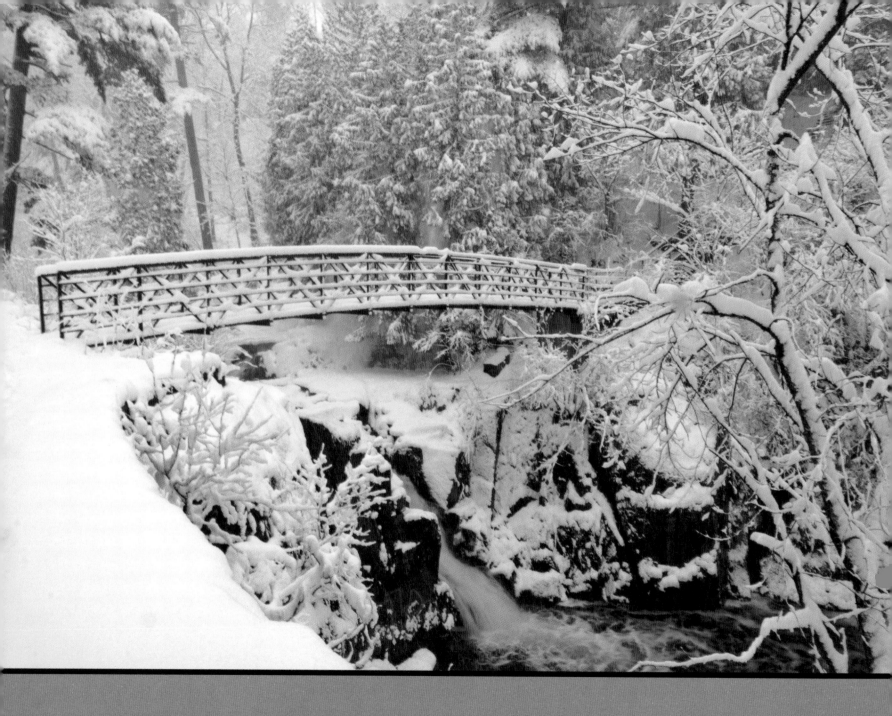

48. Footbridge over Chester Park's "Big Ten" waterfall, winter.

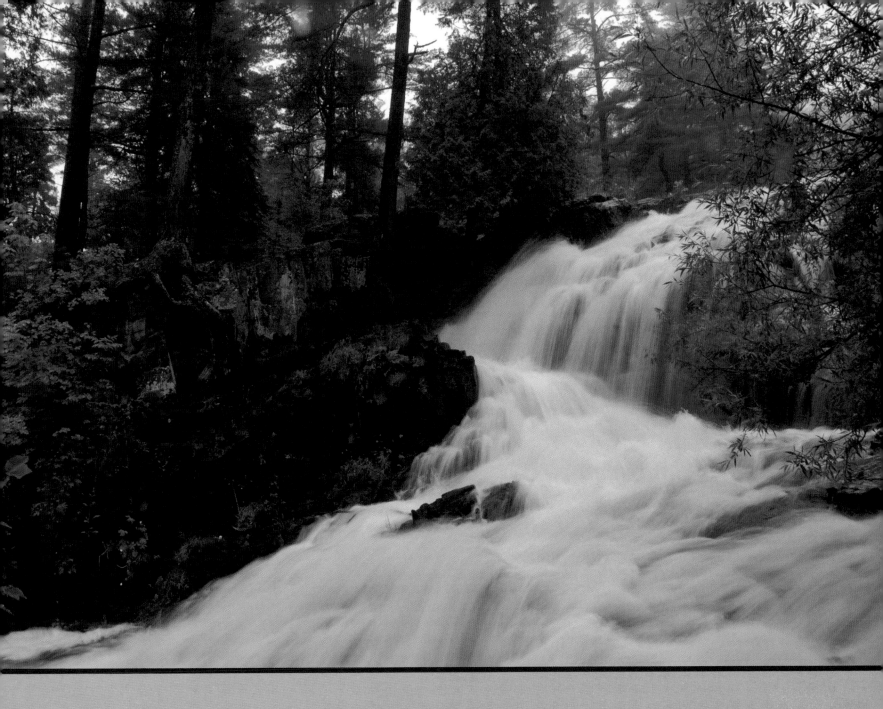

49. Waterfall just below Skyline Parkway, Chester Park, spring.

50. Along the trail in Chester Park, summer.

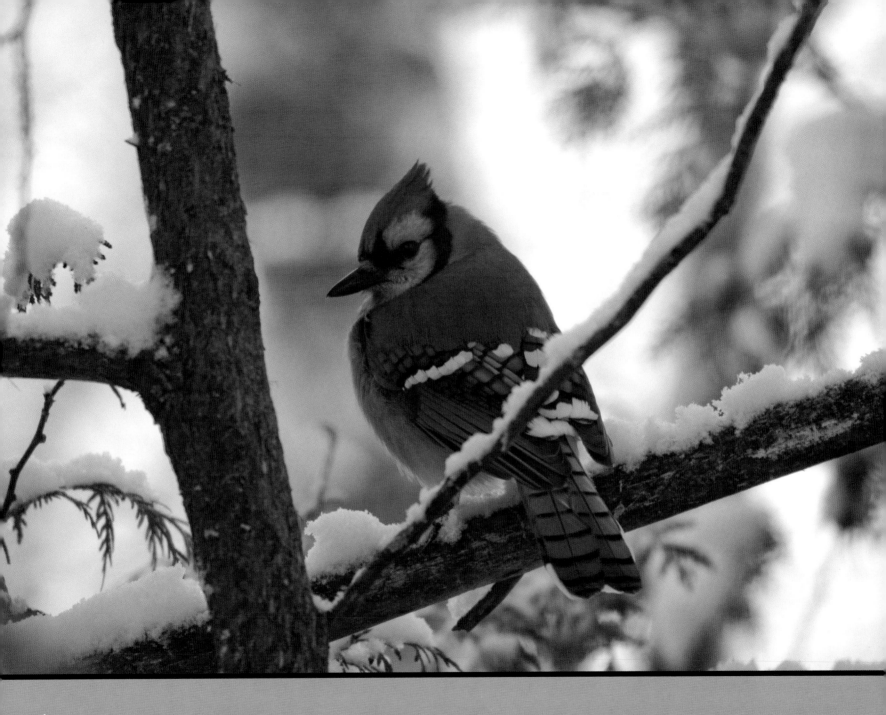

51. Blue Jay perched on a cedar tree, Chester Park, winter.

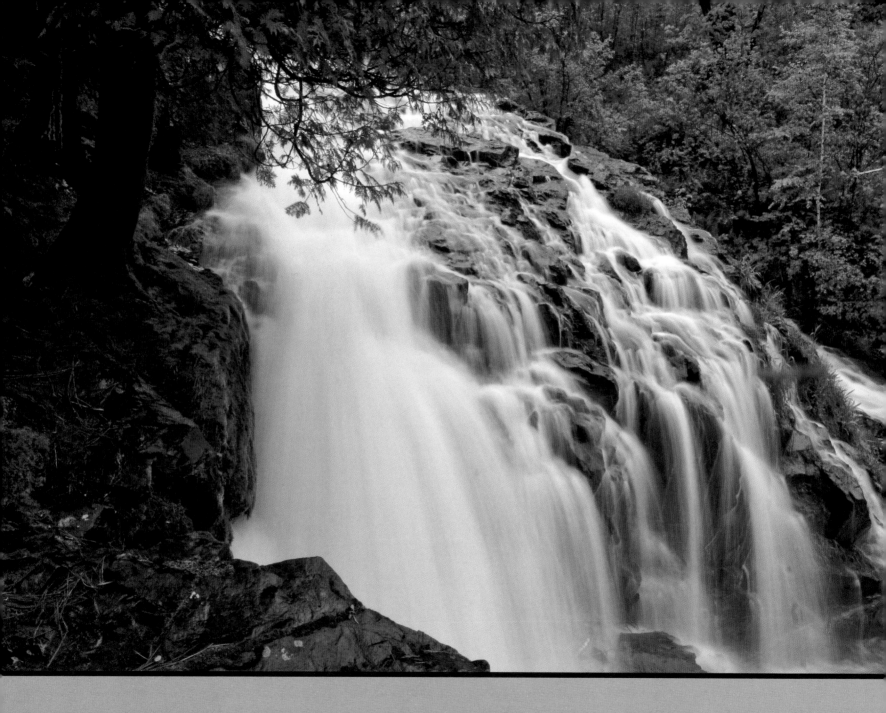

52. The falls in Chester Park below Skyline Parkway after a rain, summer.

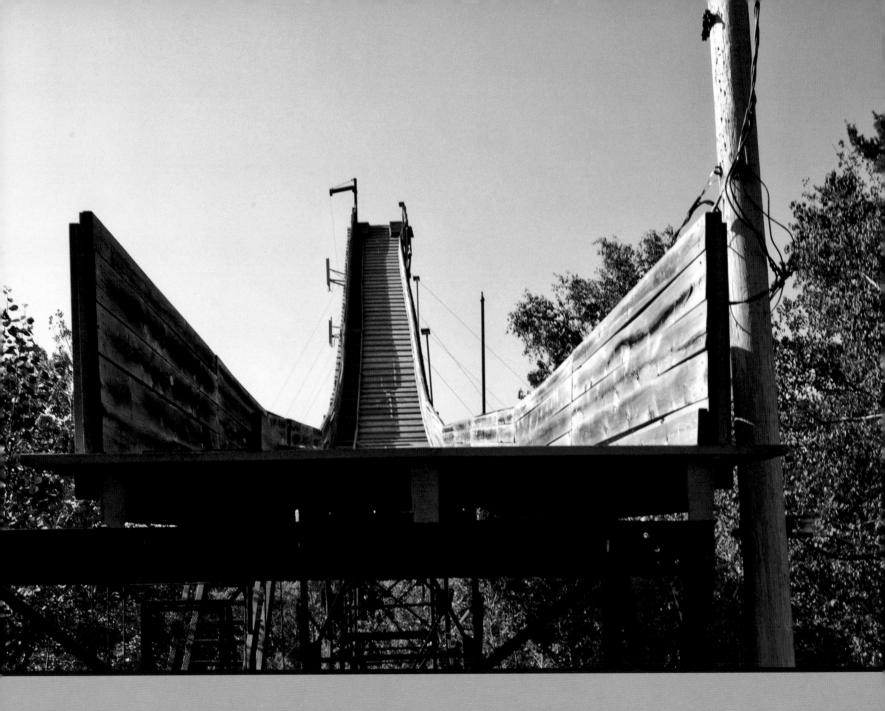

53. What remains of "Big Chester," one of three historic ski jumps still standing above Chester Bowl, Chester Park.

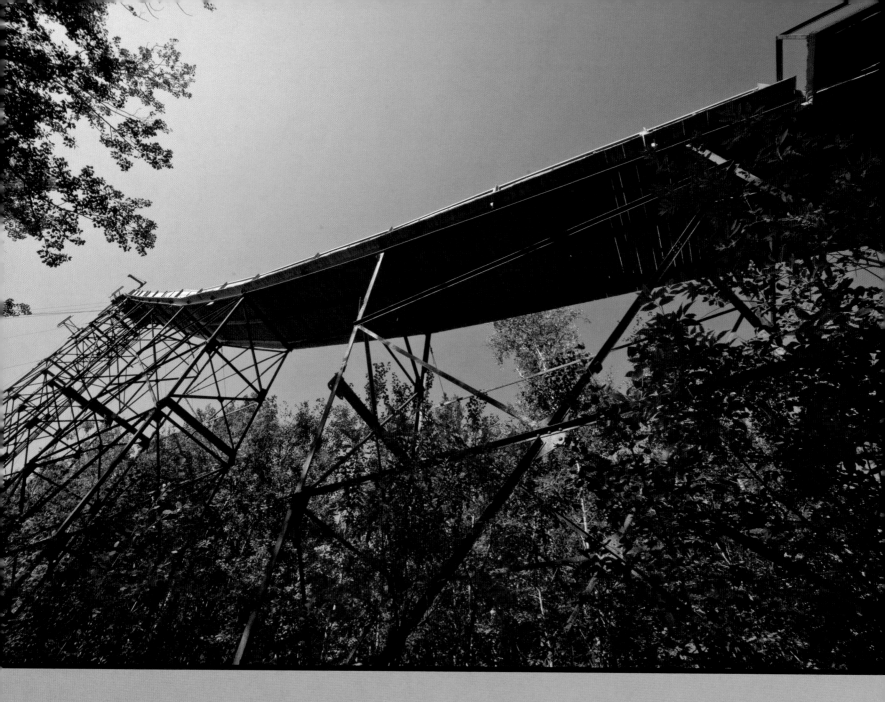

54. When "Big Chester" was erected in 1924, it was the tallest ski jump in the world at 155 feet.
The top forty feet were removed during World War II as scrap metal for the war effort, reducing the jump to its current height of 115 feet.

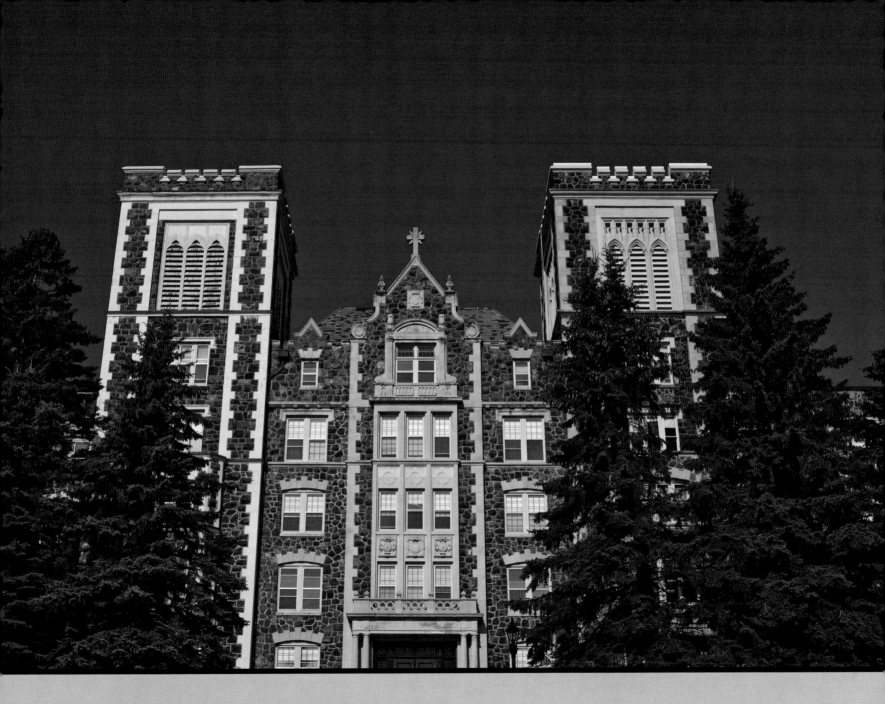

55. Villa Scholastica, 1001 Kenwood Avenue (1909; Frederick German, A. Werner Lignell, and Frank Ellerbe, architects).

The tower at right was not added until 1928; the building is now the College of St. Scholastica's Tower Hall.

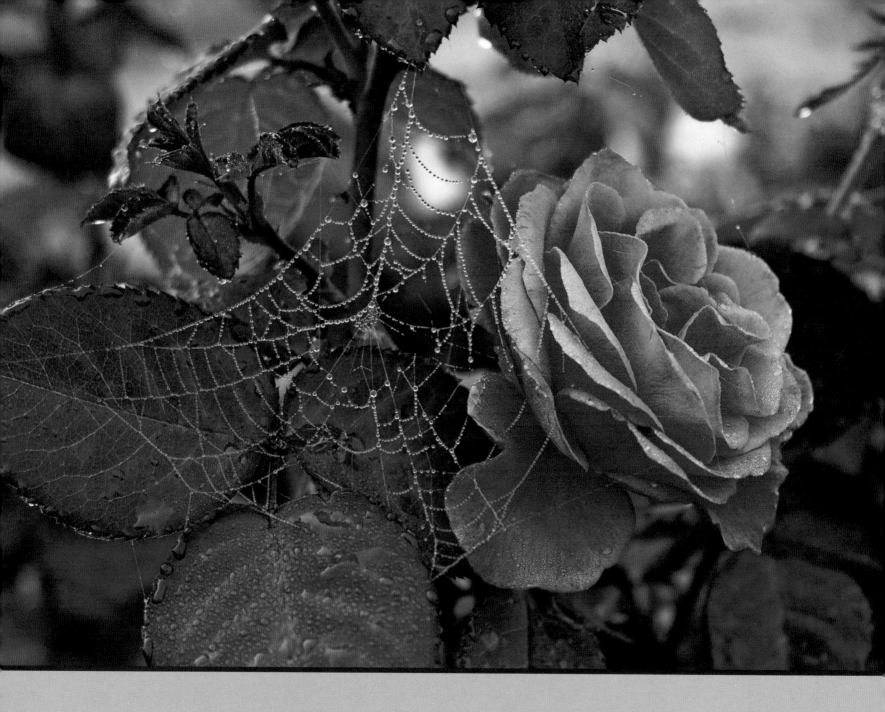

56. A dew-covered spiderweb at the Duluth Rose Garden in Leif Erikson Park.

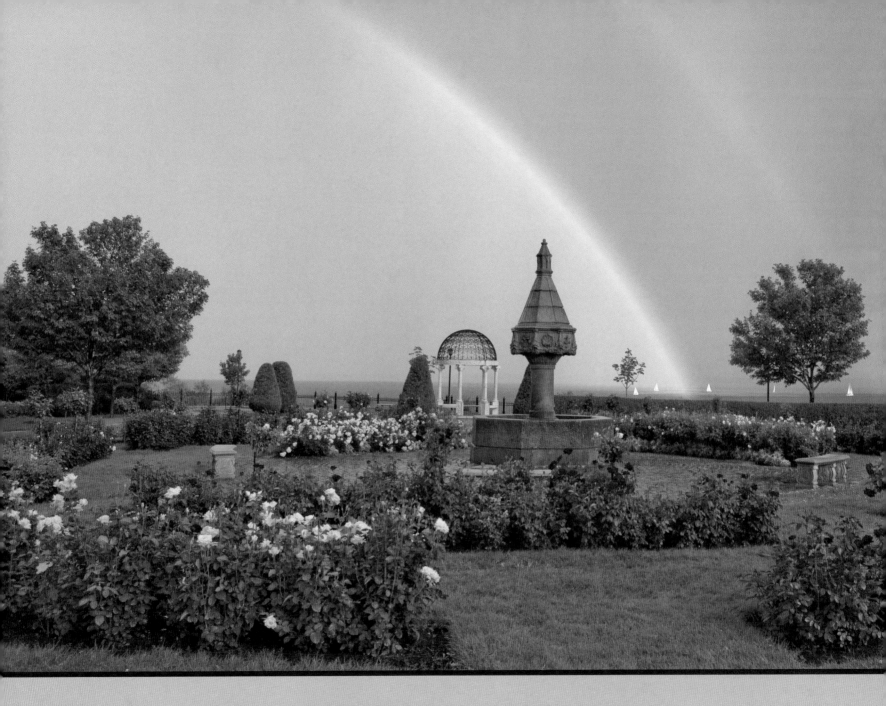

57. Rainbows over the Duluth Rose Garden, Leif Erikson Park, summer.

The "fountain," built in 1905, was actually a watering trough for horses and dogs that originally stood at London Road and Superior Street.

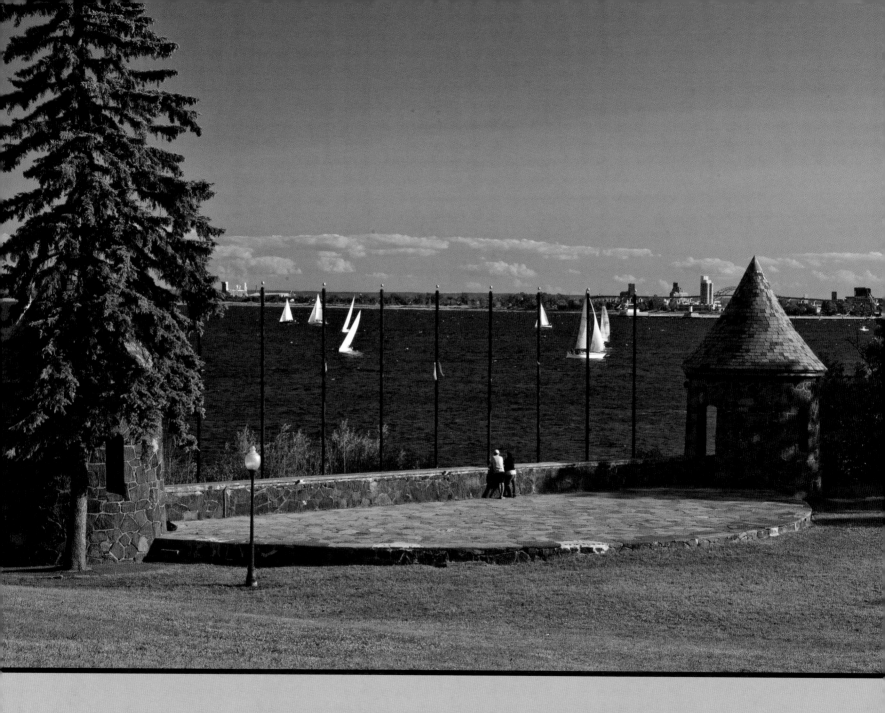

58. Leif Erikson Park's stone "castle stage"—the single man-made element of the park's natural amphitheater, summer.

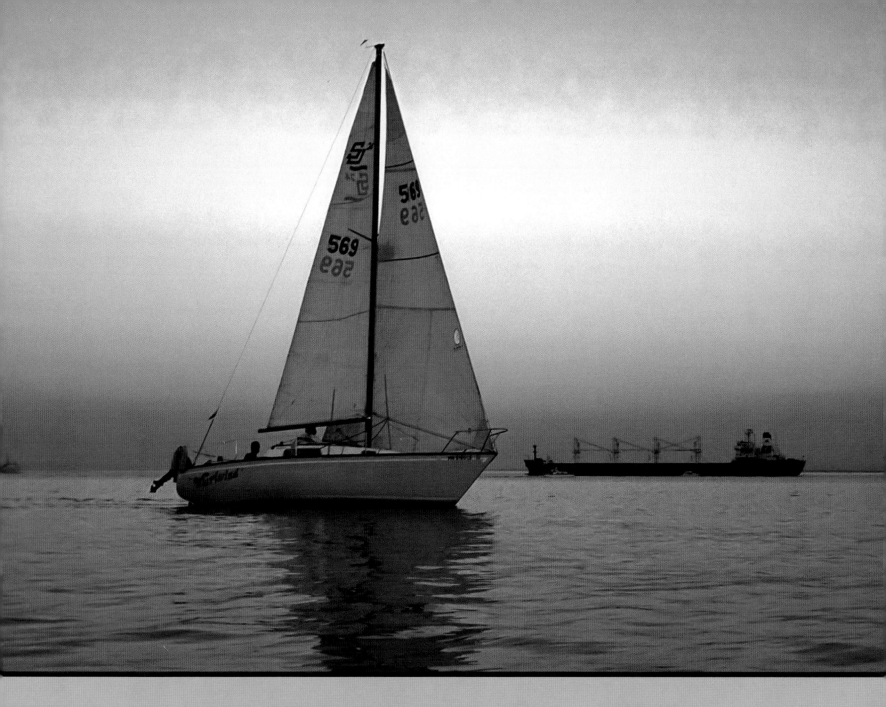

59. Sailing Lake Superior during one of Duluth's traditional Wednesday evening sailing regattas off Leif Erikson Park, summer.
The sailboats seen on the two previous pages are also participating in a Wednesday evening regatta.

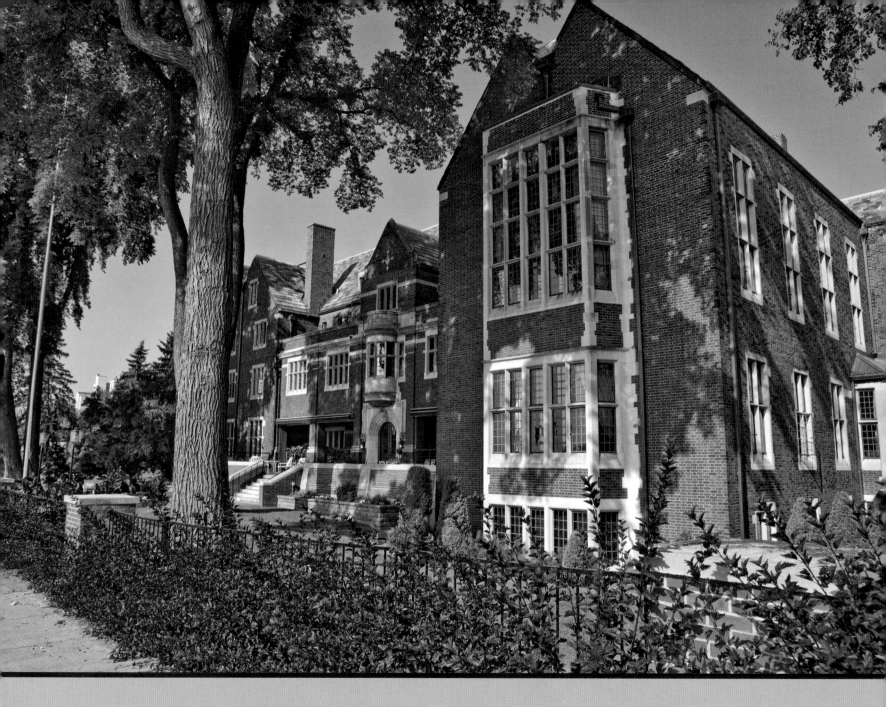

60. The Kitchi Gammi Club, 831 East Superior Street (b. 1912; Bertram Goodhue, architect).
Placed on the National Register of Historic Places in 1975.

61.
Stone carving of a
Native American "holding"
a lantern, an architectural
detail of the Kitchi Gammi Club
carved by O. George Thrana.

Thrana's work can still
be found on buildings
throughout Duluth
(see pages 69 and 70).

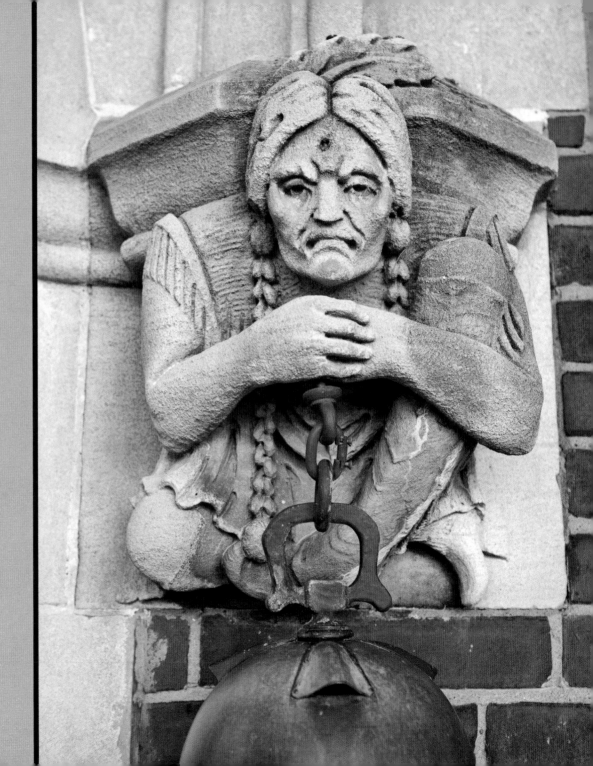

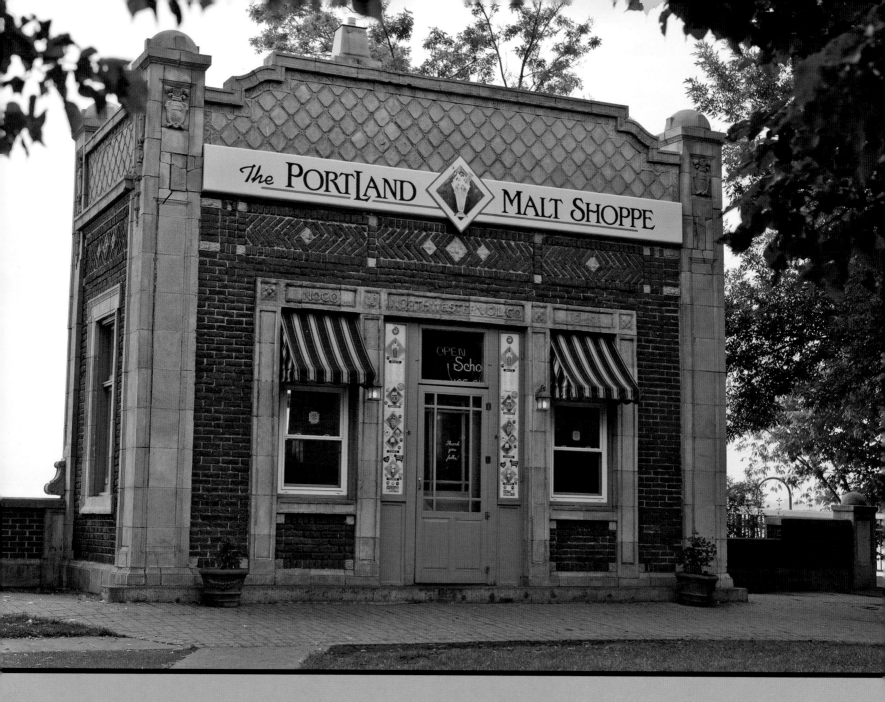

The PortLand Malt Shoppe

NOCO — NORTHWESTERN OIL CO.

OPEN

62. Northwestern Oil Company Filling Station (b. 1921; architect unknown).
The building is now the home of the Portland Malt Shoppe.

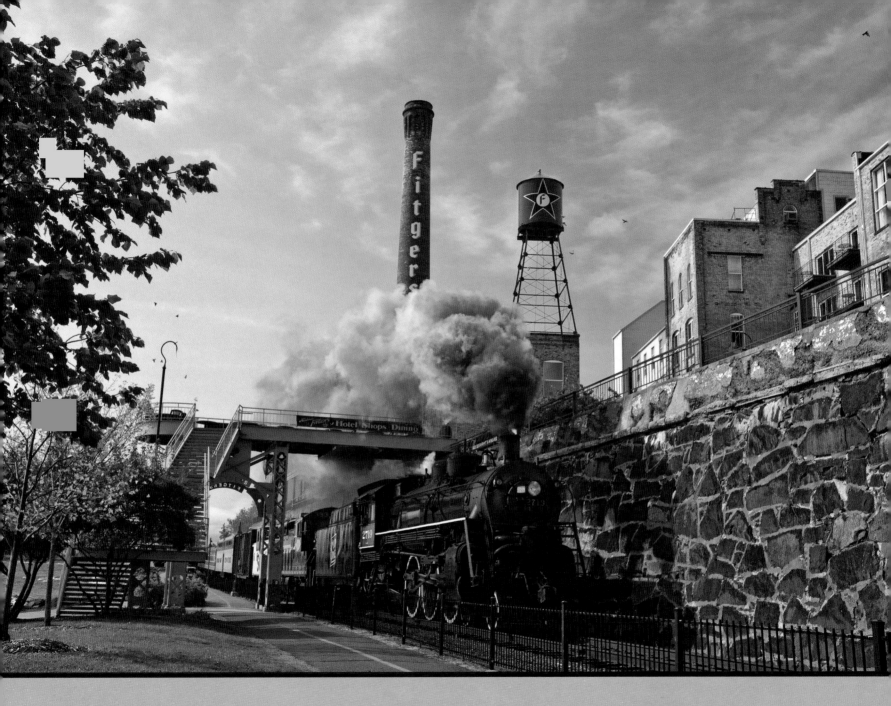

63. Steam locomotive 2719 pulls a train on the North Shore Scenic Railroad alongside the Lakewalk and past the historic Fitger Brewery.

The Fitger Brewery was placed on the National Register of Historic Places in 1984.

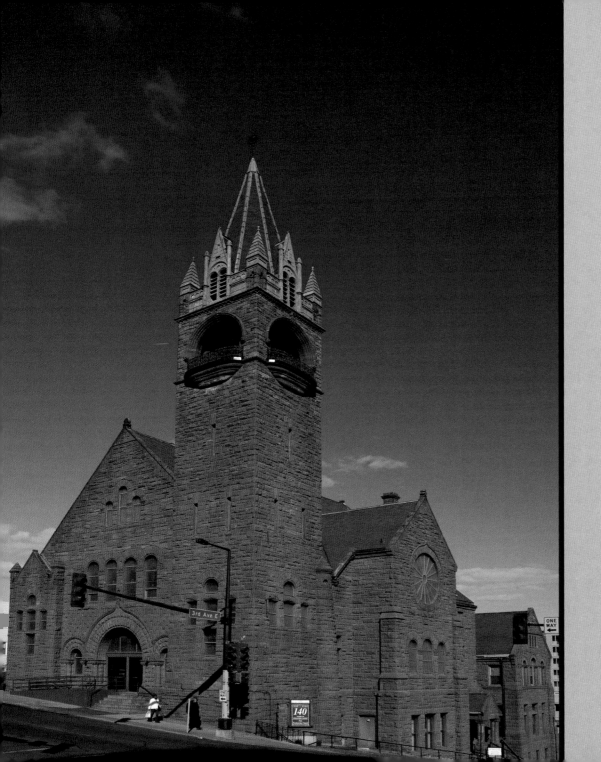

64.
First Presbyterian Church,
300 East 2nd Street
(b. 1891; Oliver Traphagen &
Francis Fitzpatrick; architects).

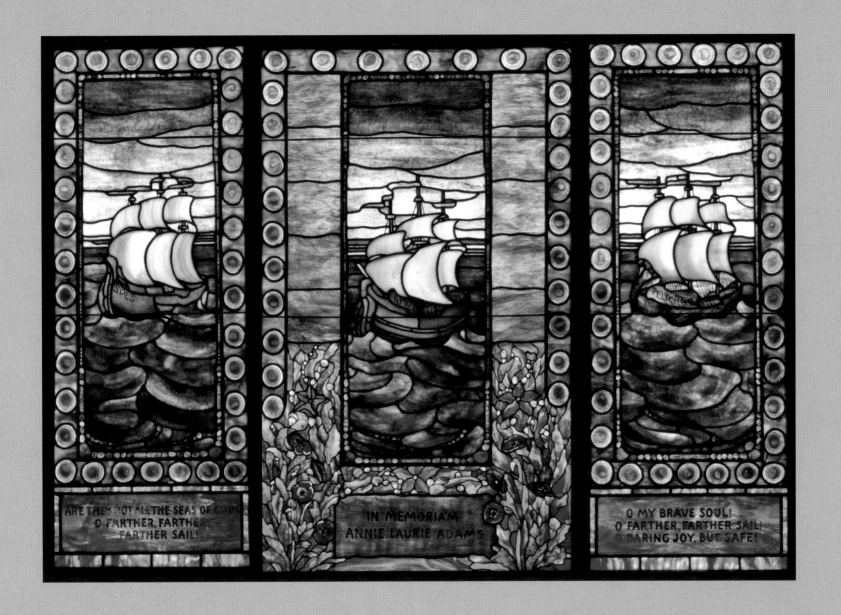

Within the stained glass windows:

ARE THEM NOT ALL THE SEAS OF GOD?
O FARTHER, FARTHER,
FARTHER SAIL!

IN MEMORIAM
ANNIE LAURIE ADAMS

O MY BRAVE SOUL!
O FARTHER, FARTHER SAIL!
O DARING JOY, BUT SAFE!

65. "Ships at Sea," one of many Tiffany windows gracing First Presbyterian, was designed by Duluth's own Ann Weston.

Ms. Weston's glass work can be seen in other Duluth churches and the Duluth Union Depot (sse page 73).

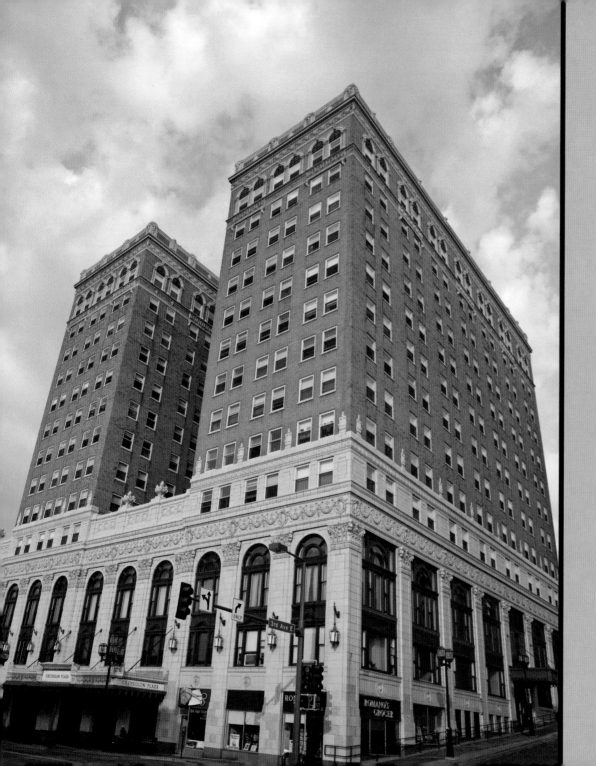

66.
The Hotel Duluth,
227 East Superior Street
(b. 1925; Martin Tullgren
& Sons, architects).

Now known as
Greysolon Plaza,
the building houses
senior living facilities and
an upscale lounge while
its restored entry foyer,
ornate ballroom, and
Moorish Room serve
as popular sites for
wedding receptions
and other social events.

Placed on the
National Register of
Historic Places in 2006
as part of Duluth's Commercial
Historic District, a twenty-square
block area of Superior 1st Streets
between 4th Avenue West
and 4th Avenue East.

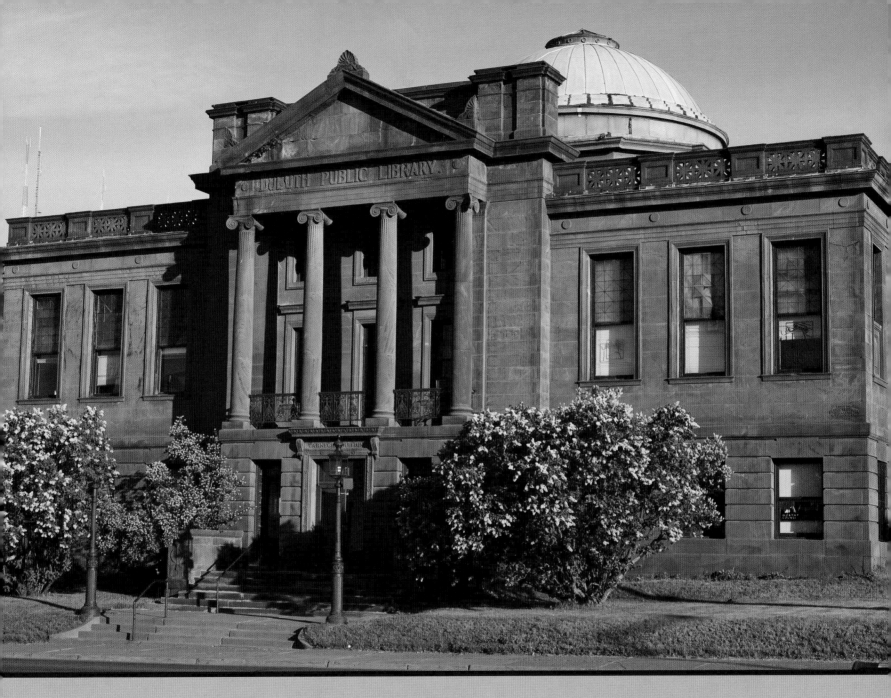

67. Duluth Public Library, 102 West 2nd Street (b. 1902; Adolph A. Rudolph, architect).

Andrew Carnegie donated $25,000 to build Duluth's library; the building closed as a library in 1980 and is now the Carnegie Office Building.

Placed on the National Register of Historic Places in 1978.

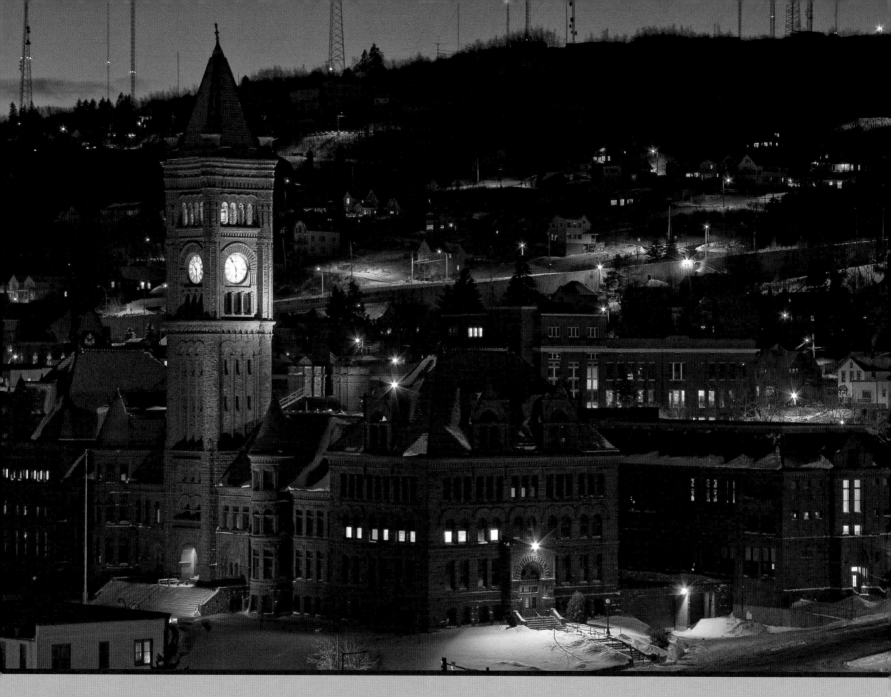

68. Historic Duluth Central High School, Lake Avenue & East 2nd Street (b. 1892; Emmet S. Palmer & Lucien P. Hall, architects).
Closed as a high school in 1971, the building now houses the Duluth School District's administrative offices.
Placed on the National Register of Historic Places in 1972.

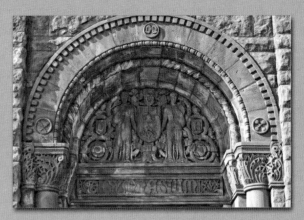
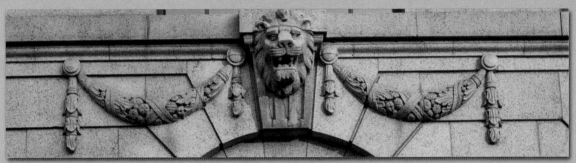
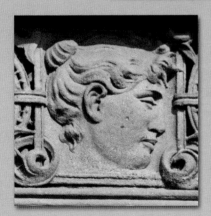
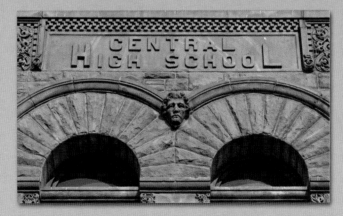
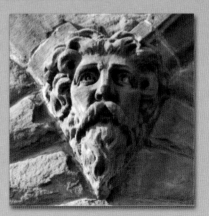

69. Details of stone carvings on Historic Central High School carved by Norwegian immigrant and Duluthian O. George Thrana (1872–1939).

"About the entrance in the tower angelic cherubs lovingly smile while overhead grotesque animal figures leer their prurient intents."
– Architectural historian James Allen Scott, on Thrana's Duluth Central High School carvings

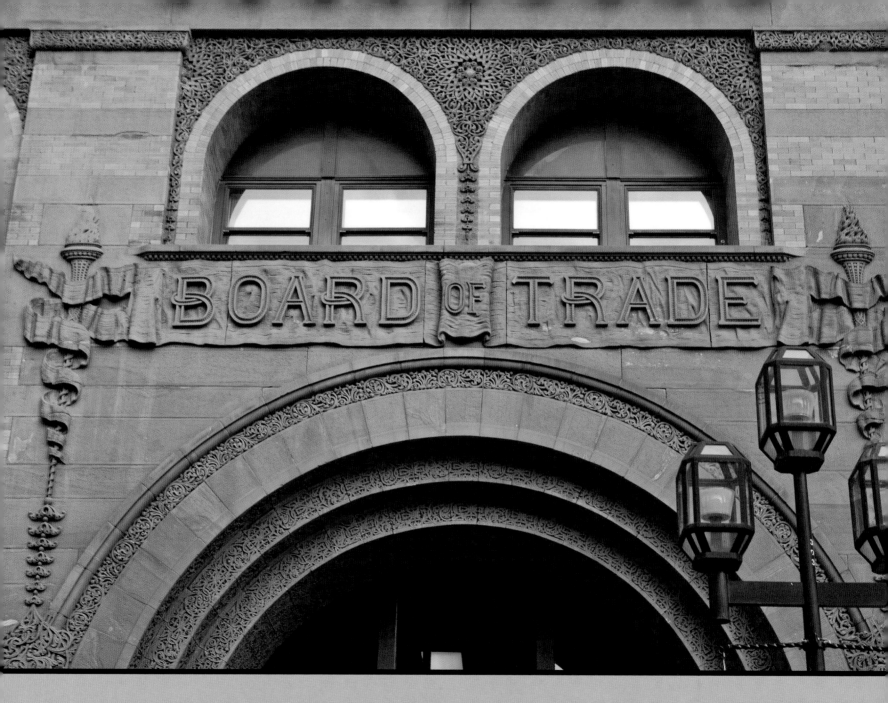

70. Entrance to the Board of Trade Building, 301 West 1st Street (b. 1895; Oliver Traphagen & Francis Fitzpatrick, architects). Now an office building, the elaborate carvings over its two-story entrance were executed by O. George Thrana (see previous page).

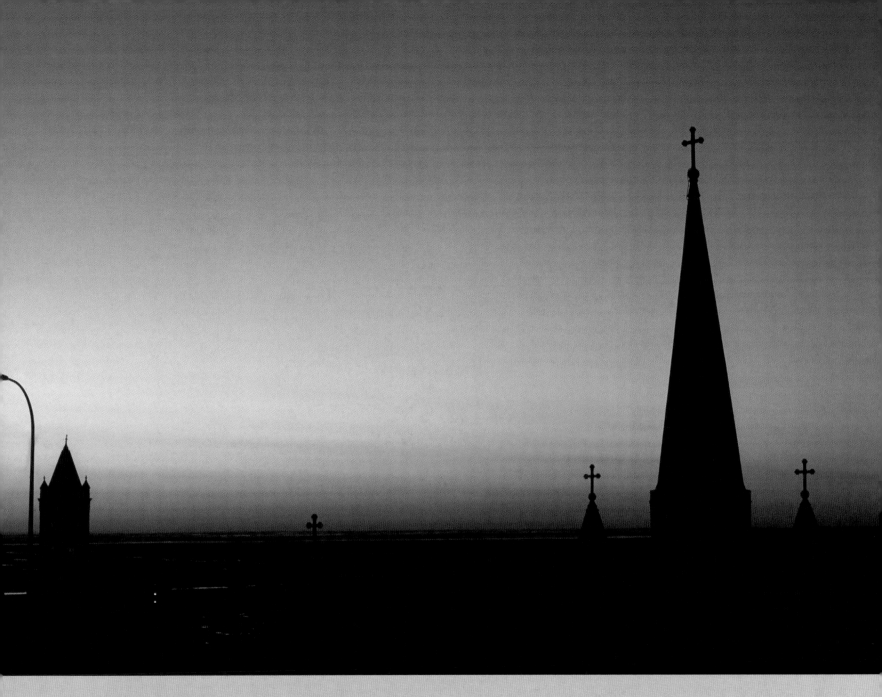

71. Silhouette of the Cathedral of Sacred Heart, 201 West 4th Street (b. 1896; Gearhard Tenbusch, architect).

Deconsecrated in the 1980s, the building is now home to the Sacred Heart Music Center.

Placed on the National Register of Historic Places in 1986.

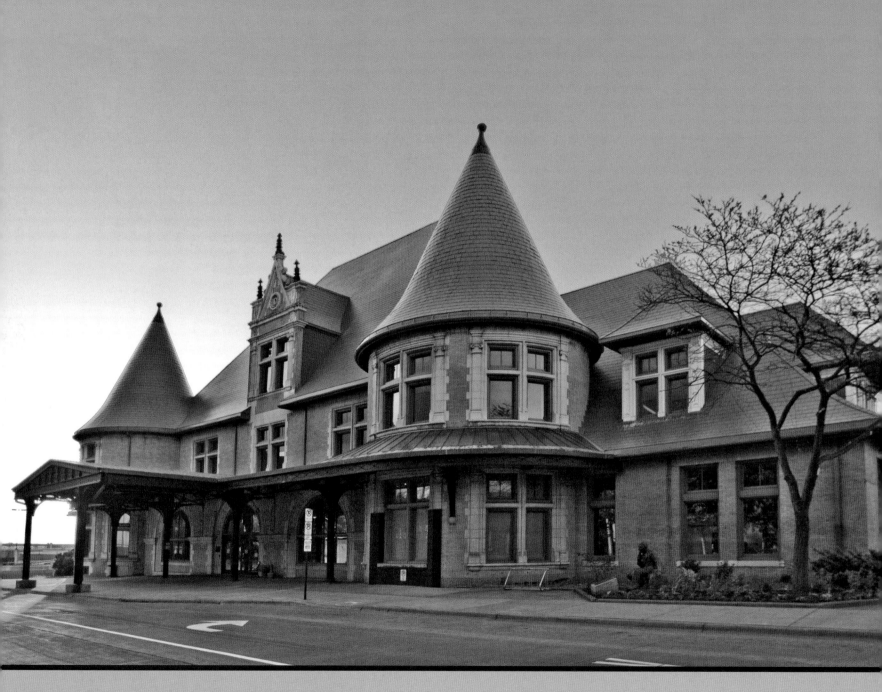

72. Union Depot, 505 West Michigan Street (b. 1892; Peabody & Stearns, architects).
The building closed as a railroad depot in 1969 and is now the St. Louis County Heritage & Arts Center.
Placed on the National Register of Historic Places in 1971.

73.
The Union Depot now houses two Tiffany windows that once hung in the Historic Duluth Public Library (see page 67).

These windows were both designed by Duluth's own Ann Weston (1861–1944).

The first was the "Hiawatha Window," commissioned for the 1892 World's Fair (right).

The second, which honors Duluth's namesake, Daniel Greysolon Sieur du Luht, was commissioned in 1902 with the intent to hang side-by-side with the Hiawatha Window.

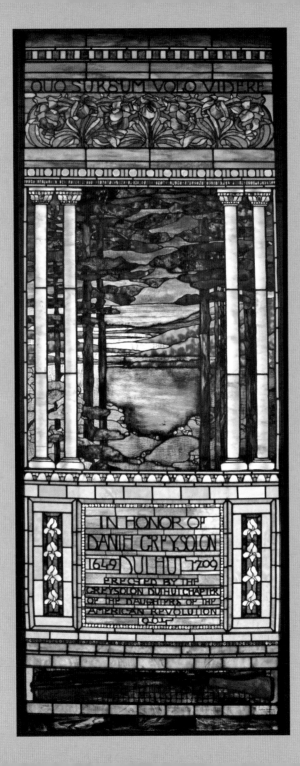

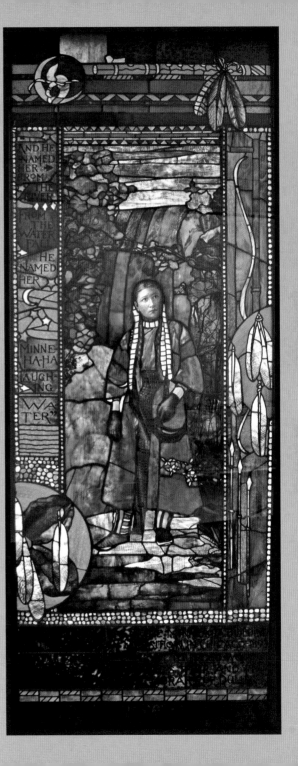

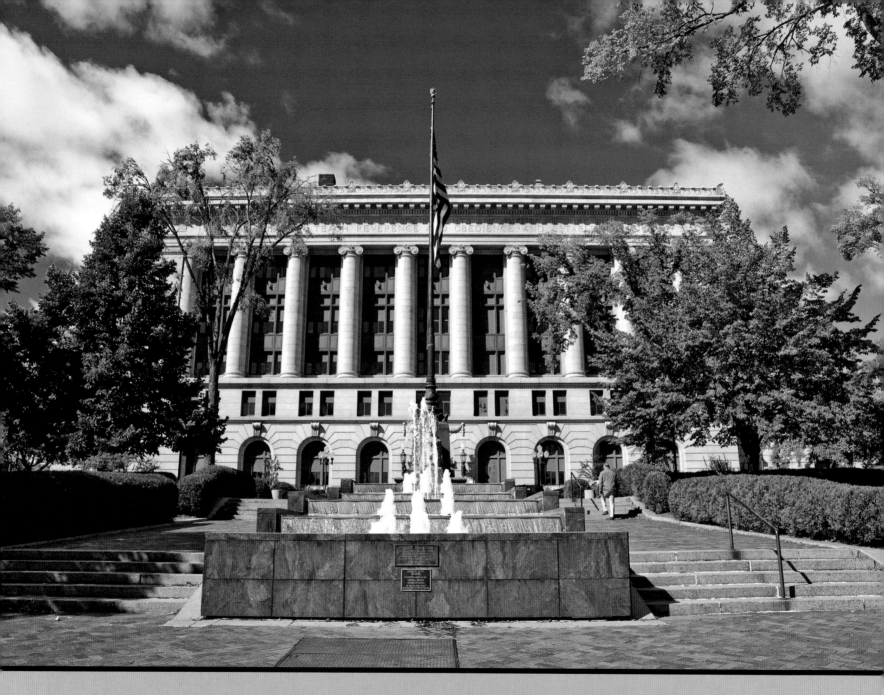

74. Priley Fountain in front of the St. Louis County Courthouse, 100 North Fifth Avenue (b. 1909; Daniel Burnham, architect).
The Courthouse and its neighbors—Duluth City Hall, the Duluth Federal Building, and the Historic St. Louis County Jail—make up Duluth's
Civic Center; all four buildings were placed on the National Register of Historic Places in 1986.

75. The Bethel Association Building, 23 Mesaba Avenue (b. 1911; Vernon Price, architect).

76. Cascade Park's gazebo, built in 1975 to replace the original pavilion, which was destroyed during a storm in 1897.
When the old, castle-like pavilion was first built, Clark House Creek ran straight through it; the creek has since been directed underground.

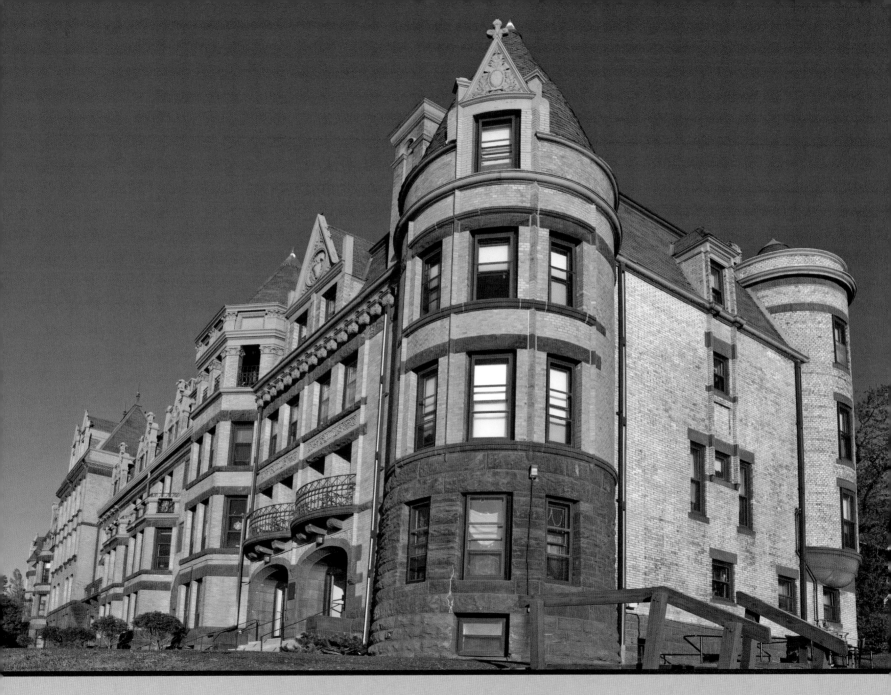

77. Munger Terrace, 405 Mesaba Avenue (b. 1871; Oliver Traphagen & Francis Fitzpatrick, architects).
Originally a townhouse whose eight units each contained sixteen rooms, it is now an apartment building with thirty-two units.
Placed on the National Register of Historic Places in 1976.

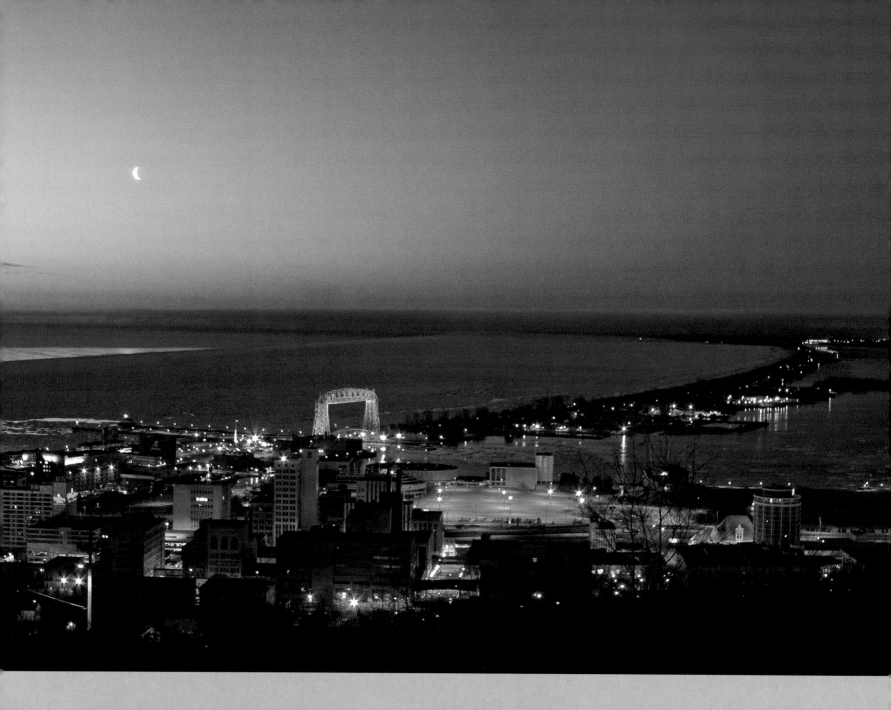

78. Dawn slowly coming up over downtown Duluth from Skyline Parkway, summer.

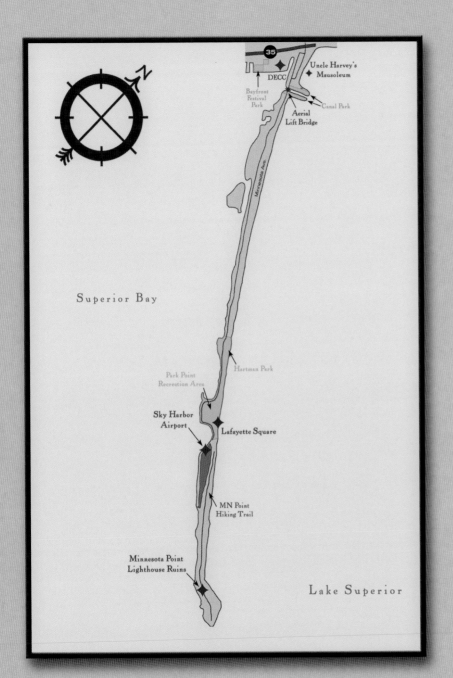

N

Uncle Harvey's
Mausoleum

DECC

Bayfront
Festival
Park

Canal Park

Aerial
Lift Bridge

Minnesota Ave

Superior Bay

Hartman Park

Park Point
Recreation Area

Sky Harbor
Airport

Lafayette Square

MN Point
Hiking Trail

Minnesota Point
Lighthouse Ruins

Lake Superior

3.
Minnesota Point

Including

Park Point,

Bayfront Festival Park,

and the

Canal Park Business District

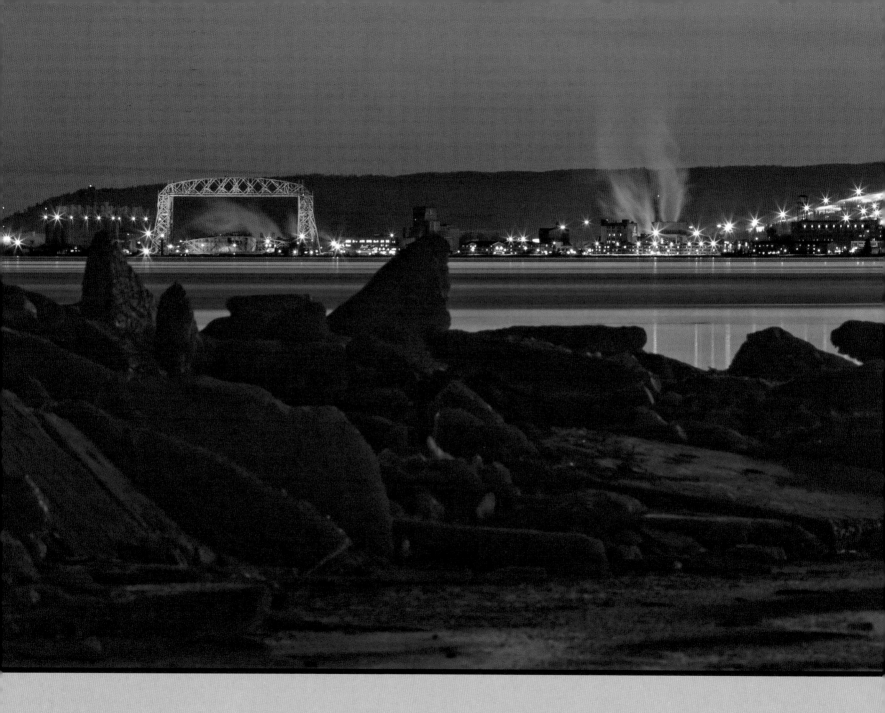

80. The Canal Park Business District's "skyline" from the east, winter.

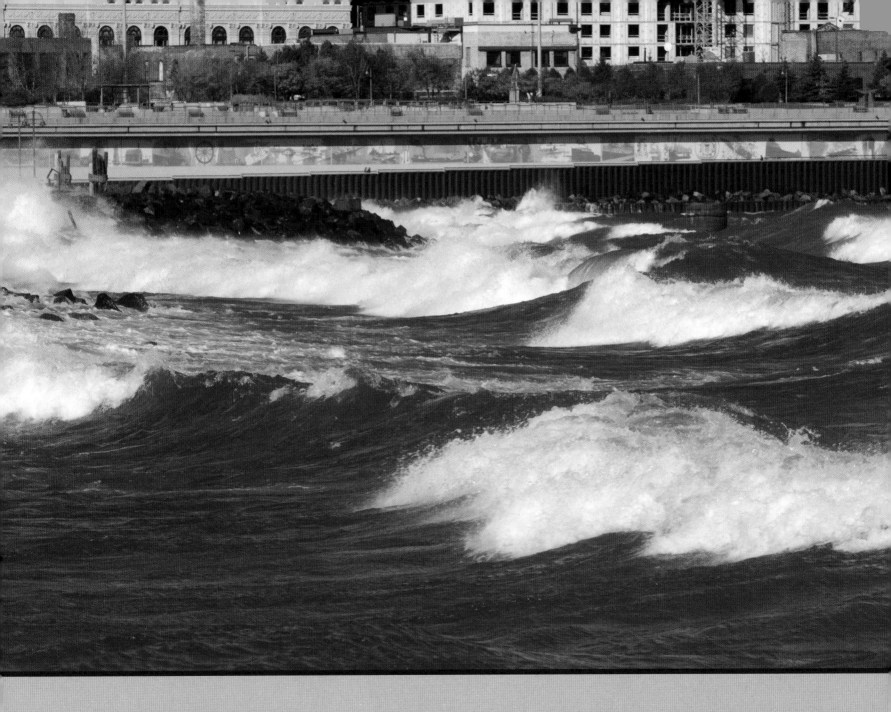

81. Waves crashing along the Duluth Lakewalk below Lake Place Park during a "nor'easter," autumn.

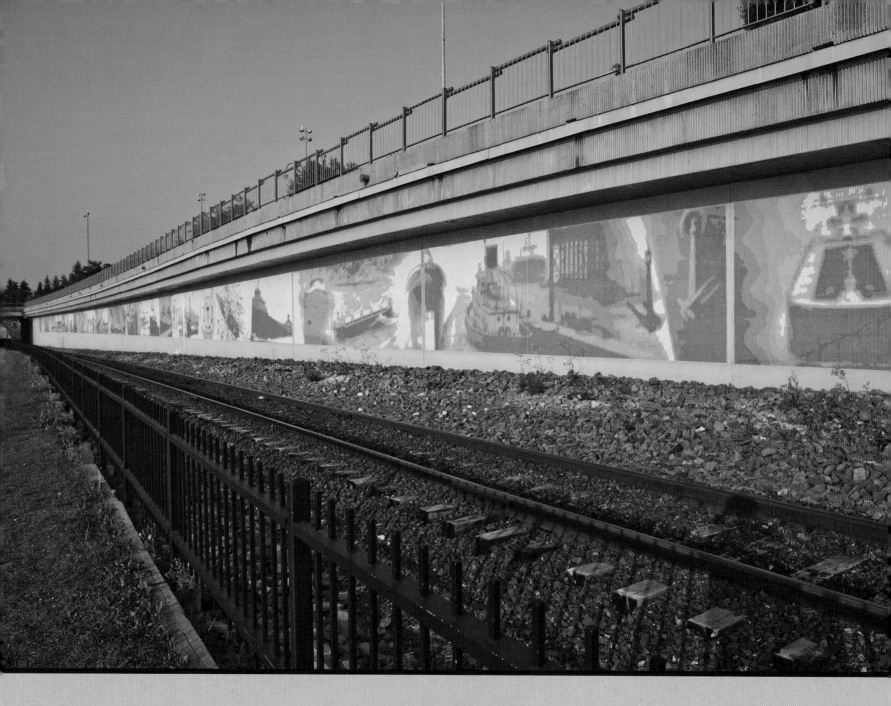

82. Duluth's mosaic tile wall along the Scenic North Shore Railroad and the Lakewalk depicts the city's maritime history. The mosaic was created in 1987 by Mark and Sandra Marino using 1.29 million three-quarter inch tiles.

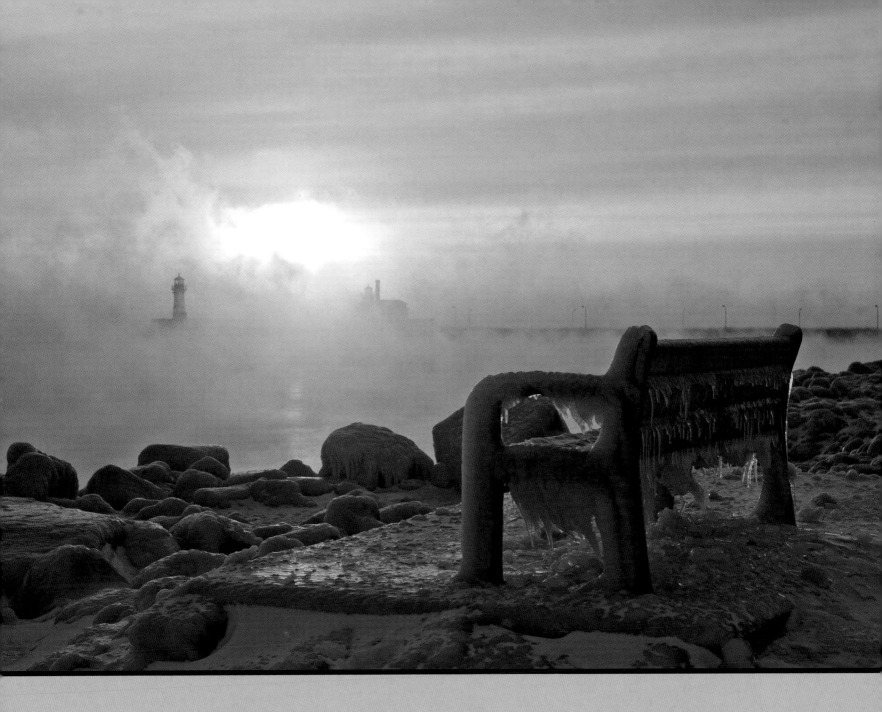

83. A bench along the Lakewalk at dawn, winter.

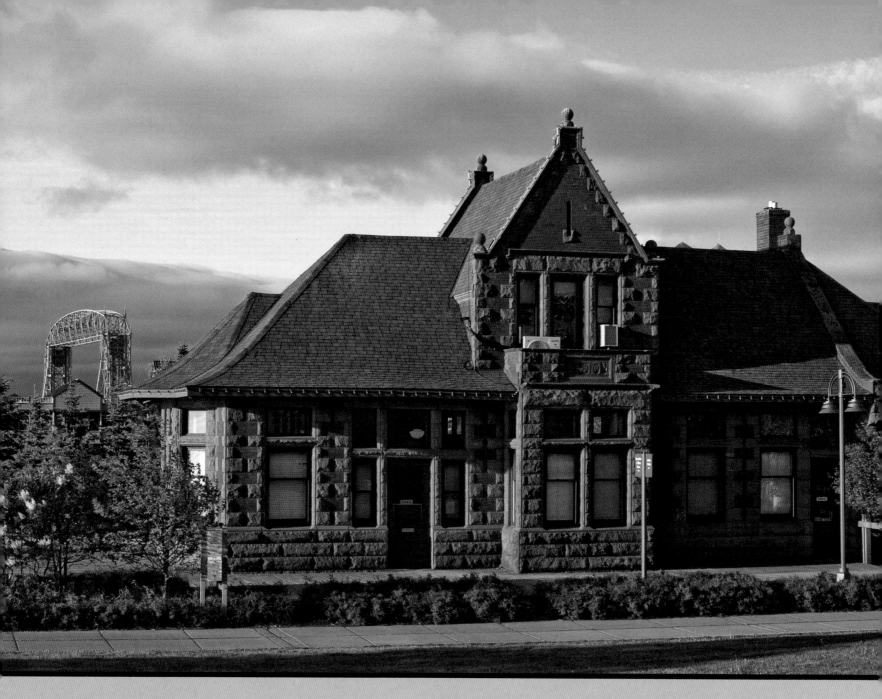

84. The Duluth, Missabe and Iron Range Endion Depot in the Canal Park Business District (b. 1899; Gearhard Tenbusch & I. Vernon Hill, architects).
Originally located at 15th Avenue East and South Street, the building was relocated in the 1980s to make way for the I-35 expansion.
Placed on the National Register of Historic Places in 1975.

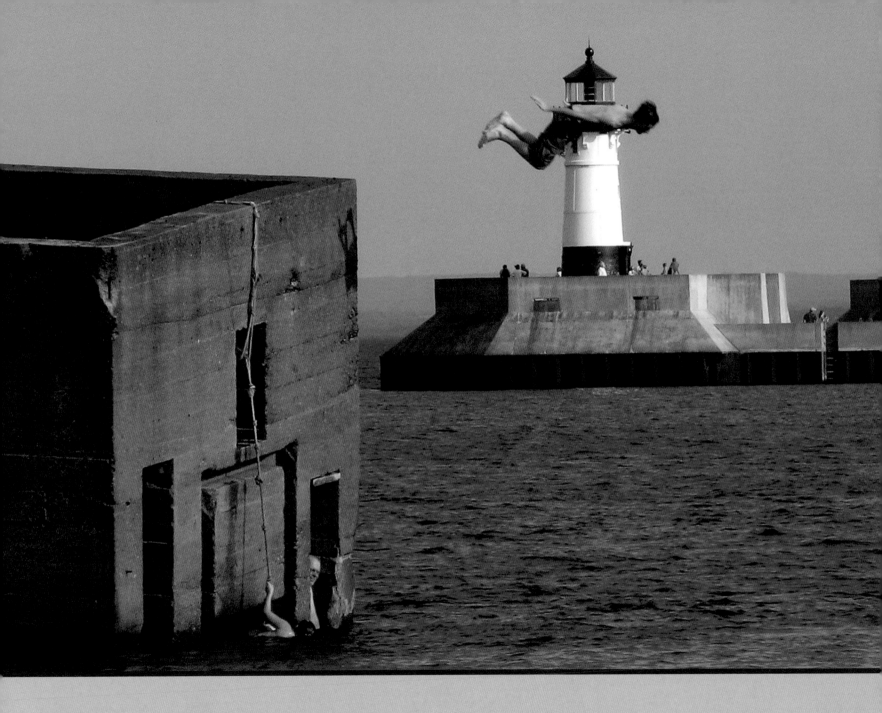

85. Using "Uncle Harvey's Mausoleum" (aka "The Cribs") as a diving platform, summer.

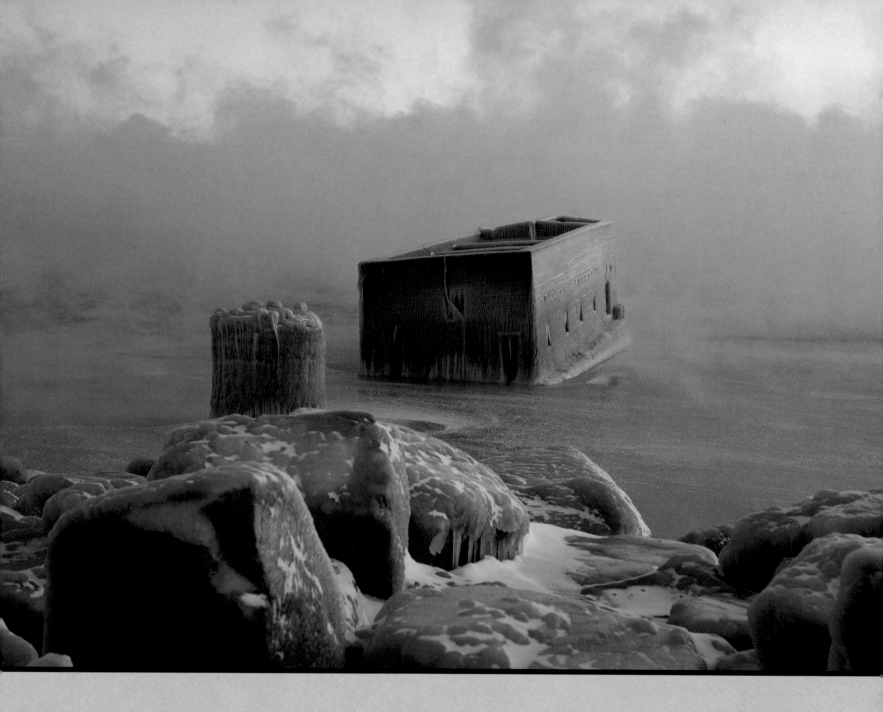

86. Less inviting in winter months, "Uncle Harvey's Mausoleum" is actually the ruins of a gravel hopper built by Harvey Whitney in 1919.

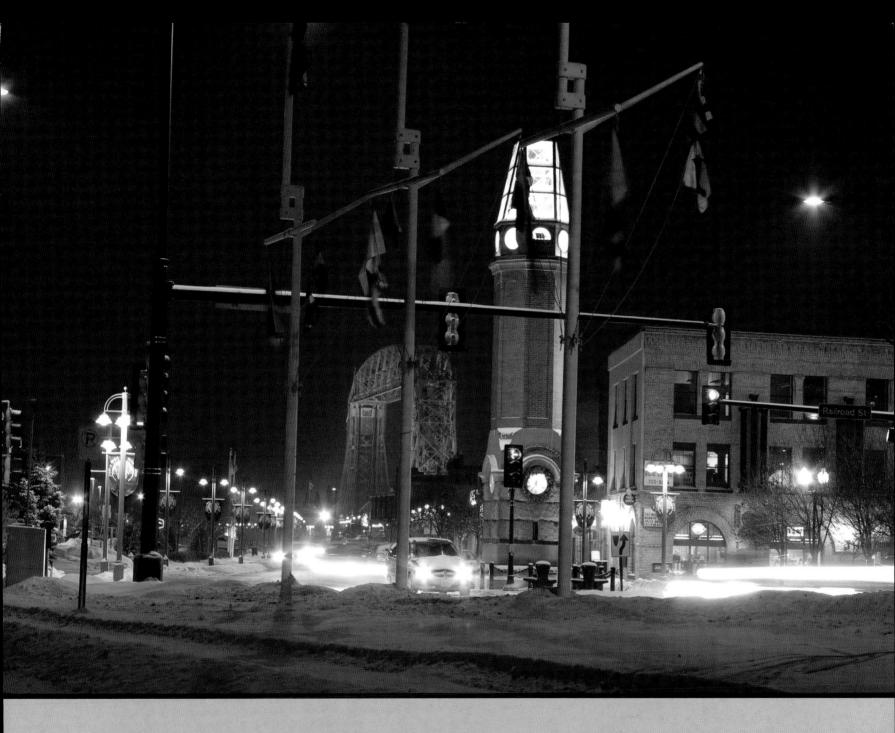

87. The Clock Tower at Lake Avenue and Railroad Street in the Canal Park Business District, winter.

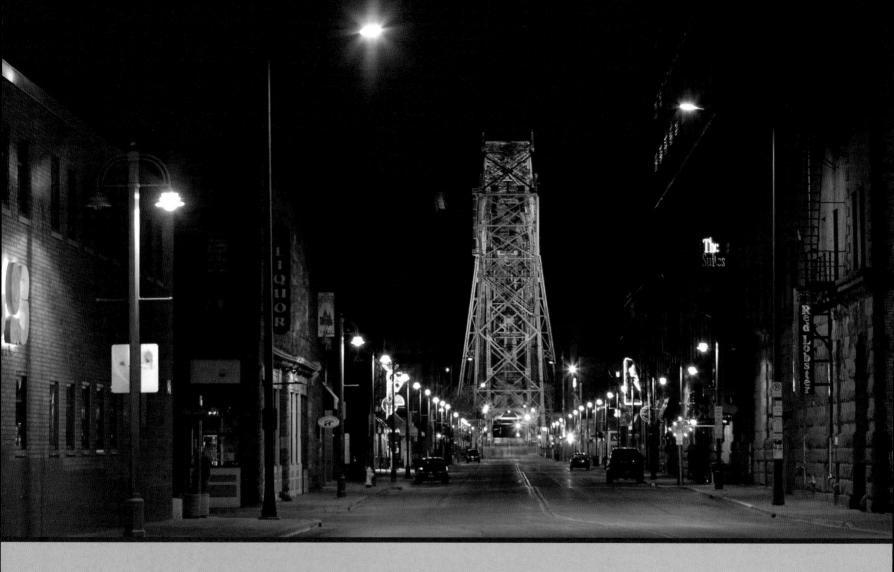

88. Down Lake Avenue at night in the Canal Park Business District, summer.

89.
The carved stone medallion
above the main doorway of
Marshall-Wells Hardware,
325 South Lake Avenue
(b. 1900; architect unknown).

By 1910 Marshall-Wells
was the largest hardware
wholesaler in the U.S.,
and third largest in the world.
Its line of tools was
branded with the
"Zenith" name.

Today the building
houses a hotel,
restaurant, offices,
and condominiums.

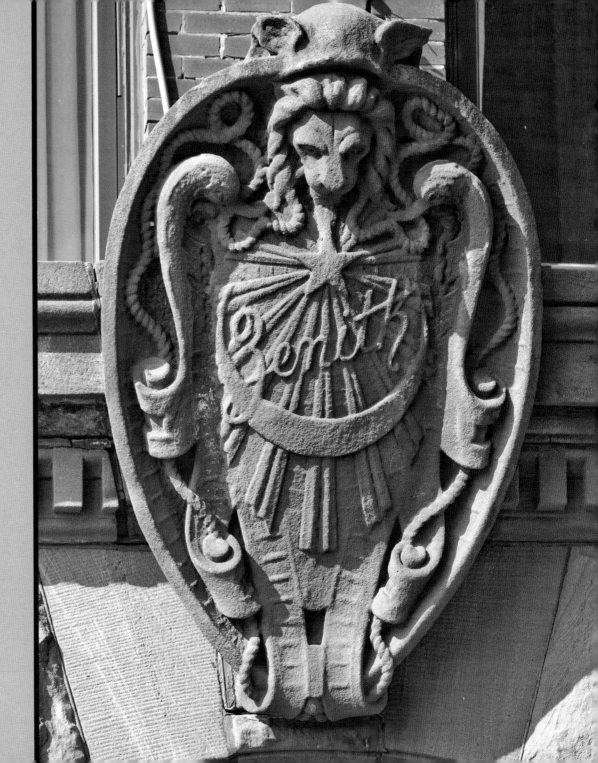

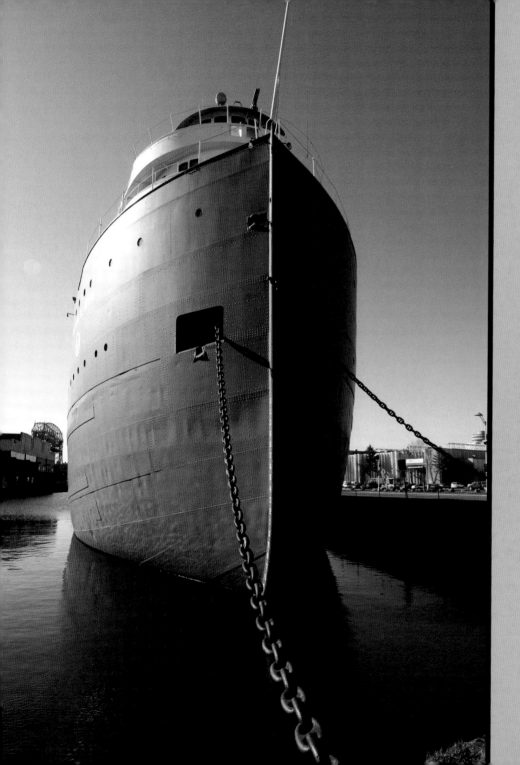

90.
A 610-foot ore boat,
the *William A. Irvin* served
as flagship of the
United States Steel fleet
from 1938 to 1978.

Placed on the
National Register of
Historic Places in 1989.

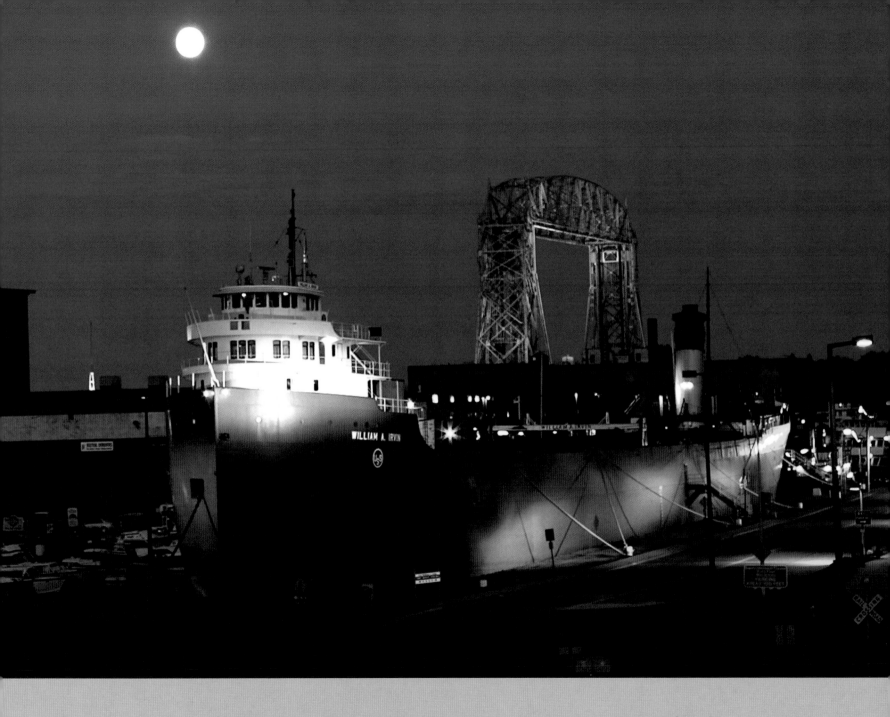

91. The *William A. Irvin* is now a floating museum permanently docked in the Minnesota Slip.

92. The Minnesota Slip Bridge in its raised position.

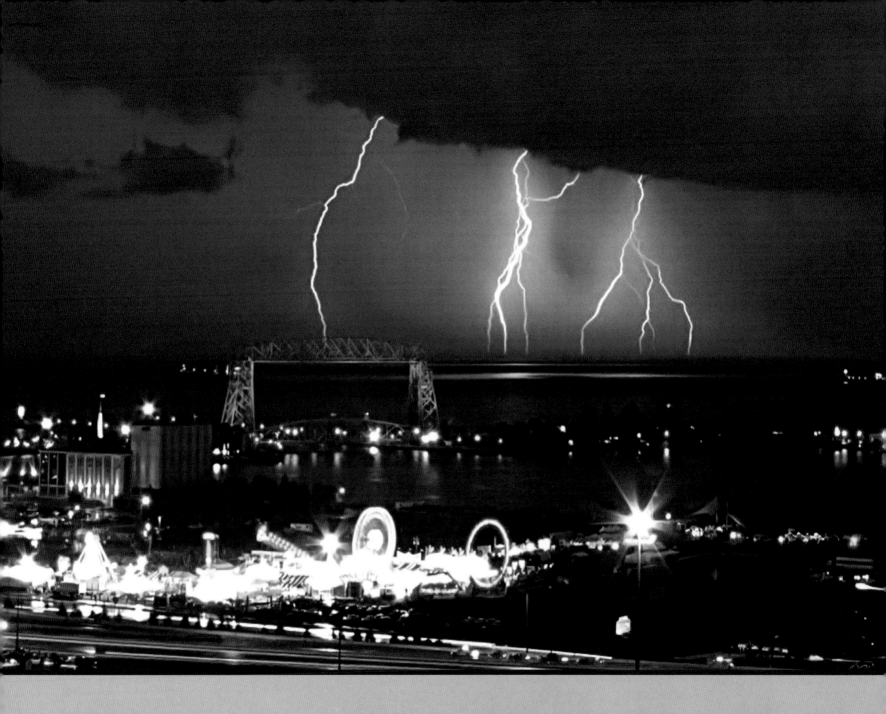

93. Bayfront Park lit up by lightning and the Mighty Thomas Show carnival, an annual Independence Day weekend event.

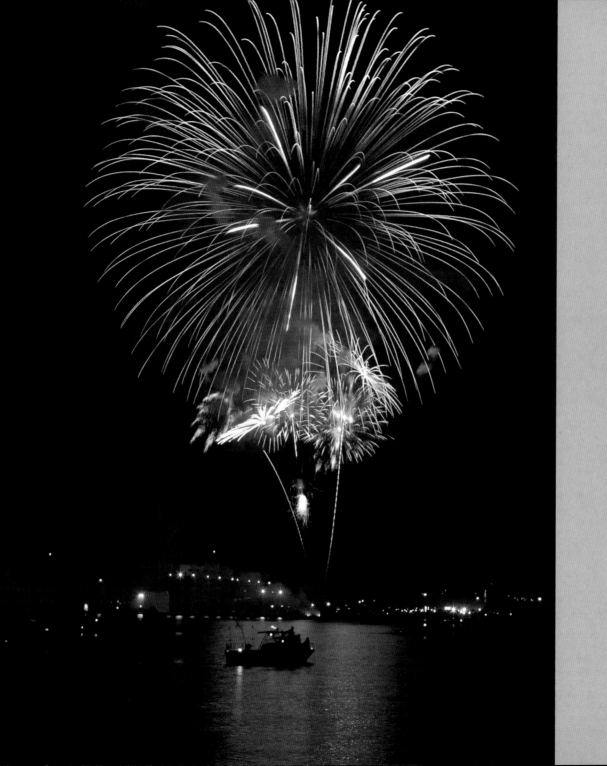

94.
Fireworks launched from
a barge anchored off
Bayfront Park,
Independence Day.

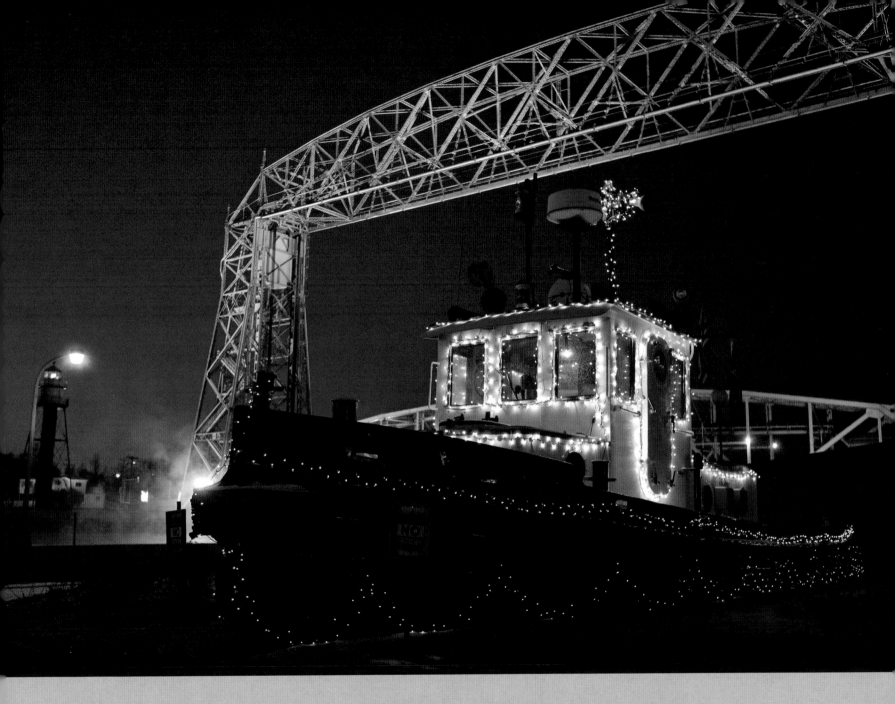

95. The retired U.S. Corps of Engineer tug *Bayfield*, now an outdoor exhibit at the Lake Superior Marine Museum in Canal Park. During its active lifetime, the *Bayfield*—built in 1909—served Bayfield, Wisconsin; Duluth; and Port Arthur, Ontario (now Thunder Bay).

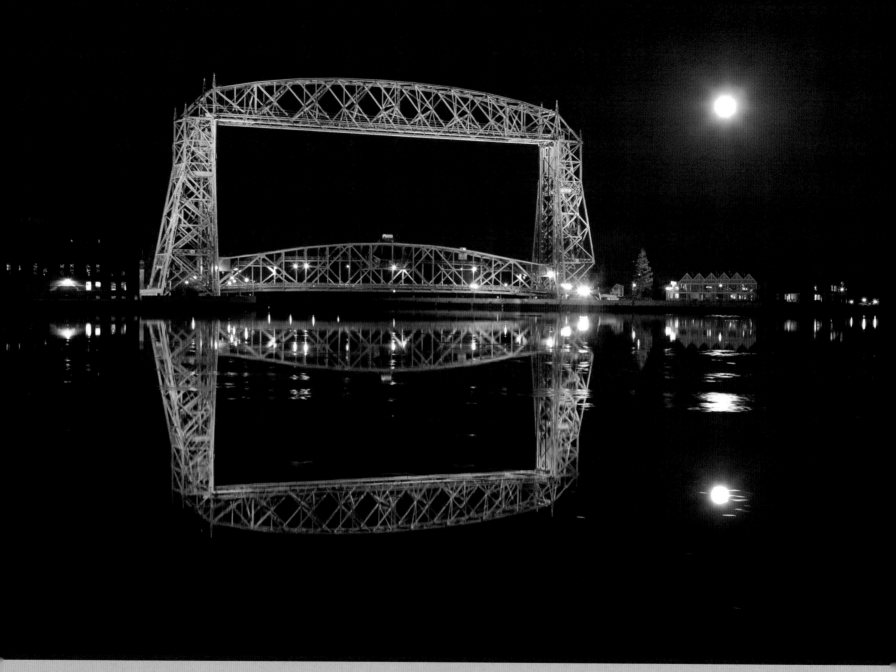

96. Duluth's Aerial Lift Bridge, constructed between 1929 and 1930 (Harrington, Howard, and Ash, architects).
Duluth's lift bridge was converted from the Duluth Aerial Transfer Bridge, built in 1905 and designed by Claude Allen Porter Turner.
Placed on the National Register of Historic Places in 1973.

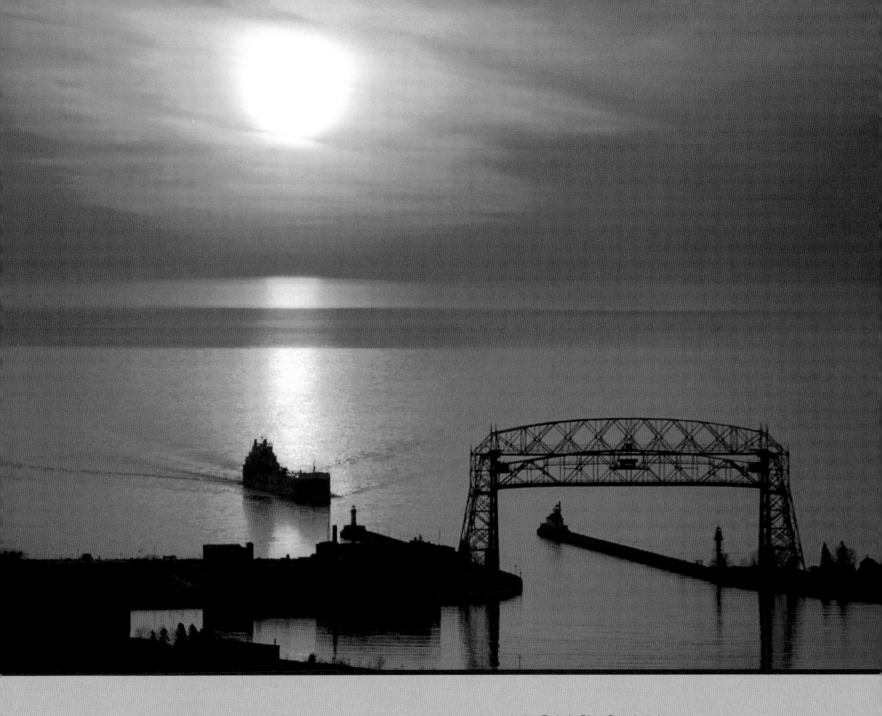

97. The Duluth Aerial Lift Bridge raised to let an ore boat pass through the Duluth Ship Canal at dawn, summer.

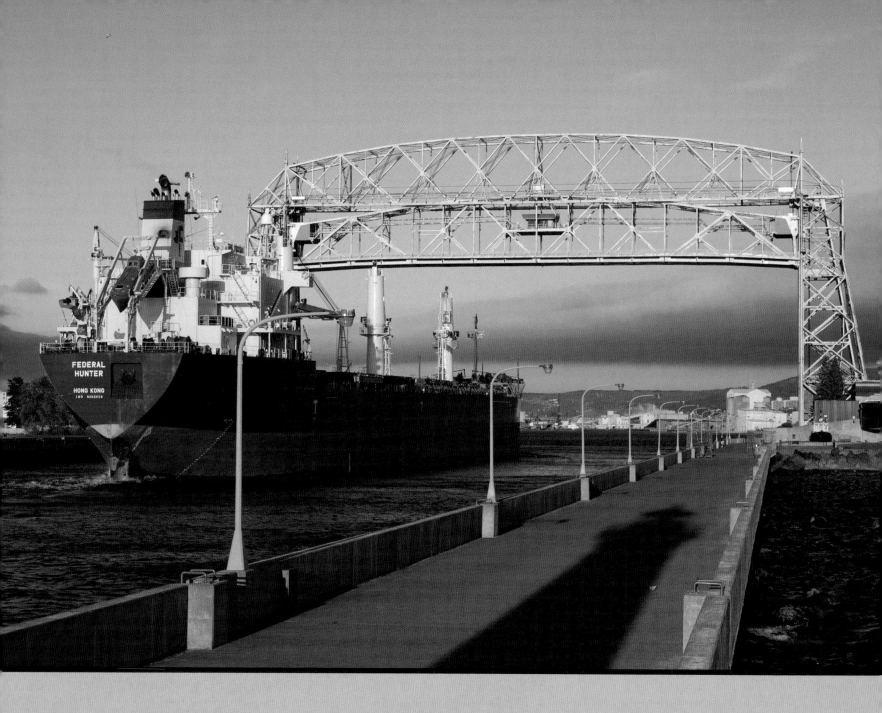

98. Hong Kong's *Federal Hunter* navigates the ship canal, passing under the Duluth Aerial Lift Bridge, summer.

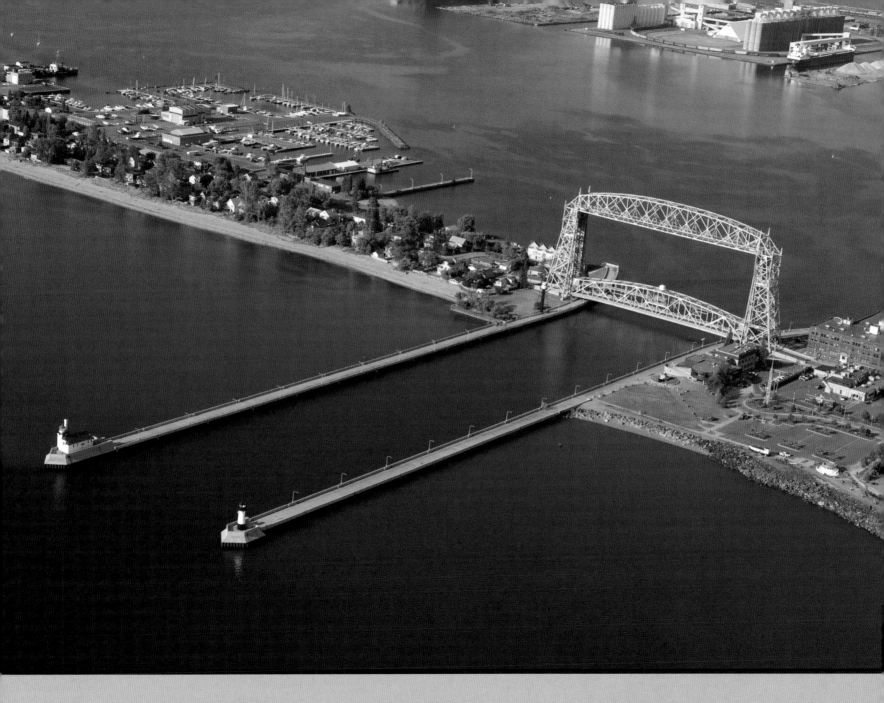

99. Duluth Ship Canal piers, lighthouses, and the Duluth Aerial Lift Bridge, summer.

The green spaces alongside the canal make up Canal Park; the development between I-35 and the canal is the Canal Park Business District.

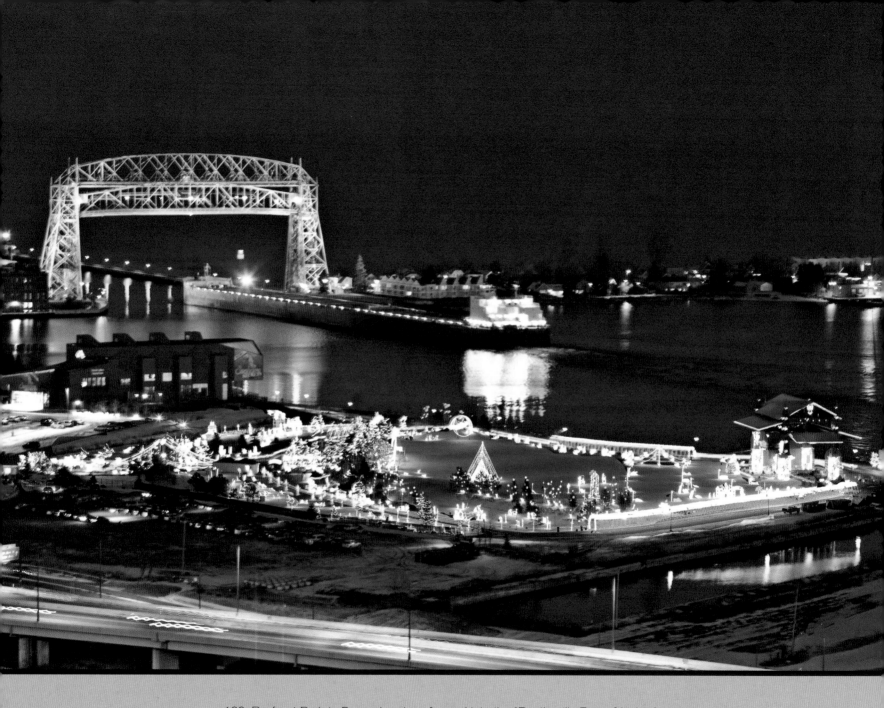

100. Bayfront Park in December, transformed into the "Bentleyville Tour of Lights."

The display began in 2001 when Nathan Bentley began decorating his Esko, Minnesota, home for the Holidays; it moved to Duluth in 2009.

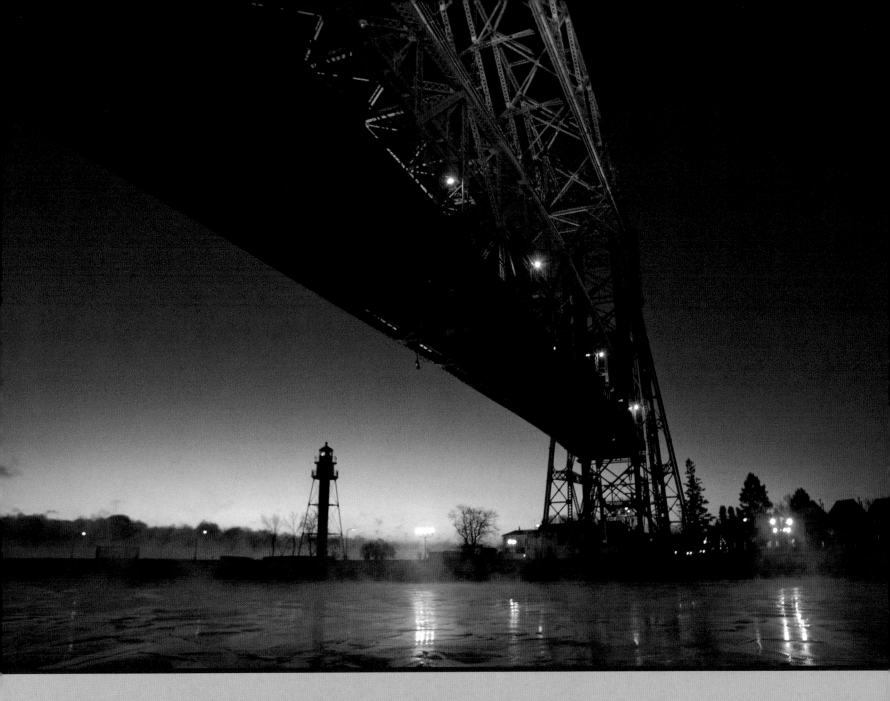

101. The Duluth Aerial Lift Bridge's road deck from below, with the Rear Range Light—the small lighthouselike structure—in the background, winter. The Rear Range Light (b. 1902) was placed on the National Register of Historic Places in 1983.

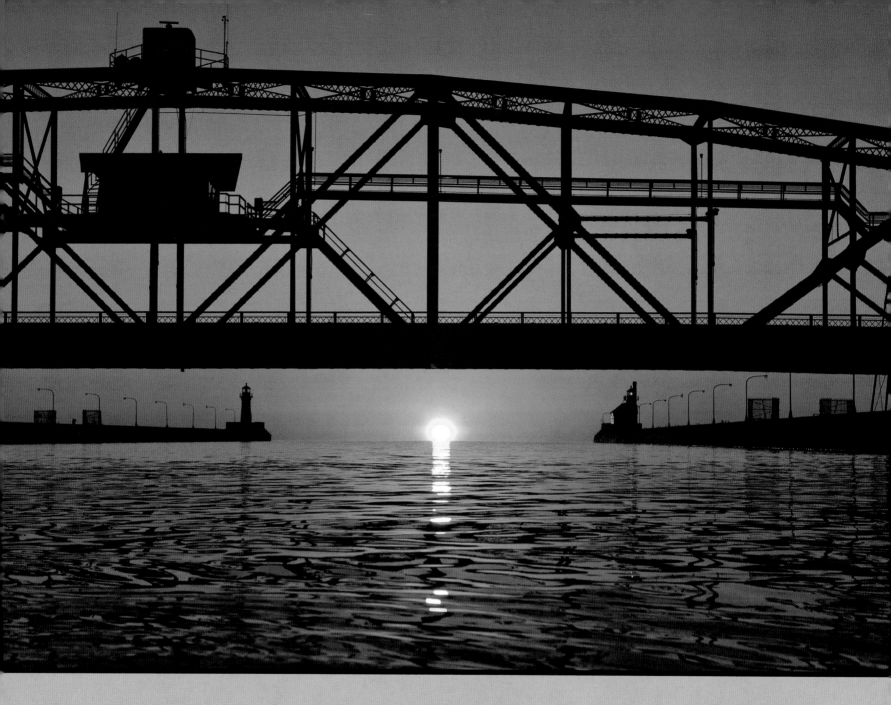

102. View from the center of the Duluth Ship Canal at daybreak.

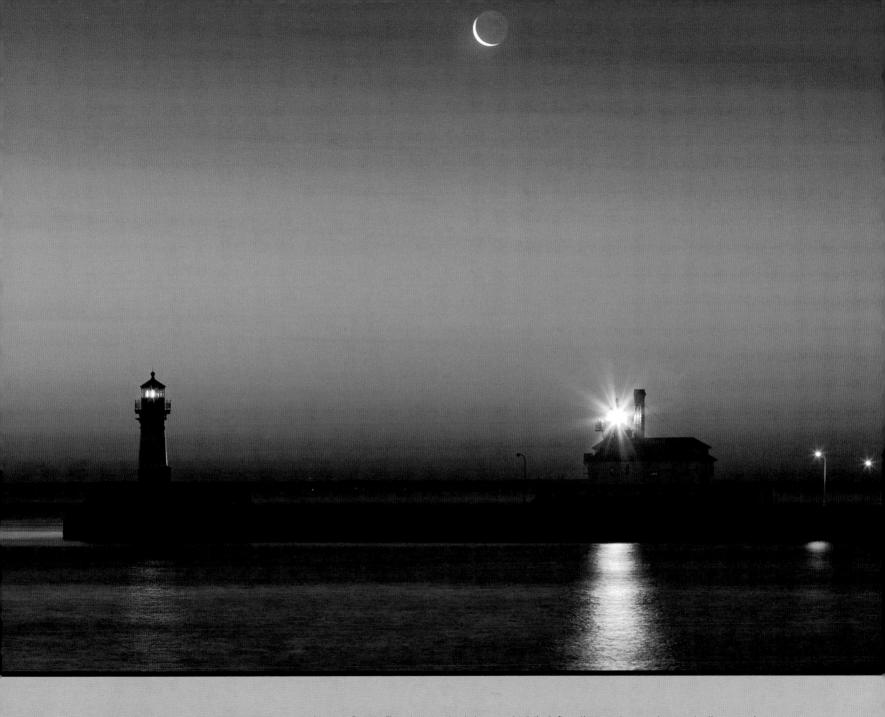

103. The North Pier Lighthouse (left) and South Breakwater Lighthouse (right) define the eastern entrance to the canal.

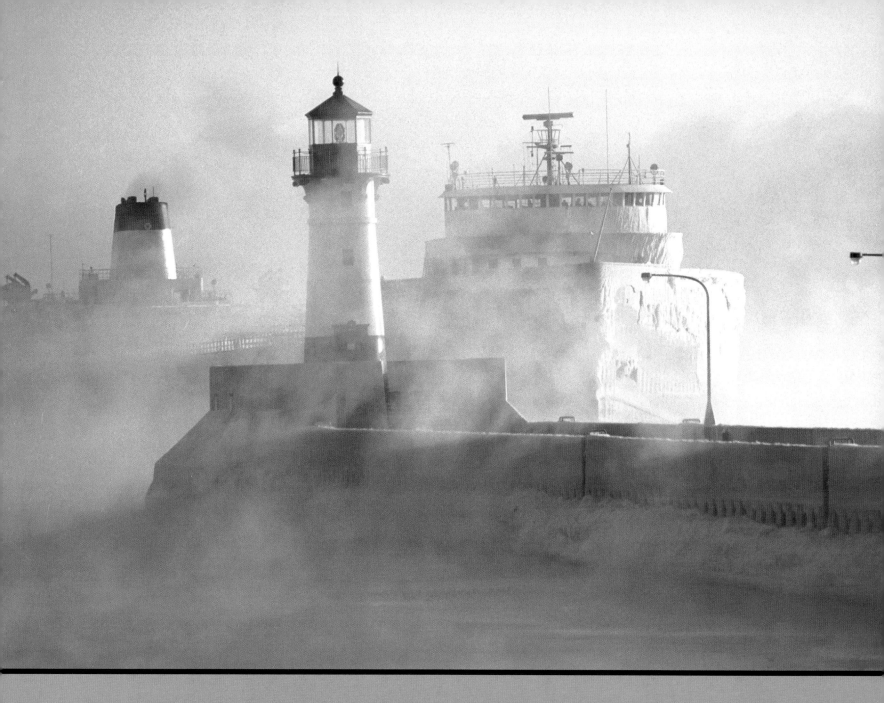

104. Sea smoke (fog over the lake caused by cold air moving over the warmer water) greets an incoming ore boat as it passes the North Pier Lighthouse while entering the canal, winter.

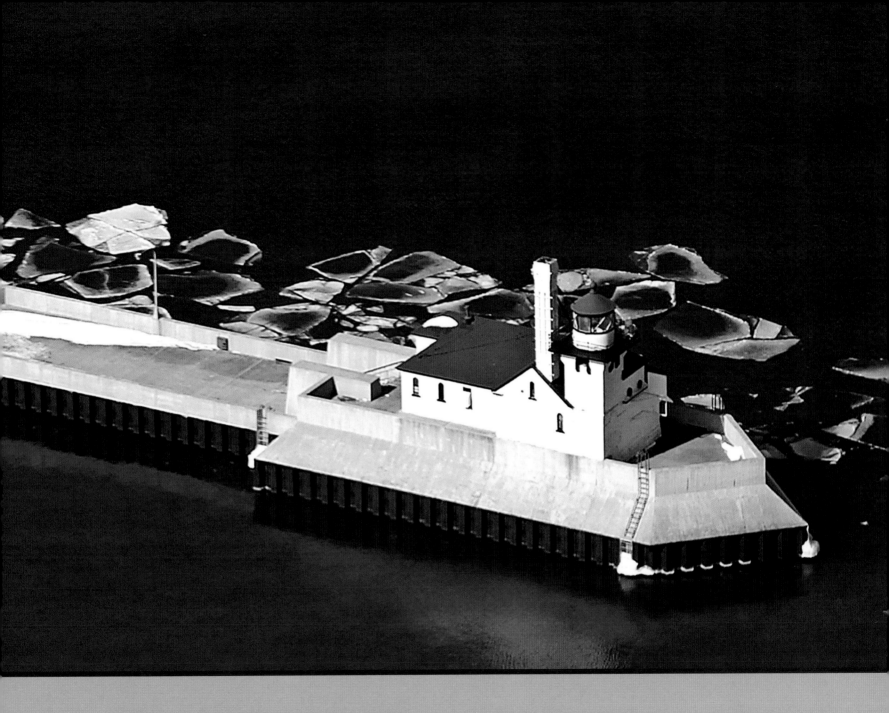

105. The South Breakwater Lighthouse; built in 1901, the light replaced another that stood atop a wooden pyramid built in 1873.

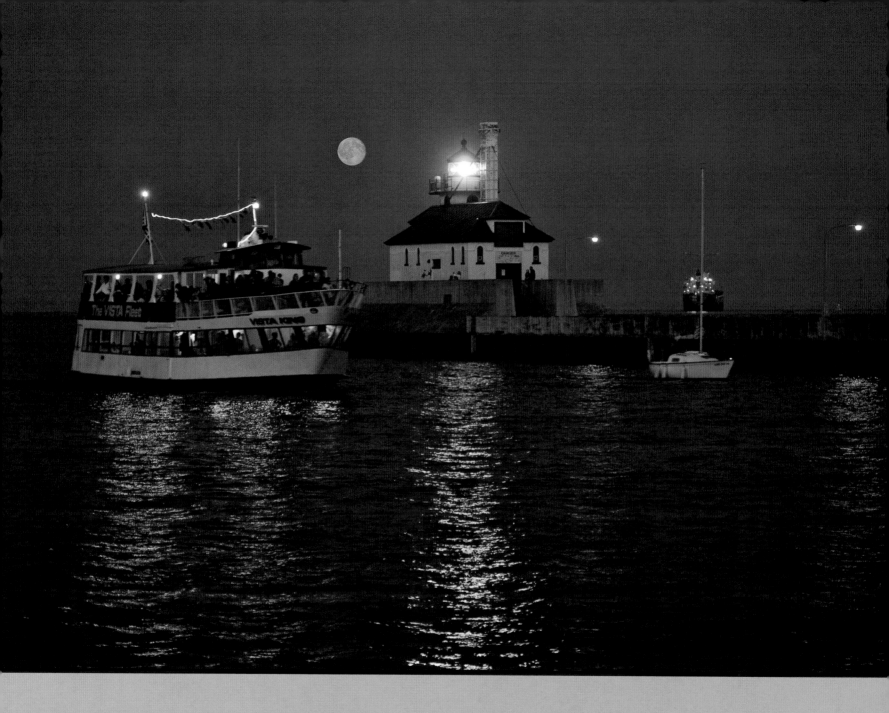

106. The *Vista King* tour boat entering the canal under a full moon, summer.

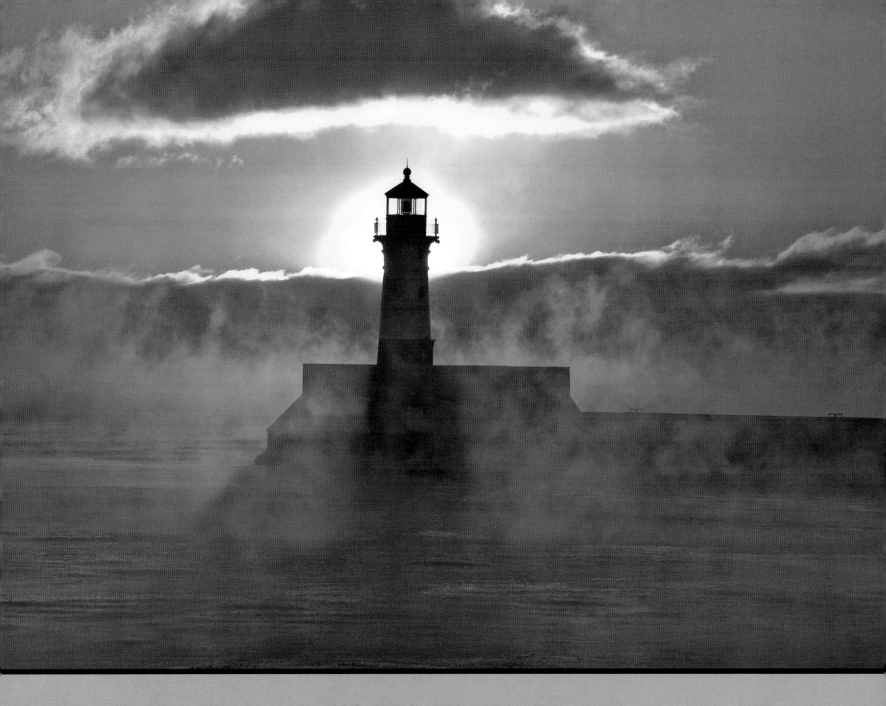

107. The North Pier Lighthouse in sea smoke.

The lighthouse was built in 1910 in response to the great Thanksgiving storm of 1905 (aka the "*Mataafa* Storm").

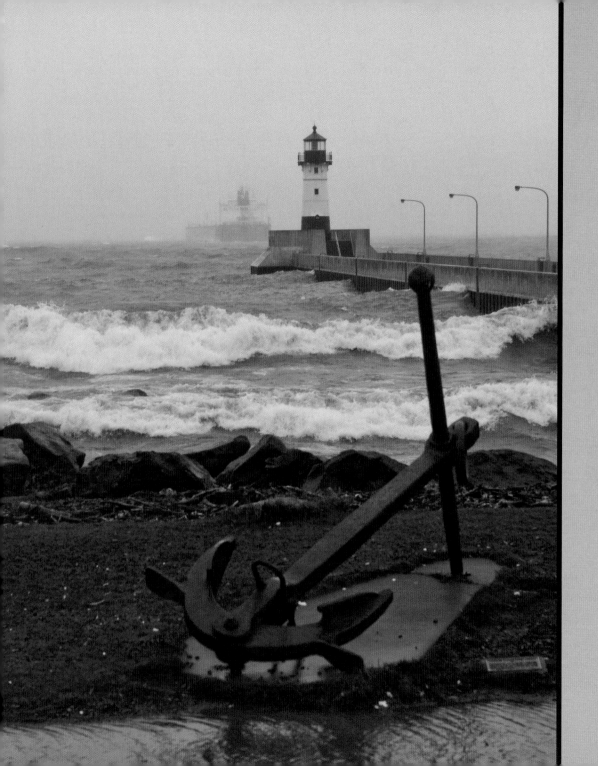

108.
The Trotman folding stock anchor from the whaleback steamer *Thomas Wilson*, which sunk a half mile outside of the canal on June 7, 1902, after a collision with the *George Hadley*. The anchor was recovered in 1973.

The wreck site was placed on the National Register of Historic Places in 1992.

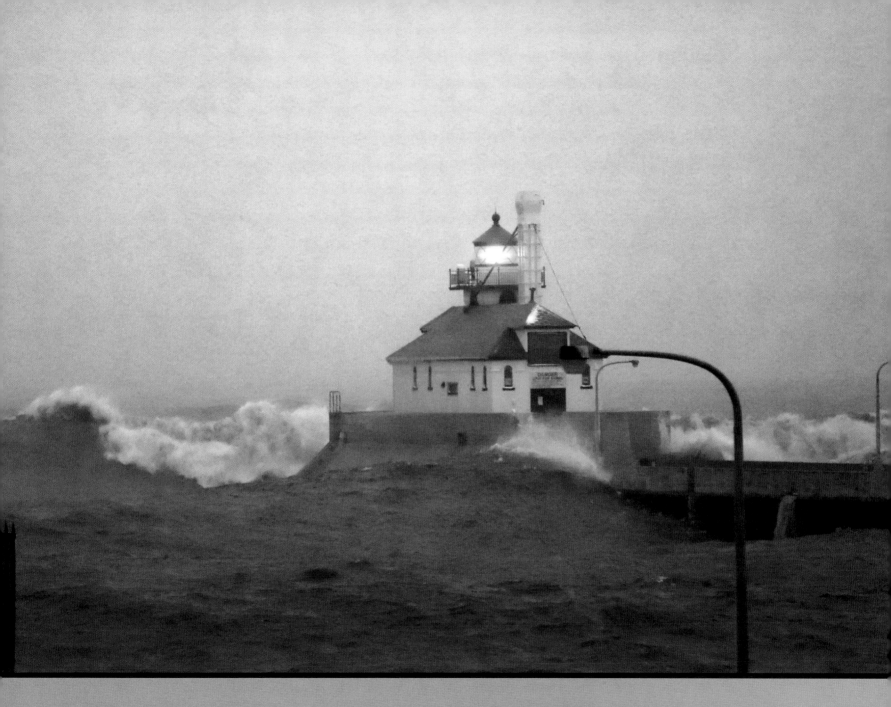

109. Waves batter the Duluth Ship Canal's piers and the South Breakwater Lighthouse during a November gale.

The canal was dug in 1870 and 1871 by the steam-powered dredging tug *Ishpeming*; the concrete piers were completed in 1902.

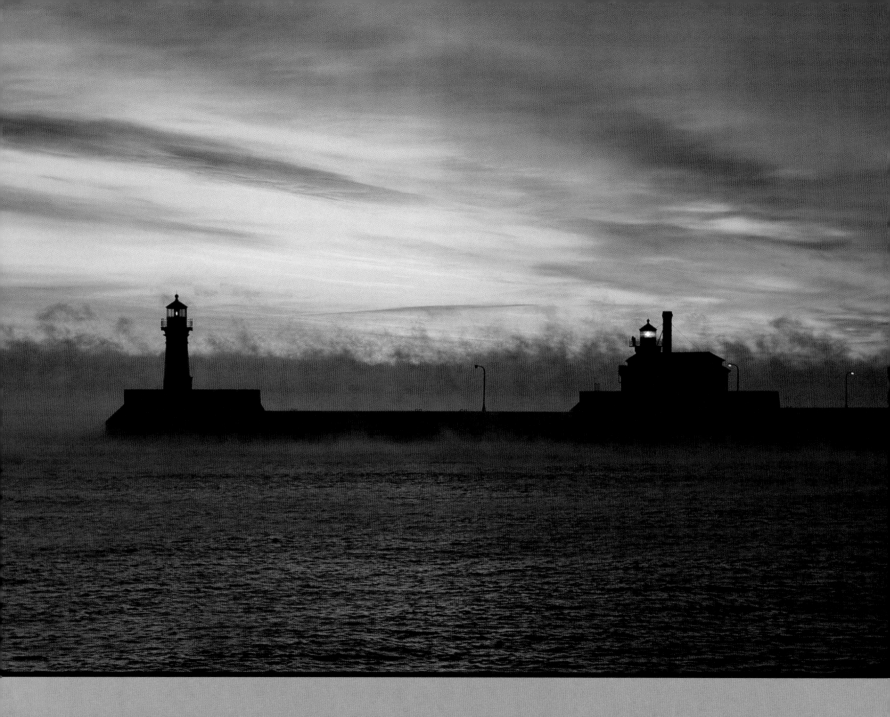

110. The canal and lighthouses bathed in sea smoke at sunrise, winter.

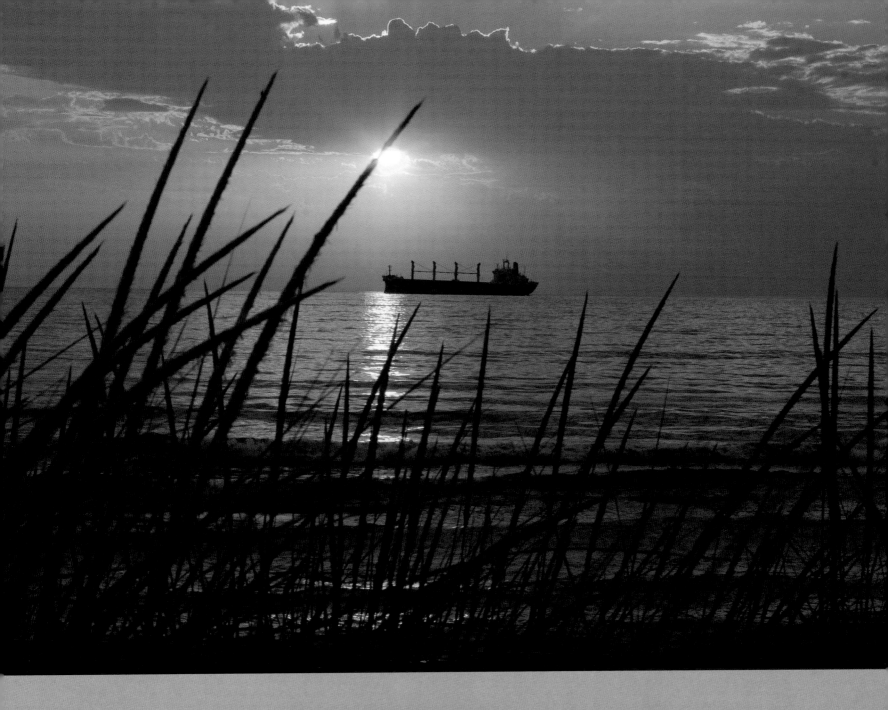

111. Saltie anchored off the beach at dawn along Minnesota Point's eastern shore, summer.

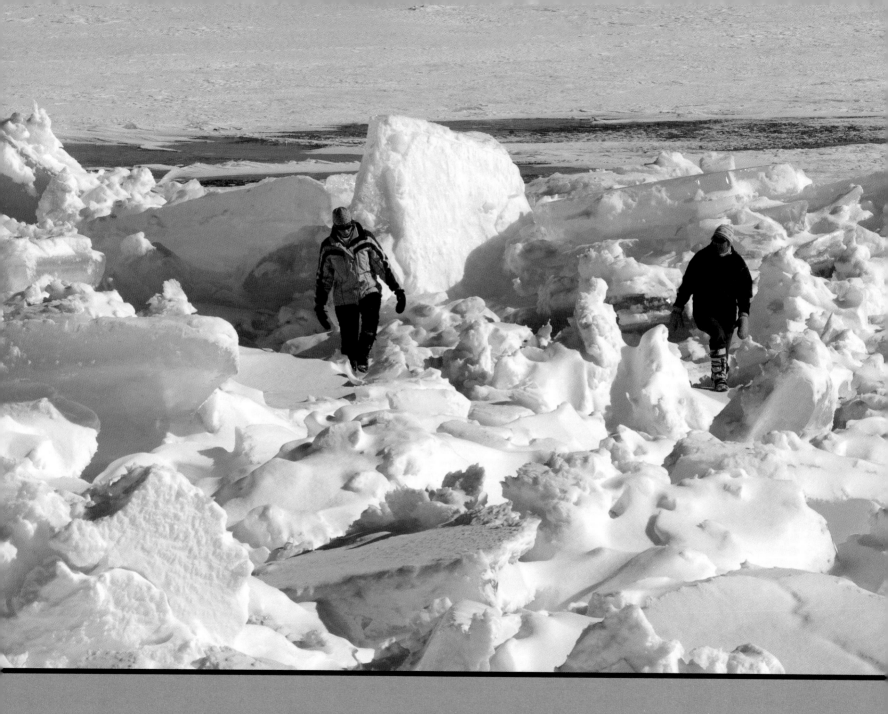

112. Hikers enjoy a stroll along the beach on the eastern shore of Minnesota Point, winter.

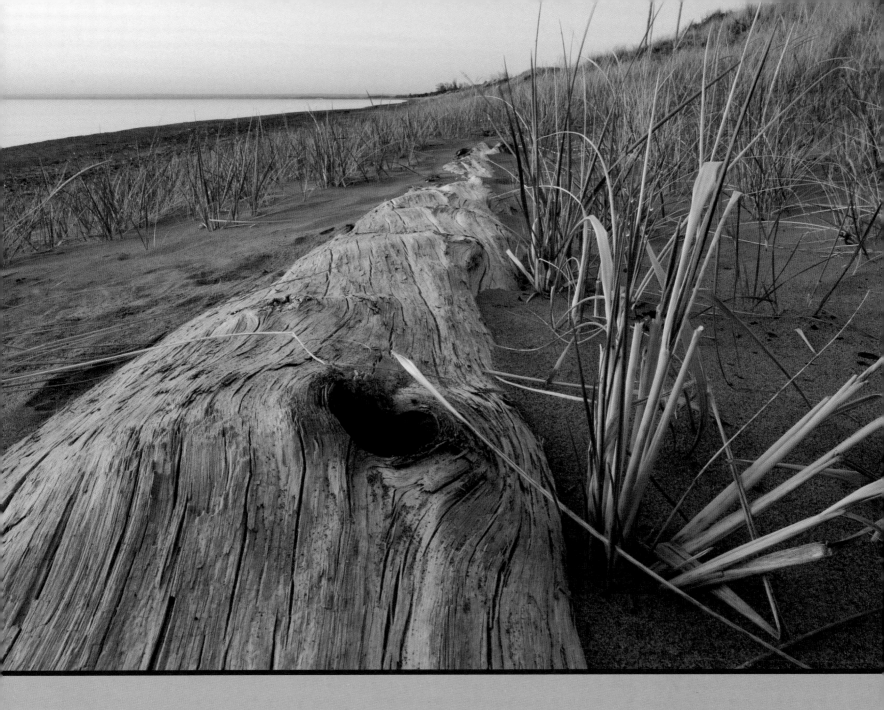

113. Driftwood along Minnesota Point's eastern shore, autumn.

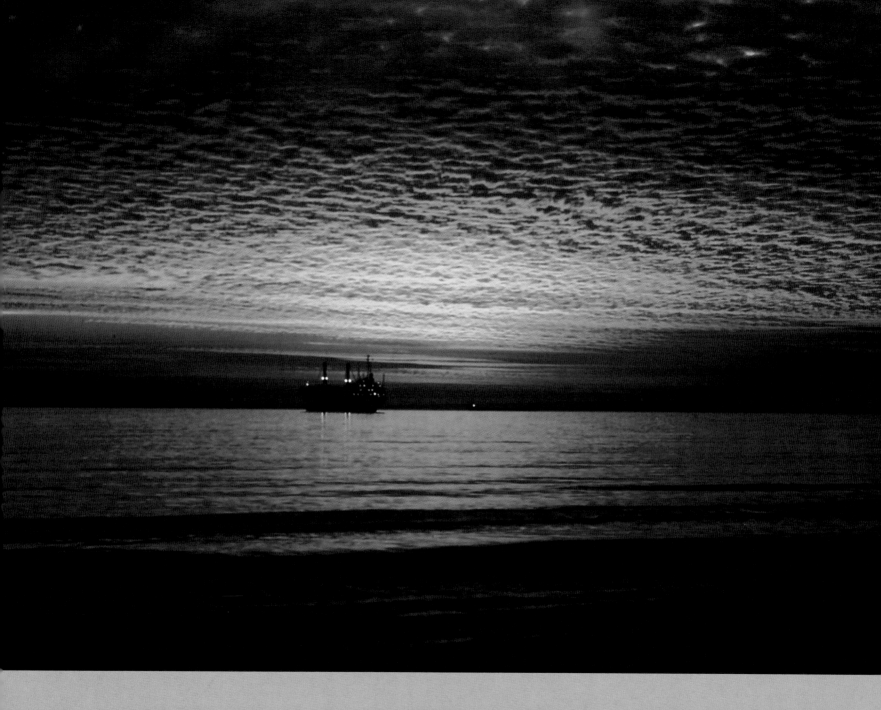

114. A saltie and an ore boat at anchor off the eastern shore of Minnesota Point at dawn, summer.

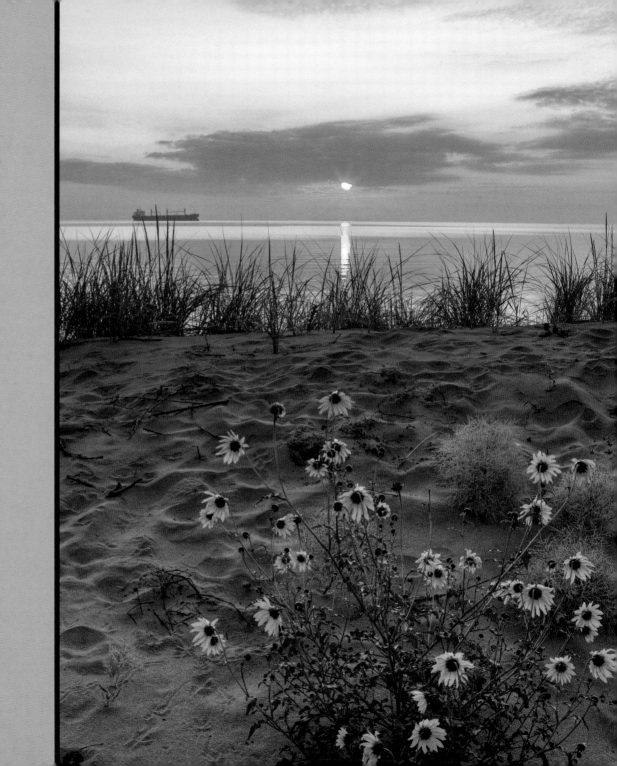

115.
Black-eyed Susans
greet the dawn on
Minnesota Point, summer.

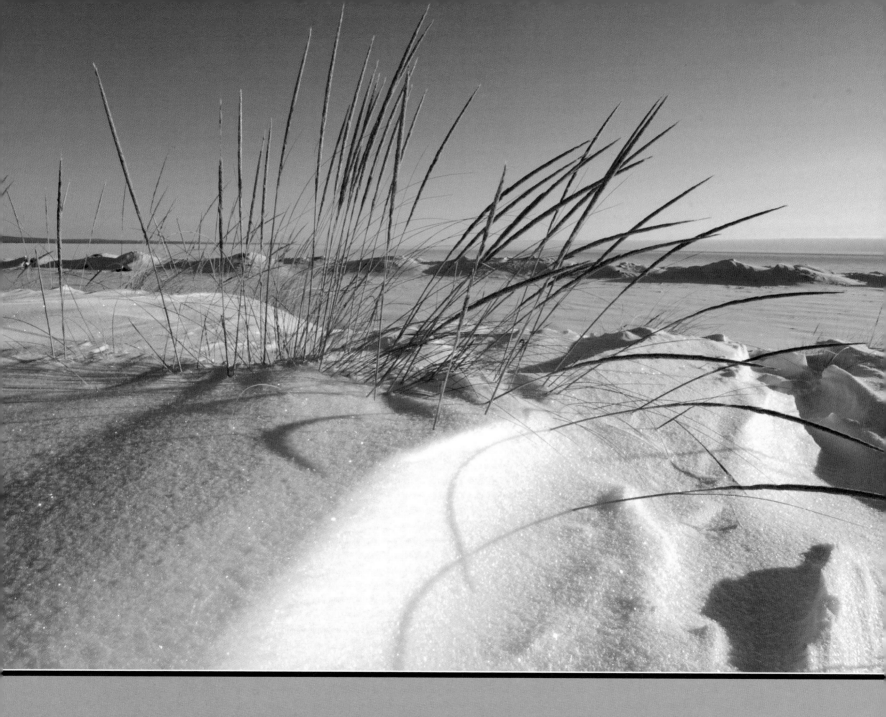

116. Beach grass on the snow-covered sand dunes of Minnesota Point, winter.

117. Old-growth pines along the Minnesota Point Hiking Trail, autumn.

118.
Ruins of the
Minnesota Point Lighthouse
at the end of Minnesota Point,
built of red Ohio brick whitewashed
with limestone in 1858 by German
stonemason Adam Dopp.

Built to help mariners
locate the Superior Entry,
the lighthouse ruins now stand
almost a half mile from the opening
because the Minnesota Point sandbar
constantly changes size and shape.

By 1885 the lighthouse
no longer served its purpose
and was closed by the government.

Placed on the
National Register of
Historic Places in 1974.

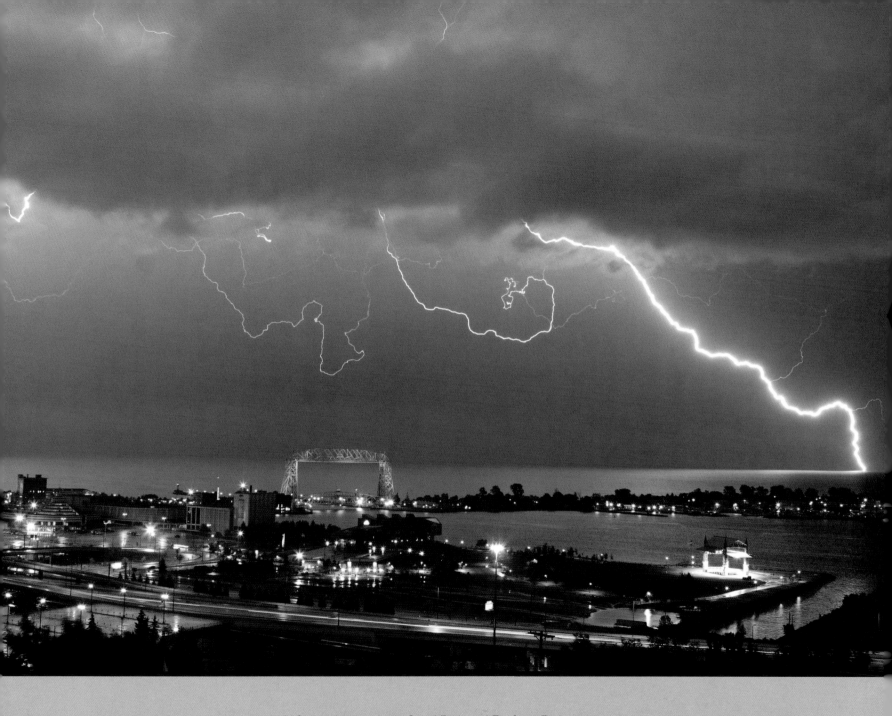

119. Curl Lightning above Canal Park and Bayfront Park, summer.

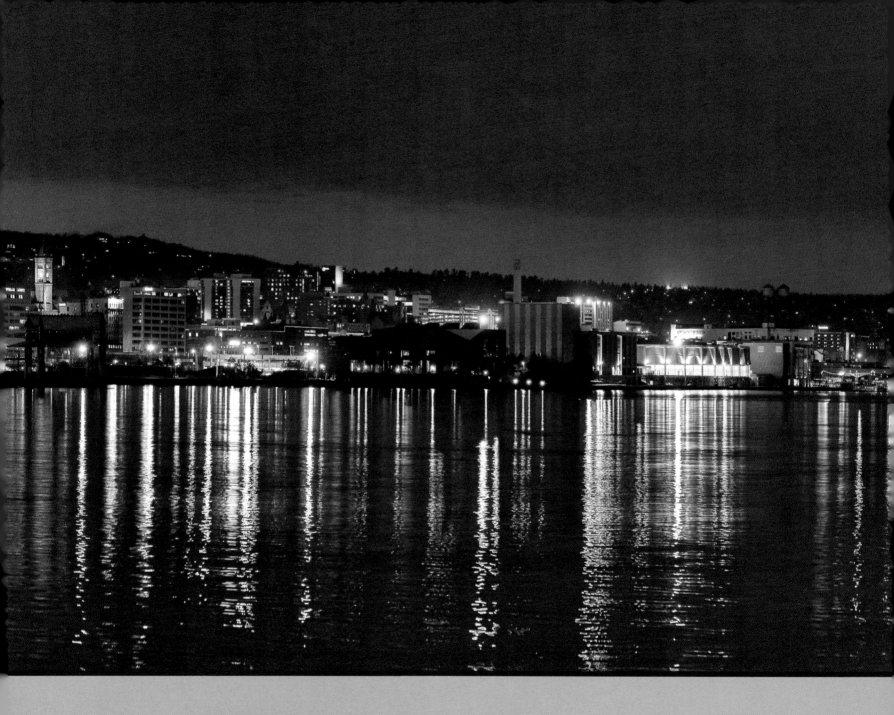

120–121. Harbor view of Bayfront Park, the Canal Park Business District, and the Aerial Lift Bridge, summer.

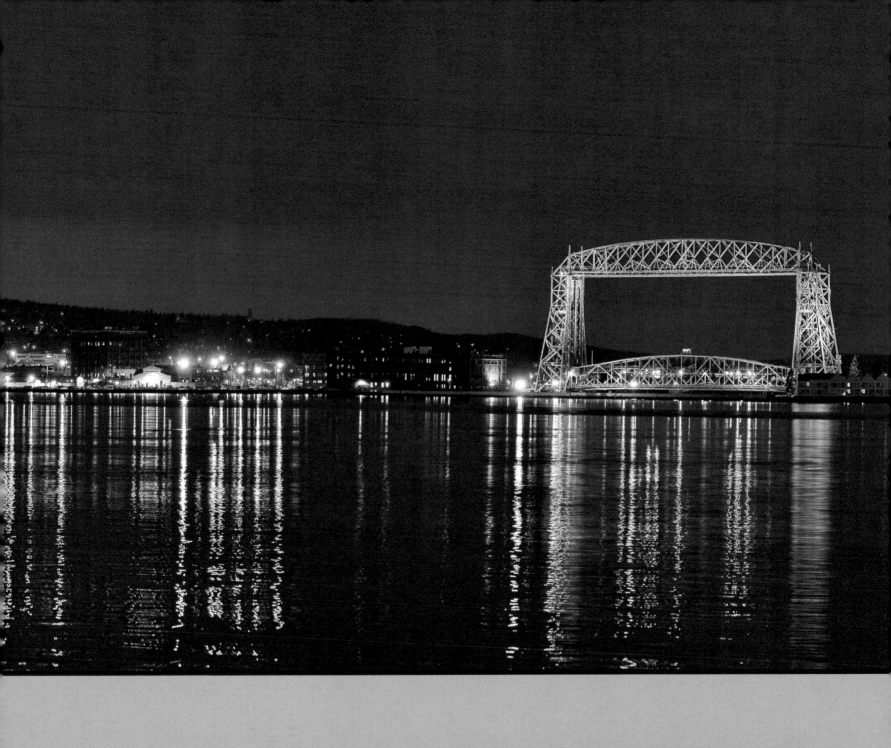

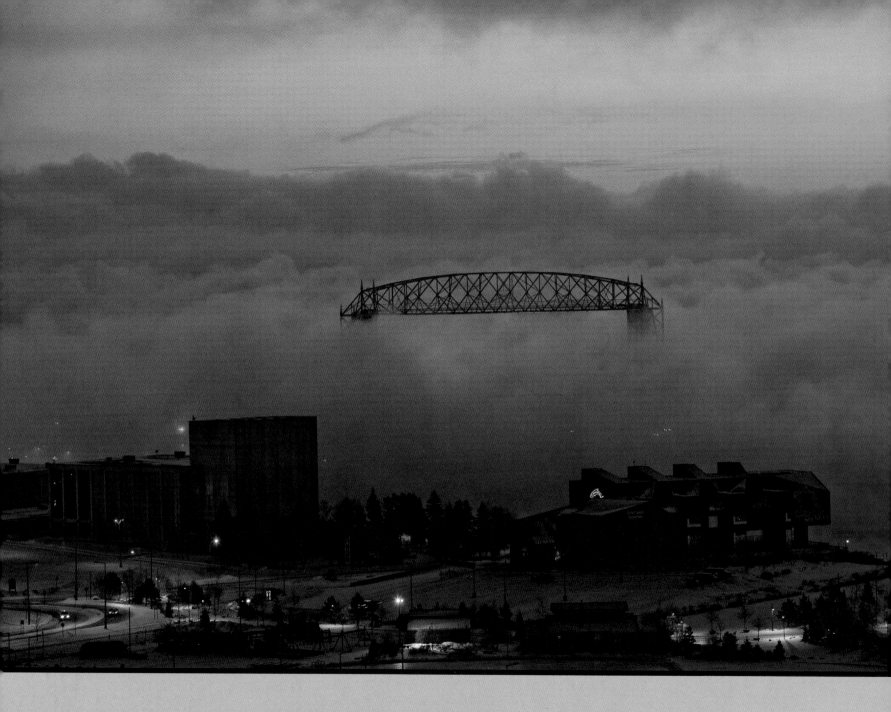

122. The Duluth Aerial Lift Bridge, shrouded in sea smoke at dawn, winter.

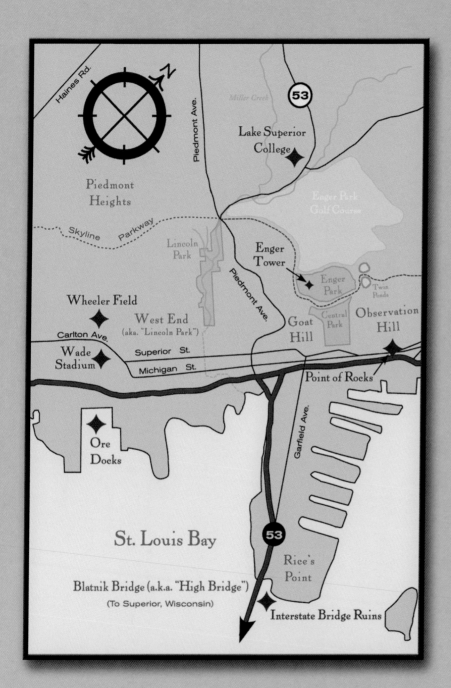

4.
West End
and
Working
Waterfront

Mesaba Avenue
to the Ore Docks

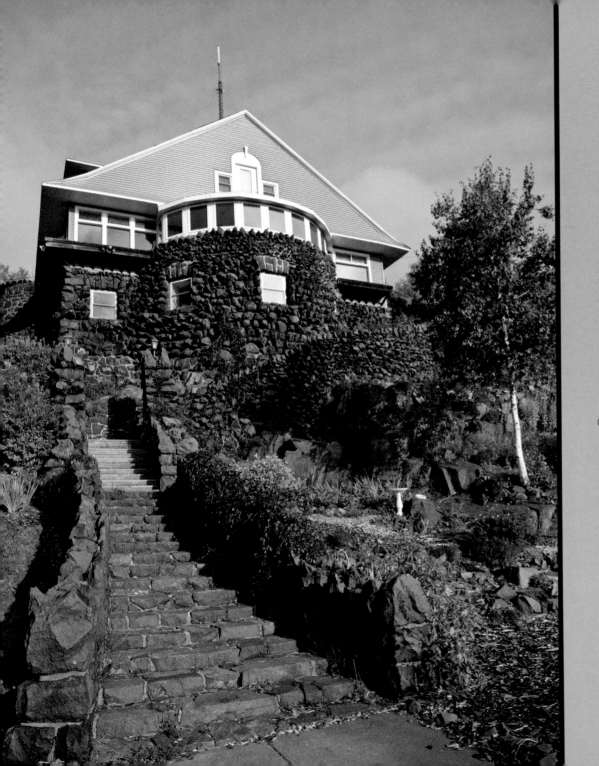

124.
The Arthur P. Cook House,
aka the "House of Rock,"
501 West Skyline Parkway
(b. 1900; I. Vernon Hill, architect).

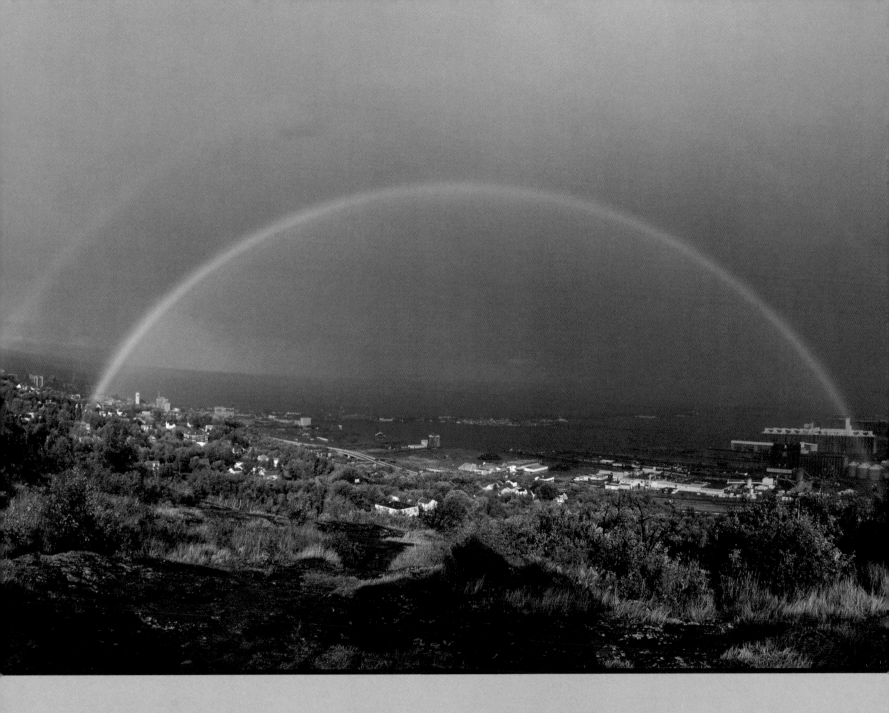

125. The view from the top of Central Park just below Skyline Parkway, summer.

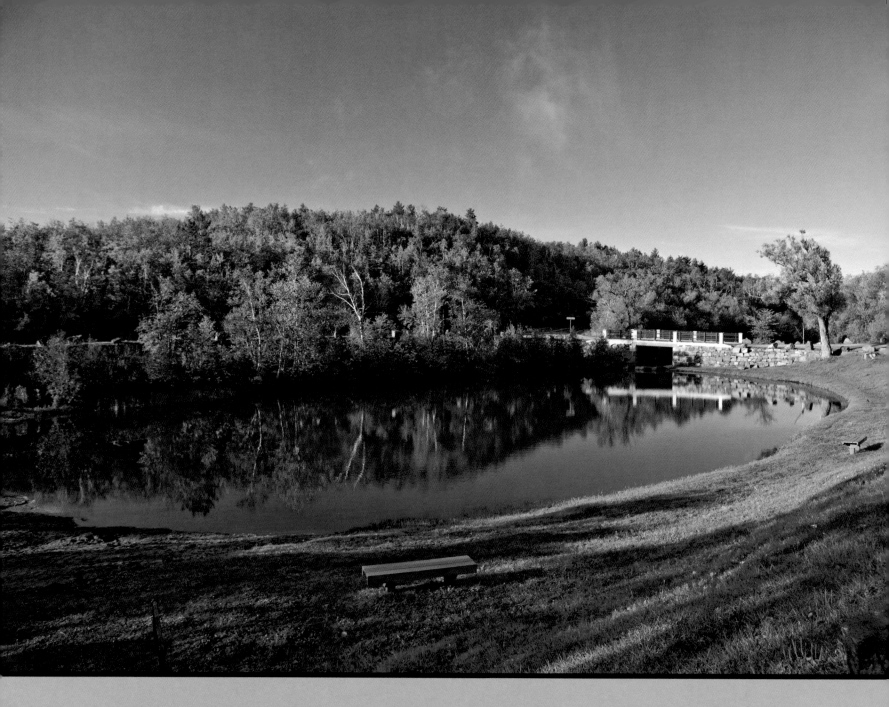

126. Twin Ponds (originally "Gem Lakes"), created by damming Buckingham Creek in the 1890s to provide a picnic spot for those enjoying "Tally-Ho" horse-and-wagon rides along Skyline Parkway (then "Boulevard Drive").

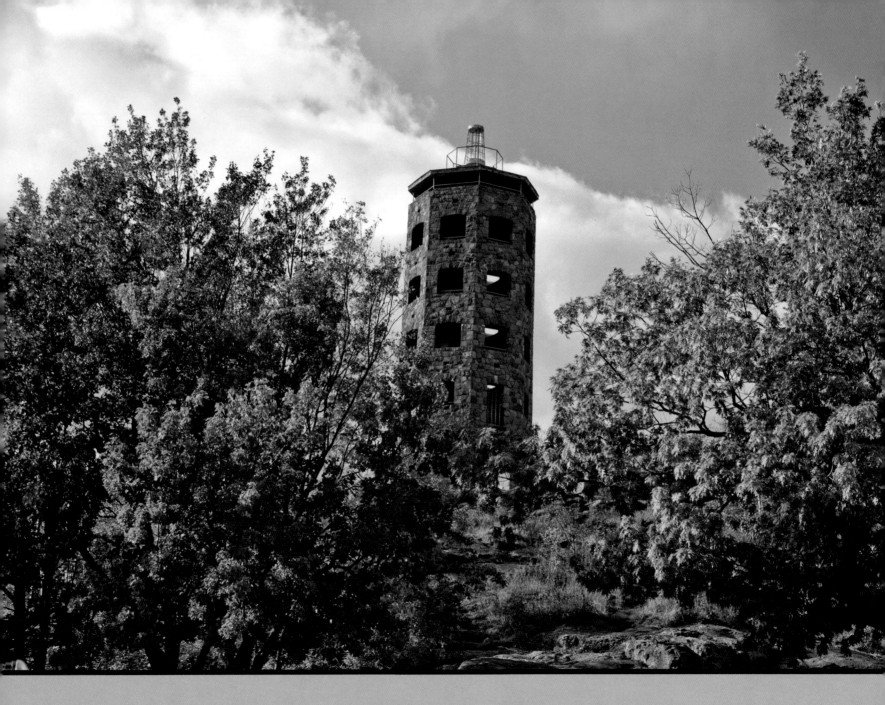

127. Enger Park's Enger Memorial Tower in autumn; built in 1939, the observation tower honors Duluth businessman Bert Enger.
Enger, a Norwegian immigrant, gave Duluth the land for nearby Enger Golf Course upon his death in 1931.

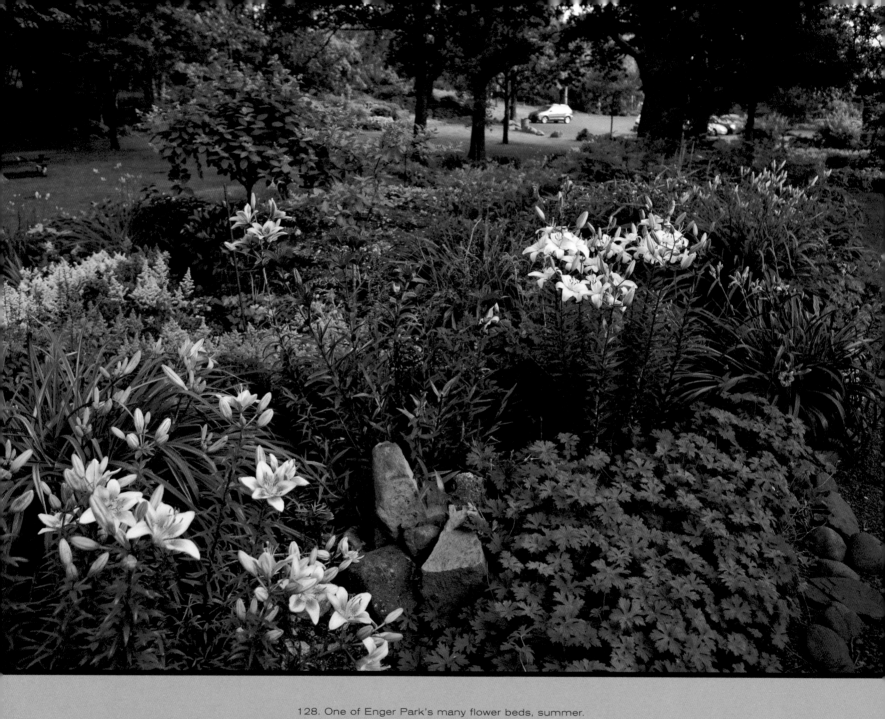

128. One of Enger Park's many flower beds, summer.

Much of Enger Park was originally part of Central Park, and two observation towers were planned as early as 1912.

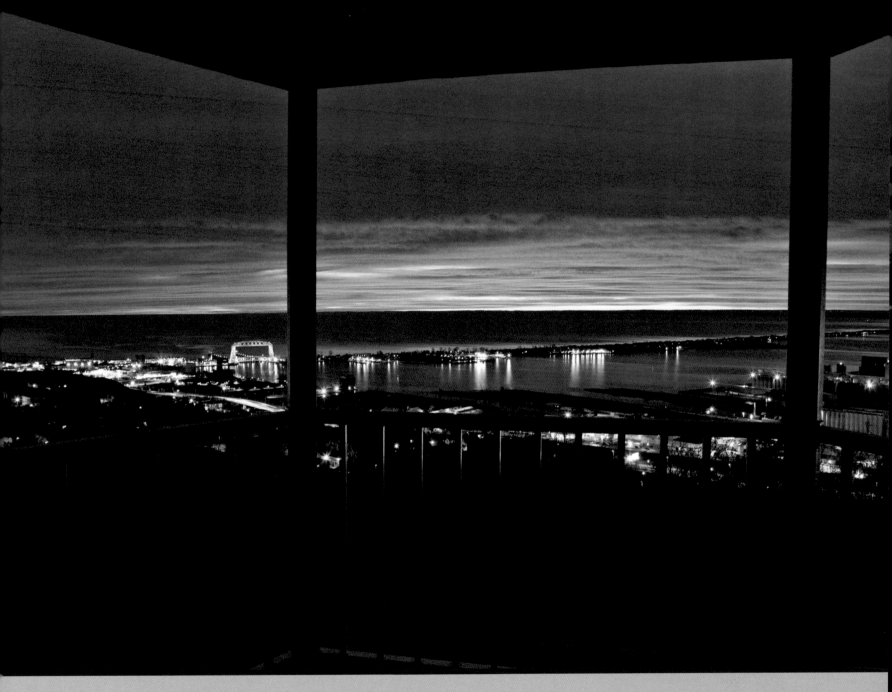

129. View from Enger Park's gazebo at dawn, autumn.

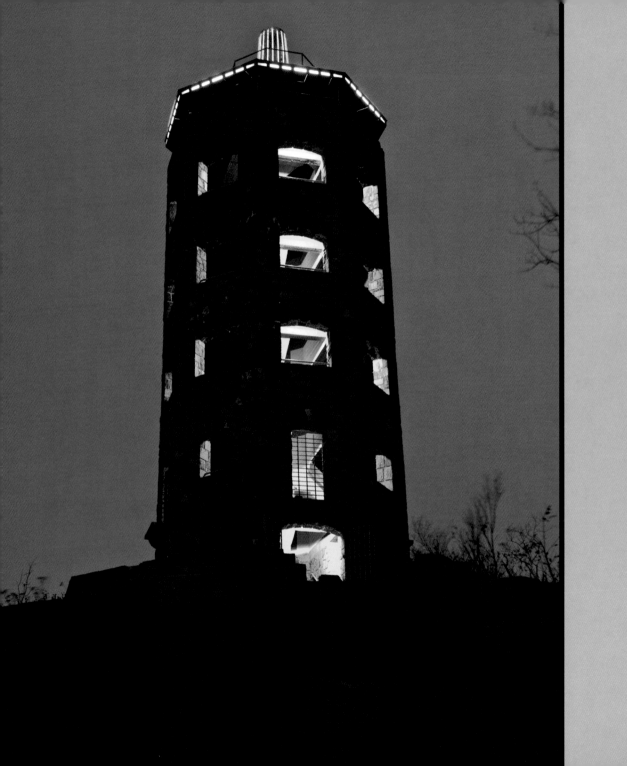

130.
Enger Memorial Tower
at dawn, autumn.

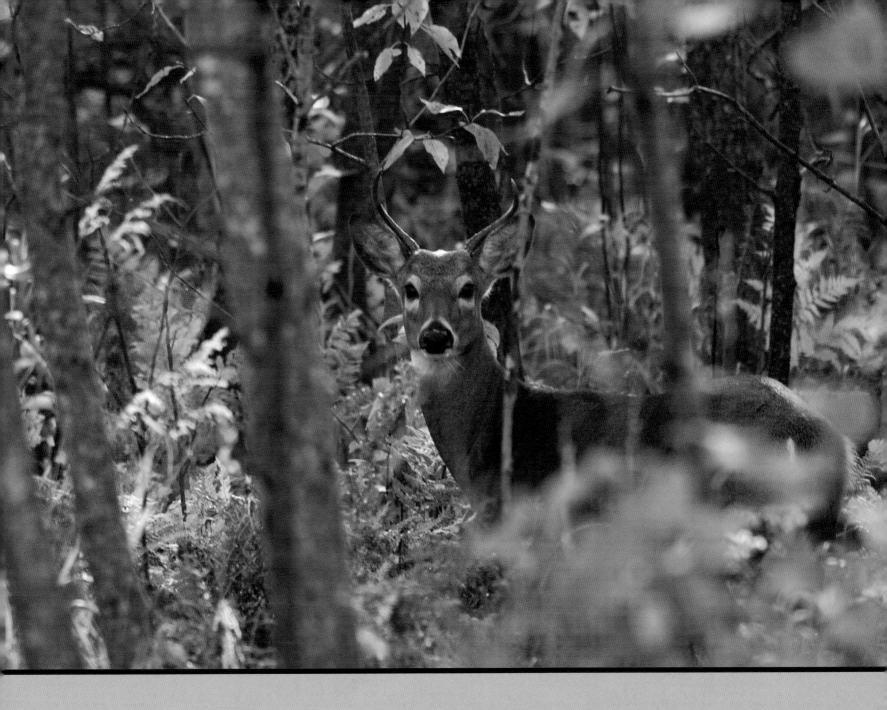

131. A white-tailed deer in the woods off Skyline Parkway near Enger Park, autumn.

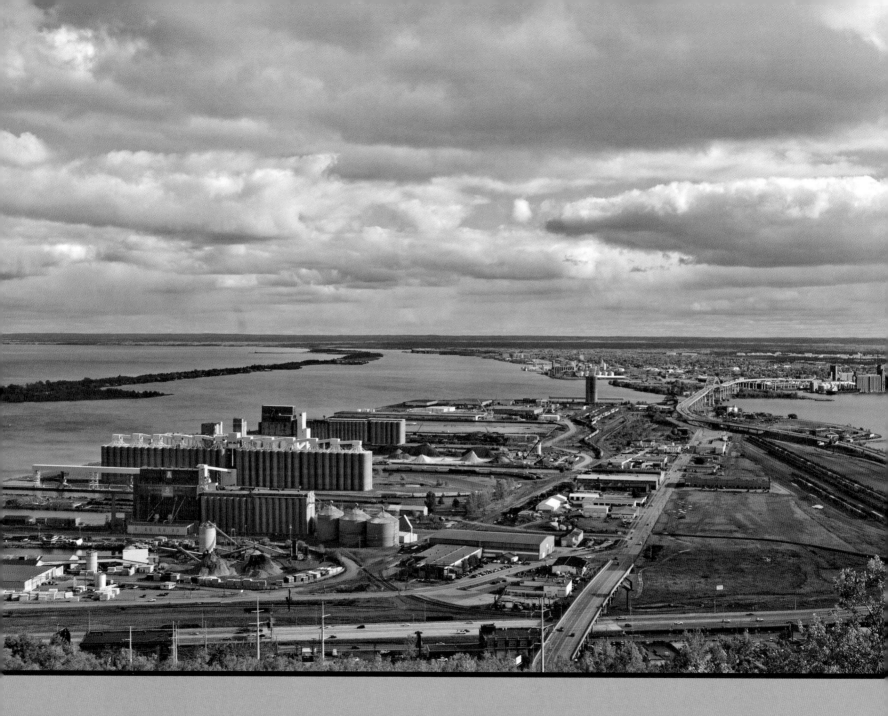

132. Rice's Point as seen from the top of Enger Memorial Tower.

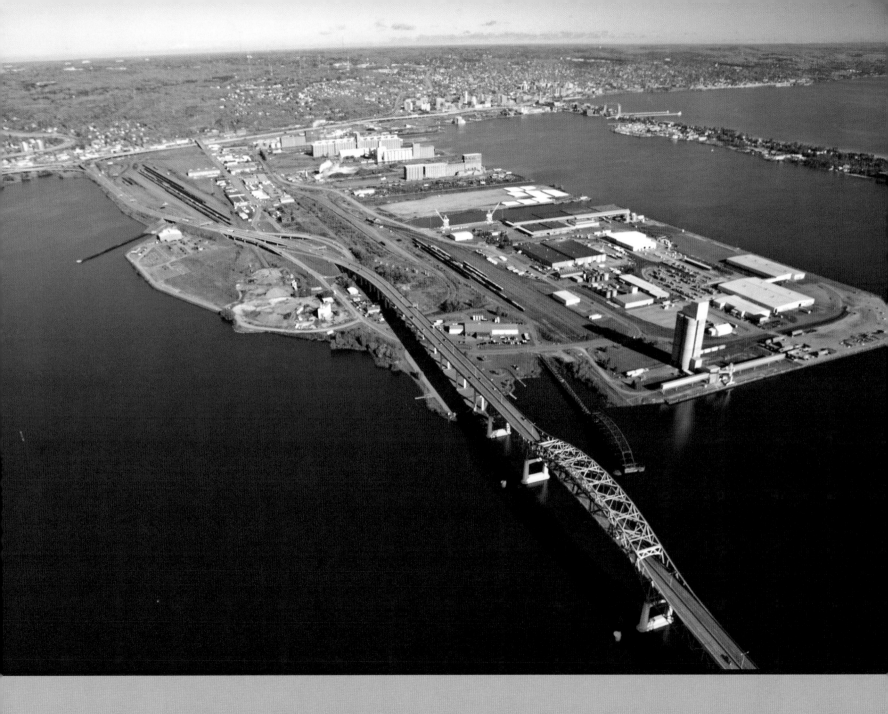

133. A bird's-eye view of Rice's Point.

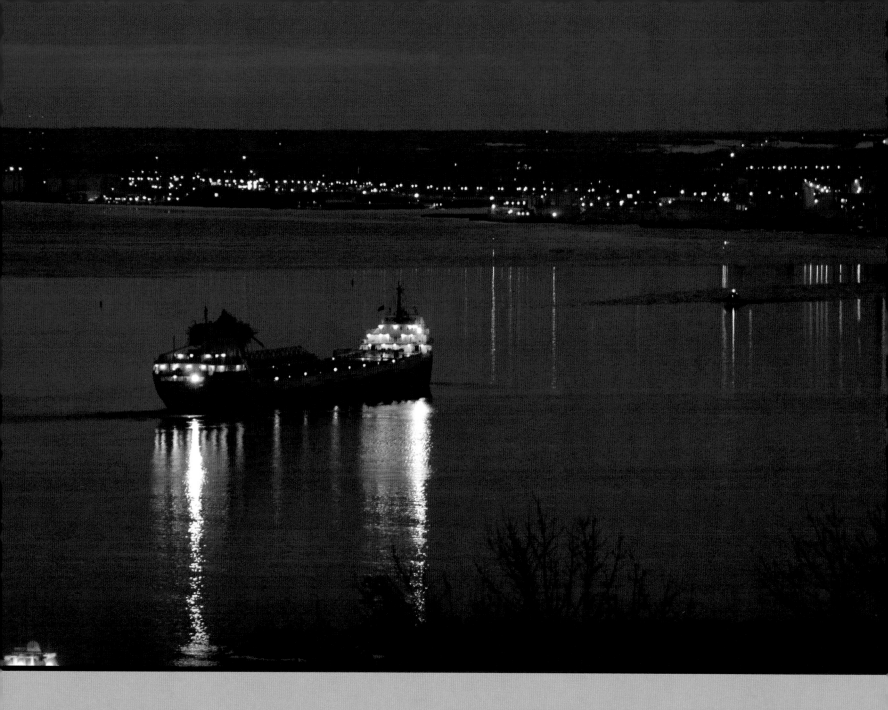

134. An ore boat on Superior Bay, headed to Rice's Point.

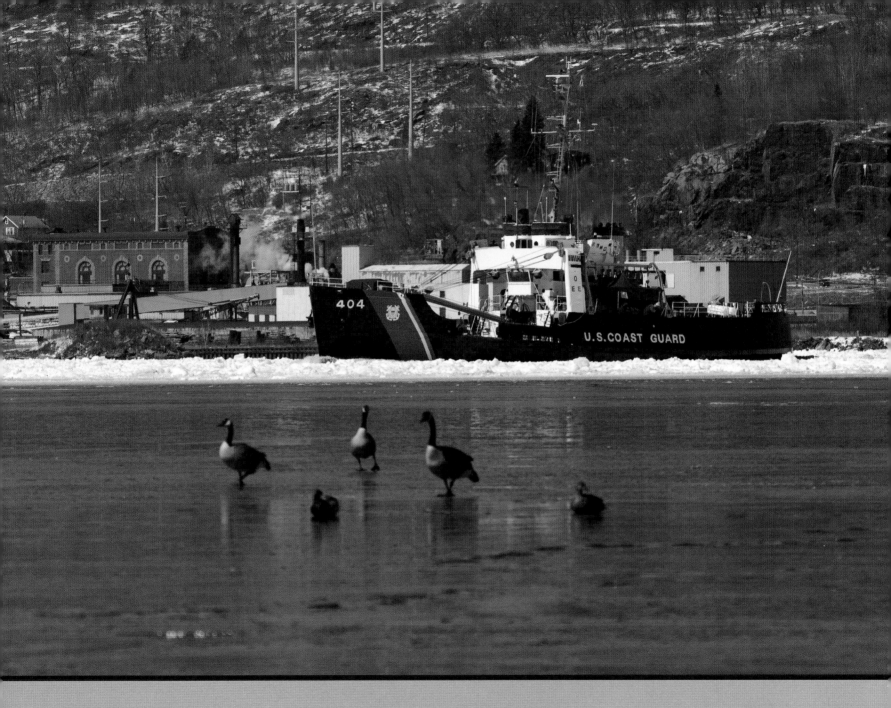

135. The United States Coast Guard Cutter *Sundew* rests on Superior Bay beneath Point of Rocks.

The vessel, built in 1944, was retired from service in 2004; it operated as a floating museum until a local businessman purchased it in 2009.

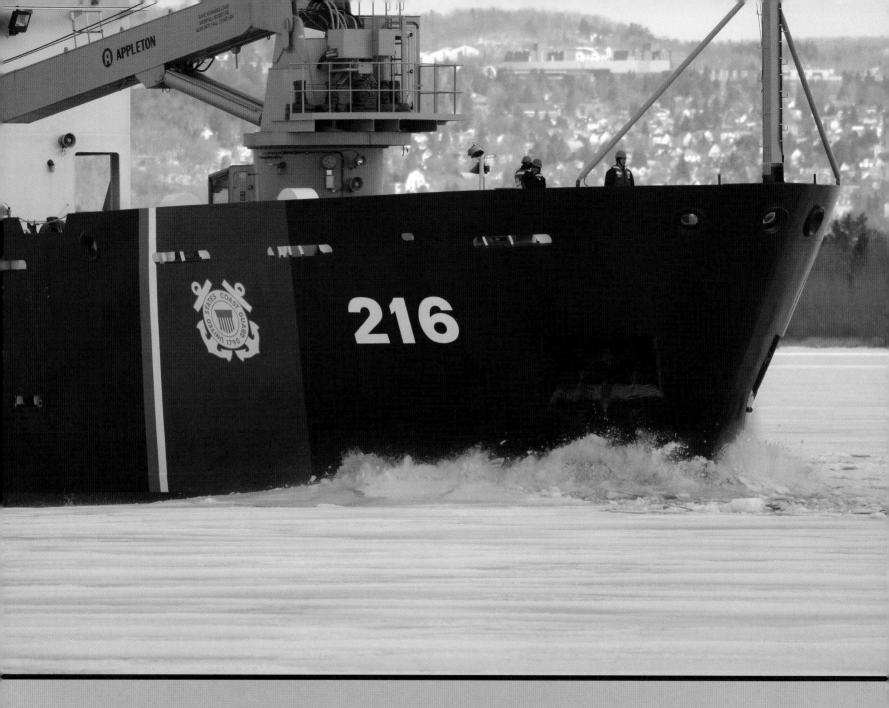

136. The United States Coast Guard Cutter *Alder*, which replaced the *Sundew* in 2004.

Both vessels are technically "buoy tenders," but they also serve (or served) in law enforcement, rescue missions, and—as shown—as ice breakers.

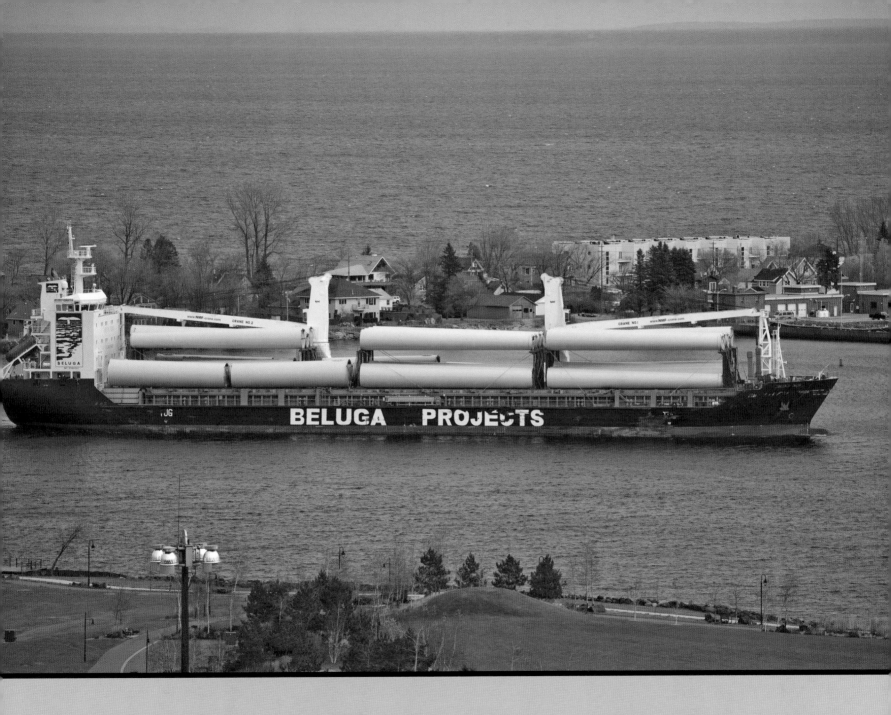

137. Saltie carrying a load of components for wind turbine generators.

138. As they have since 1886, local rowers train in Superior Bay between Minnesota Point and Rice's Point.

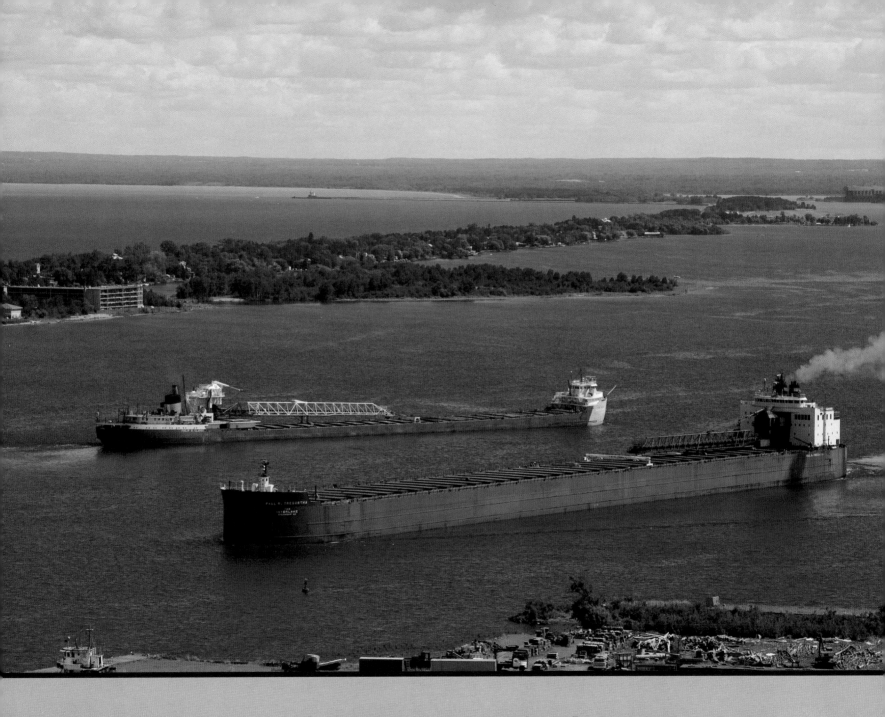

139. Two ore boats passing in the day on Superior Bay.

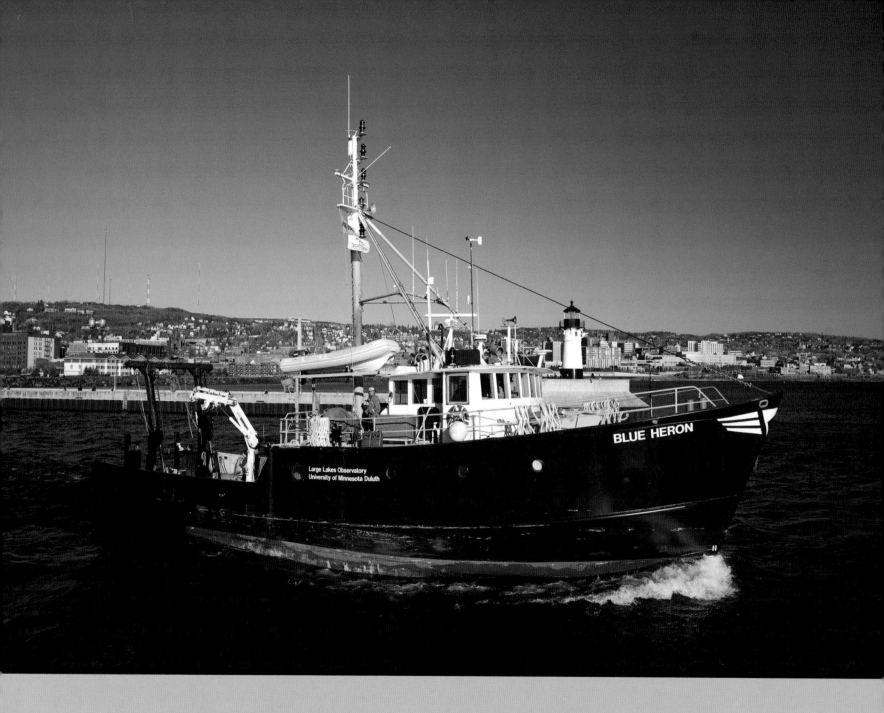

140. The *Blue Heron*, the University of Minnesota Duluth's research vessel or "large lake observatory."

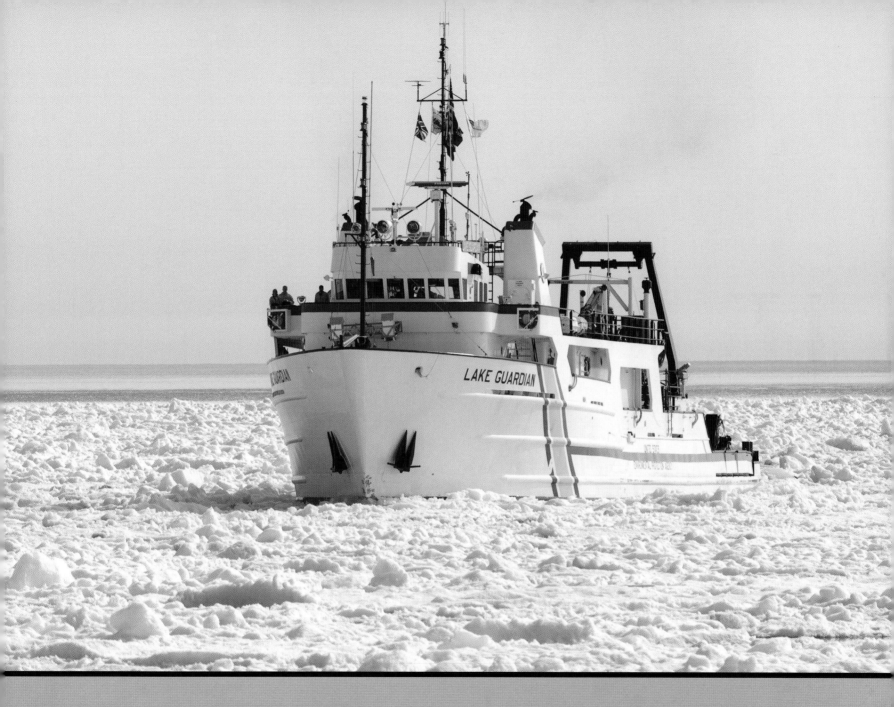

141. A frequent visitor to Duluth, the U.S. Environmental Protection Agency's *Lake Guardian* is the EPA's largest Great Lakes research and monitoring vessel—and the only self-contained, non-polluting research vessel on the Great Lakes.

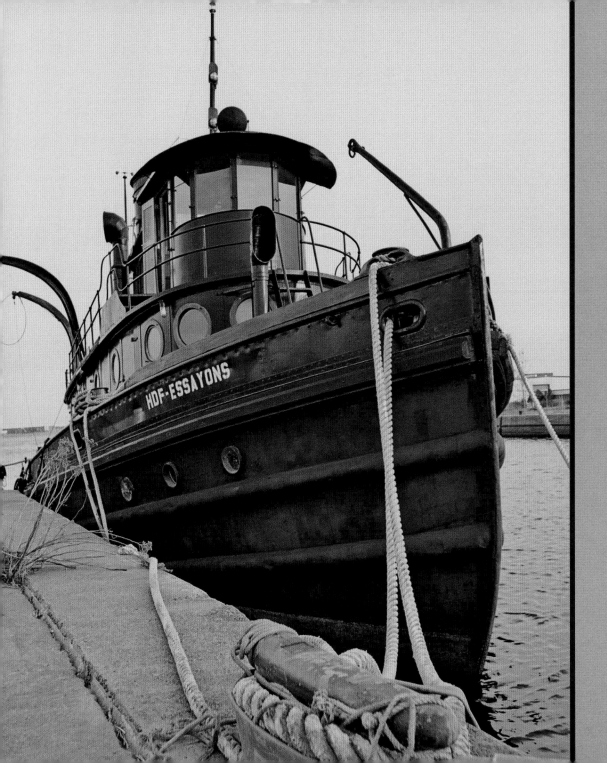

142.

The *Essayons*, built in 1908 for the U.S. Army Corps of Engineers, which oversees the Duluth Ship Canal. It was sold to Duluth's Zenith Dredge Company in 1950.

After the vessel was retired, its engine was removed and put on display at the Lake Superior Marine Museum.

Now privately owned, the *Essayons* was gutted in preparation to be converted to a floating bed and breakfast. It sank at its dock site in the spring of 2009 and currently rests at the bottom of the bay.

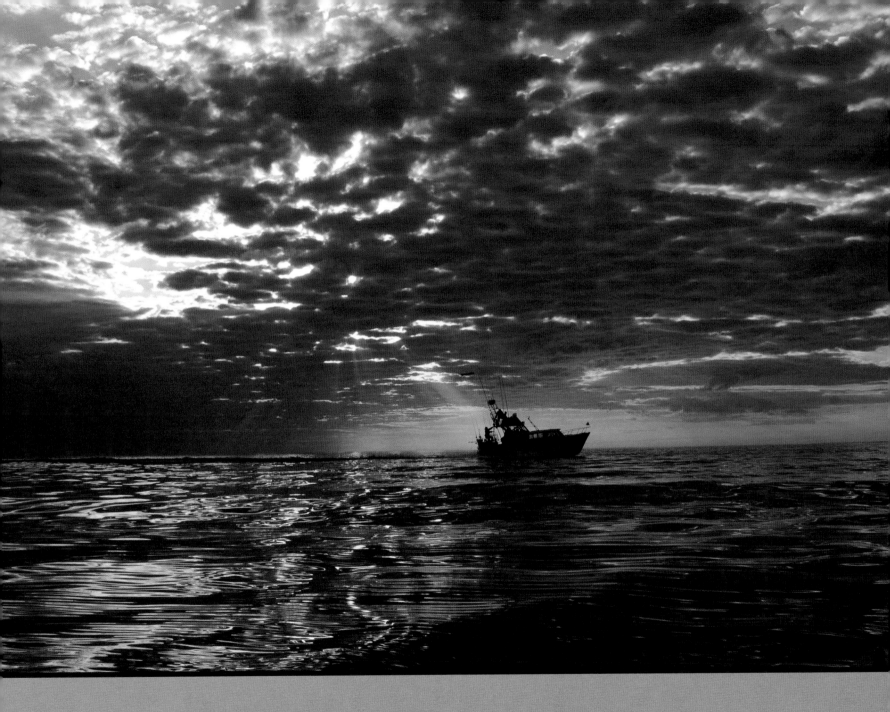

143. A charter fishing vessel gets an early start.

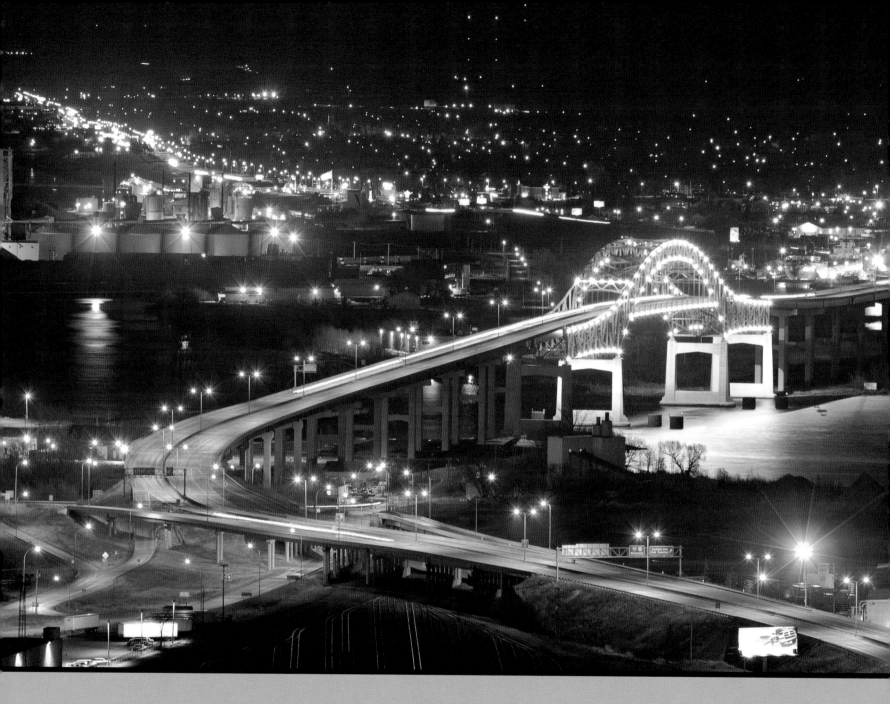

144. The Blatnik Bridge (aka the "High Bridge"), built in 1961 to replace the Interstate Bridge and named in honor of Minnesota Congressman John A. Blatnik.

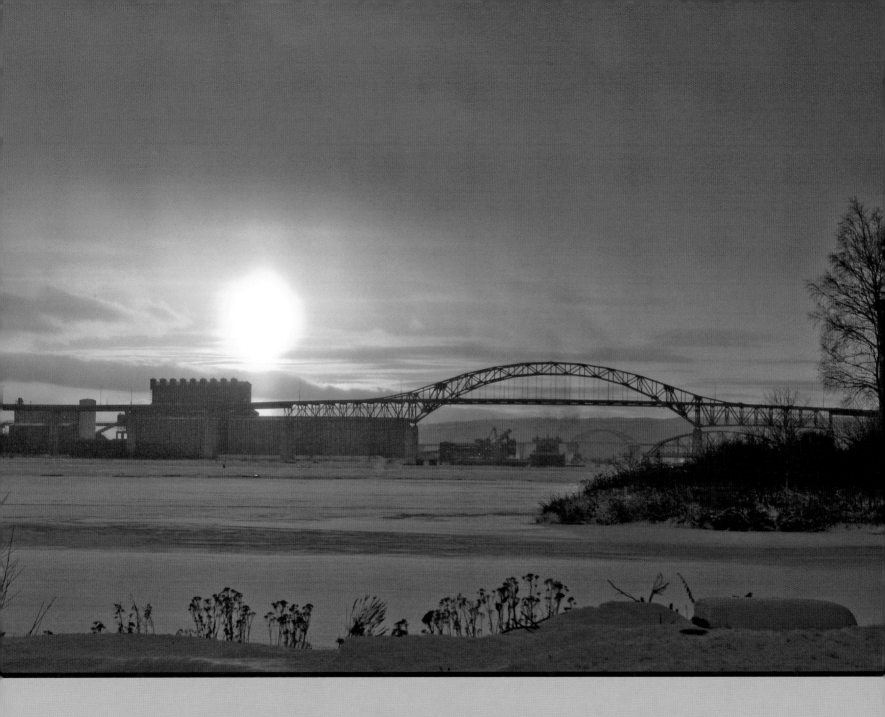

145. The sun sets behind the Blatnik Bridge, winter.

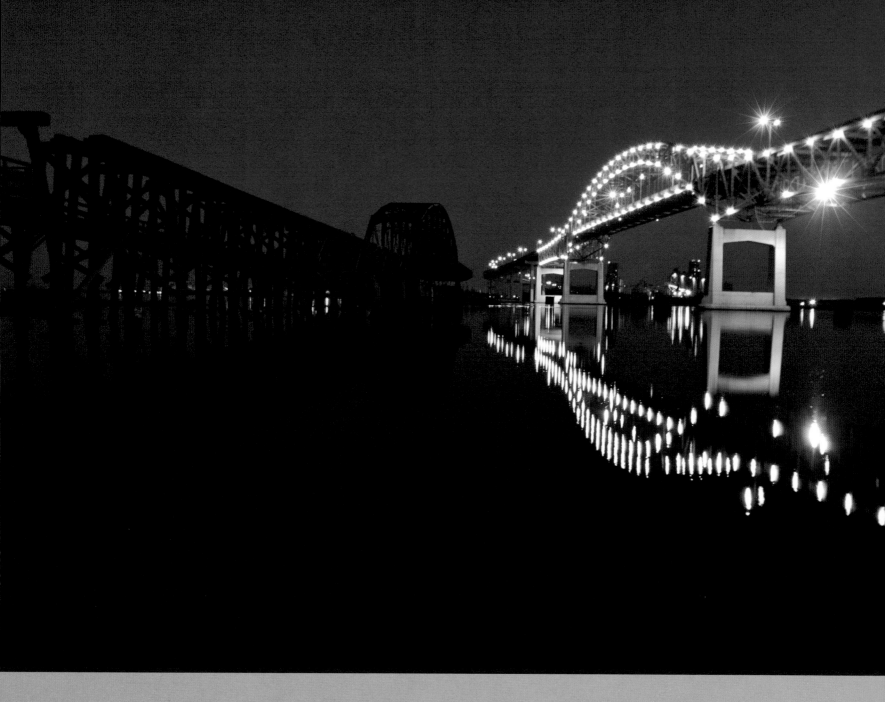

146. Ruins of the Interstate Bridge (1897–1961) stand alongside the Blatnik Bridge, its replacement.
This portion of the old bridge was retained for use as a public fishing dock.

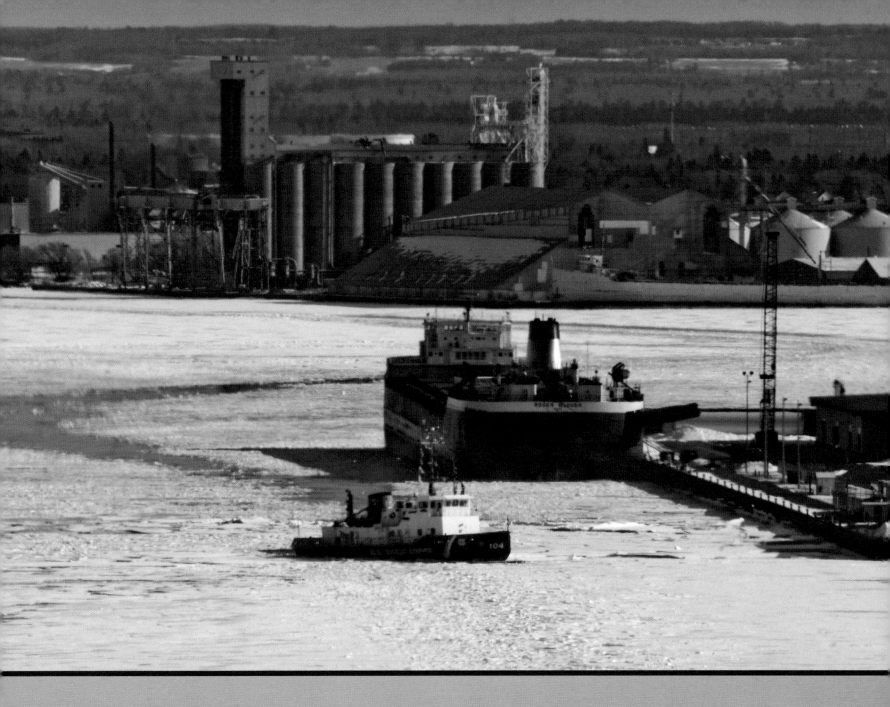

147. The Coast Guard Cutter *Biscayne Bay* breaks ice in the St. Louis Bay while the ore boat *Roger Blough* rests at anchor.

The *Biscayne Bay* usually works the Straits of Mackinaw between Lake Superior and Lake Michigan.

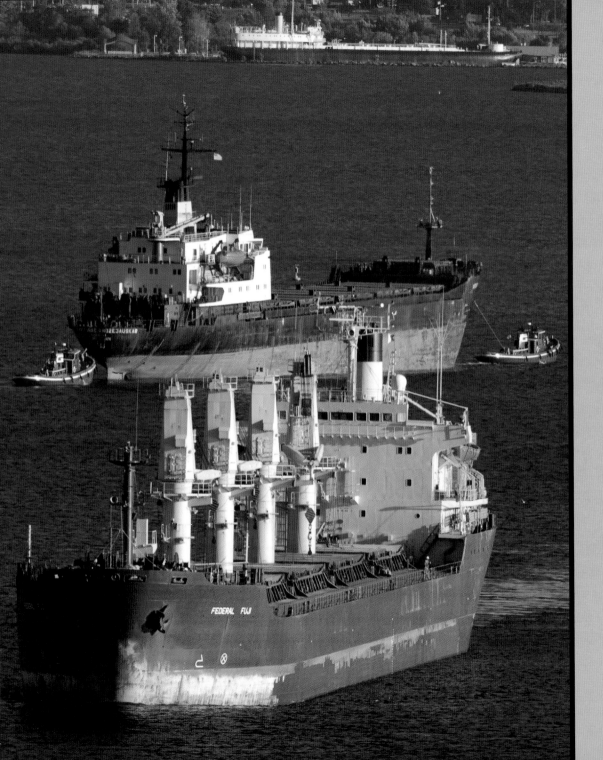

148.
Great Lakes Towing Company
tugs assisting an unknown saltie
navigating St. Louis Bay,
with the *Federal Fuji* out of
Hong Kong in the foreground.

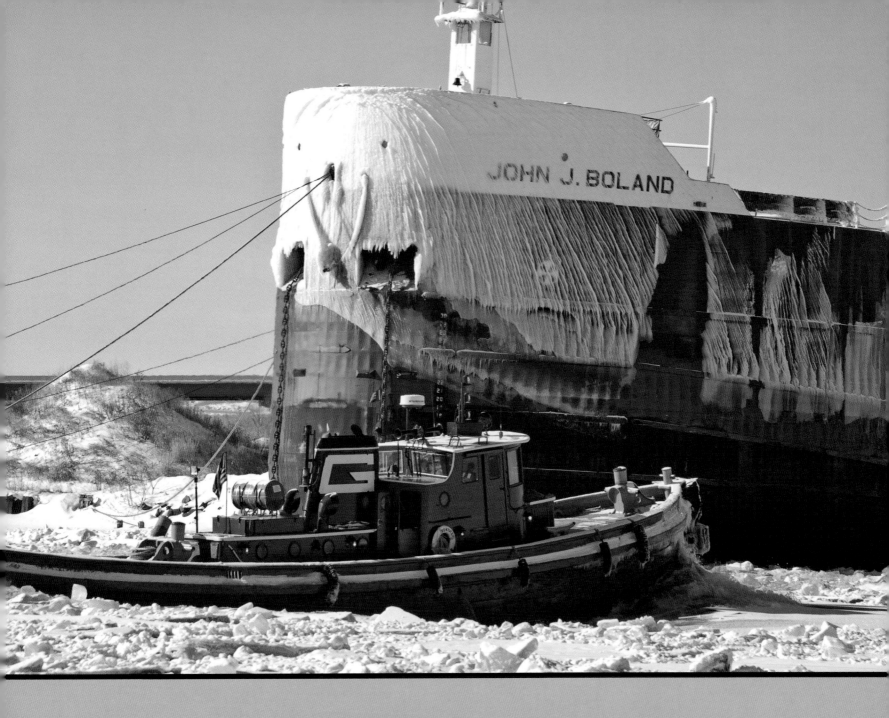

149. Another Great Lakes tug with the *John J. Boland* ore boat.

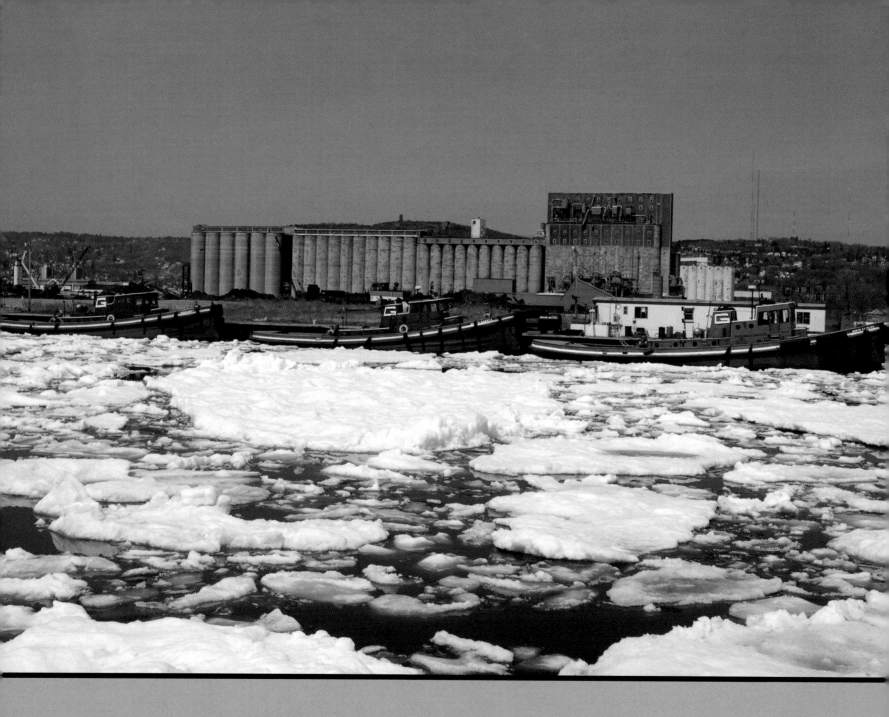

150. Great Lakes Towing Company tugs anchored off Rice's Point, winter.

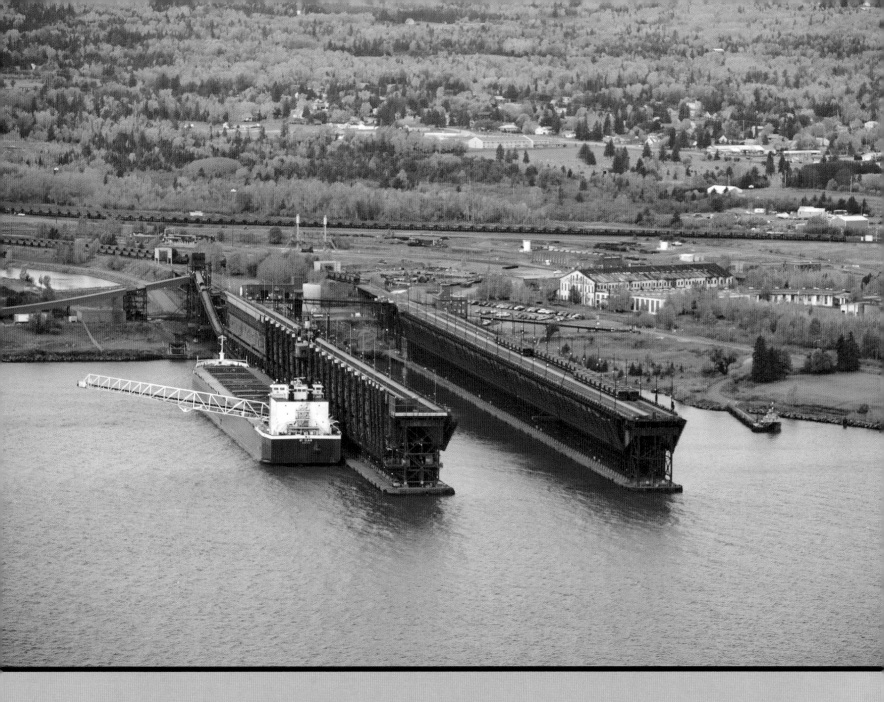

151. The ore boat *St. Clair* prepares to take on a load of ore at the historic Duluth Ore Docks.
Six ore docks once operated from this site; only two remain.

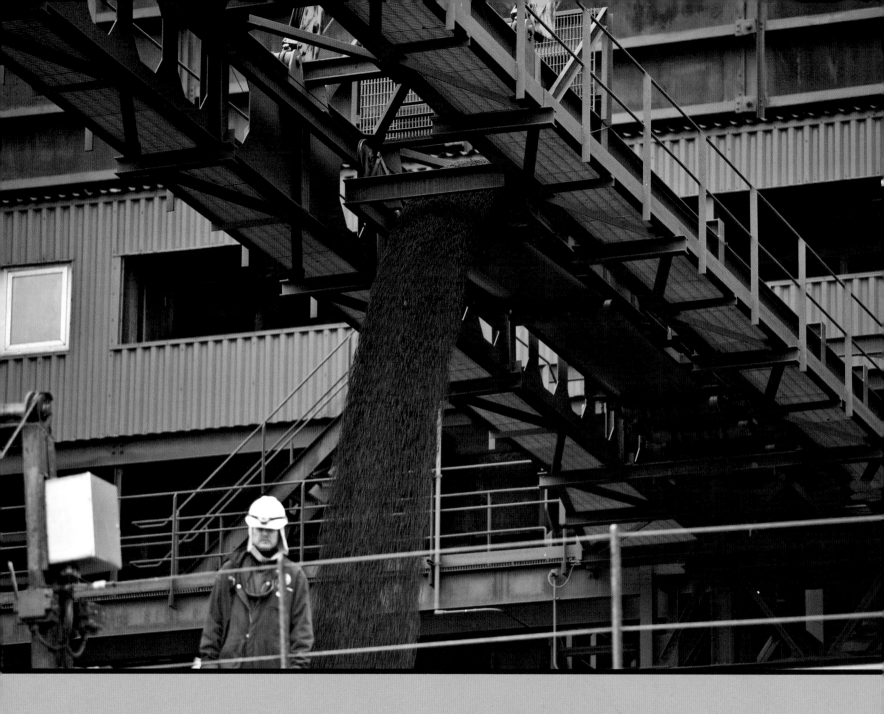

152. Ore drops into the hull of an ore boat from an ore dock conveyor fed from rail cars atop the dock.

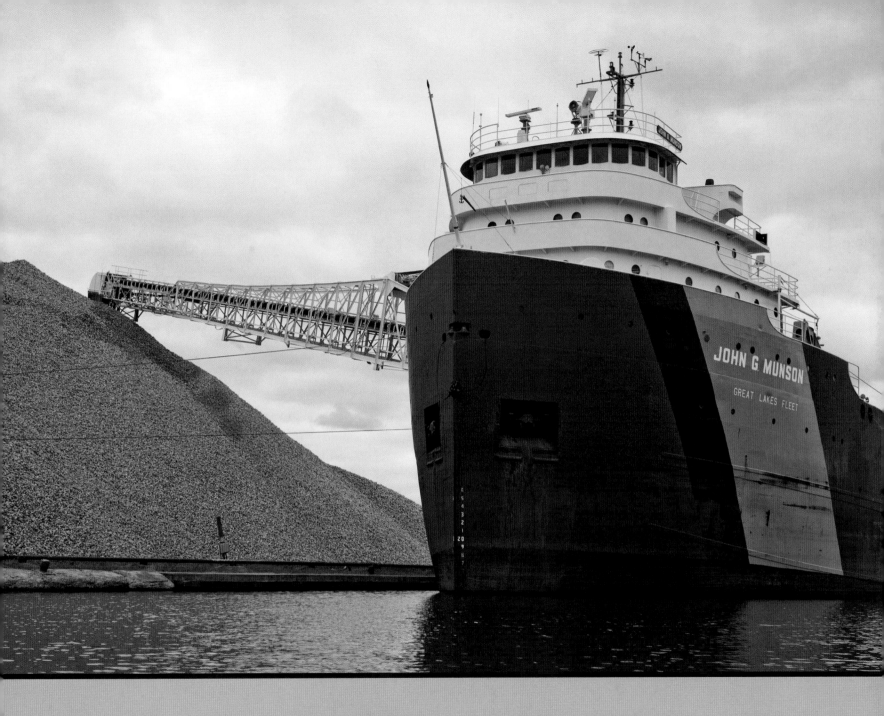

153. The *John G. Munson* ore boat unloading limestone.

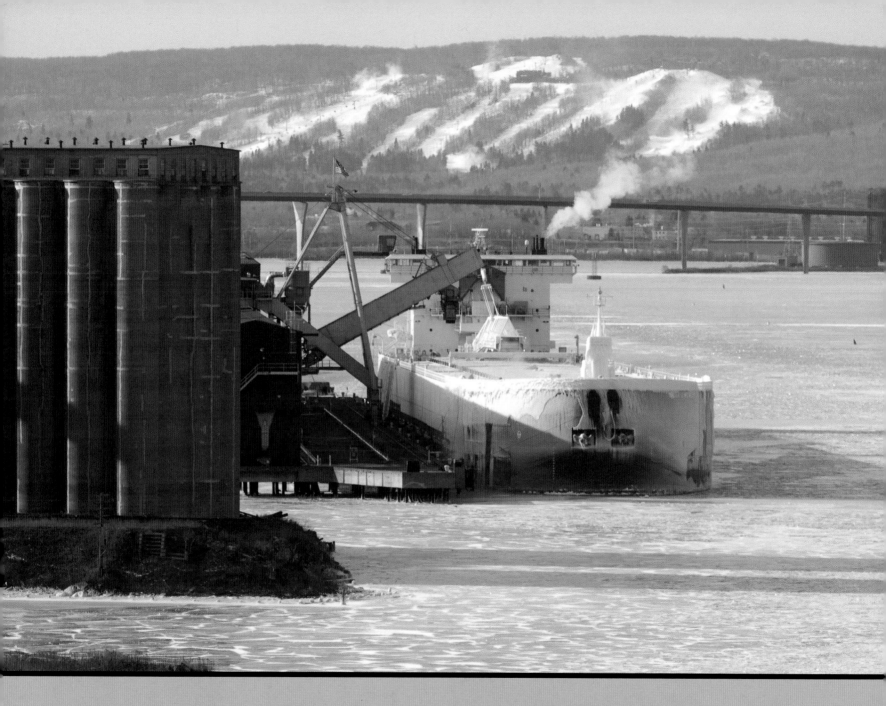

154. Spirit Mountain's ski hills provide a backdrop for an ore boat docked at elevators in Superior, Wisconsin, just across the bay from Duluth. Together, Duluth and Superior are known as the Twin Ports.

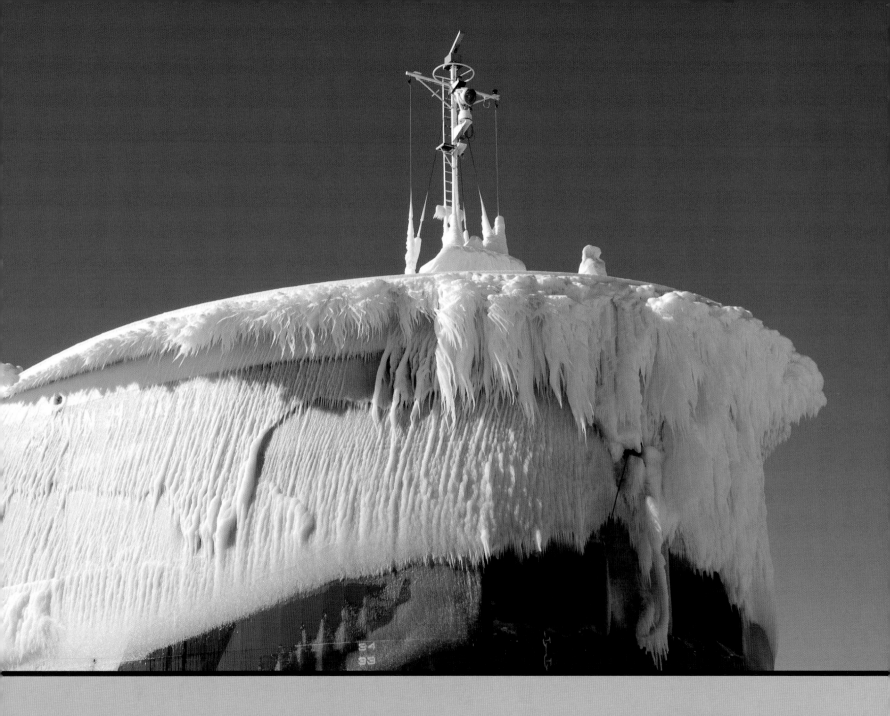

155. Wind, water, and cold combined to form a delicate ice sculpture on the bow of the ore boat *Columbia Star*.

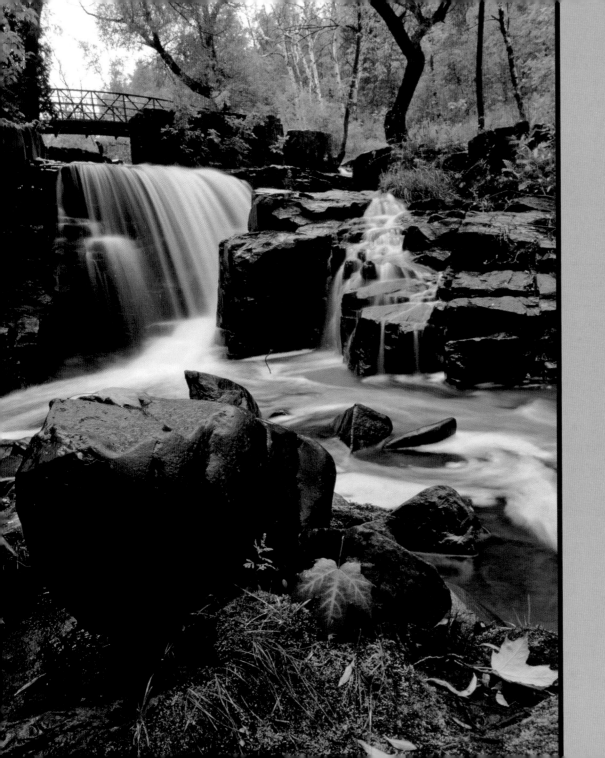

156.
Cascades on Miller Creek
in Lincoln Park, autumn.

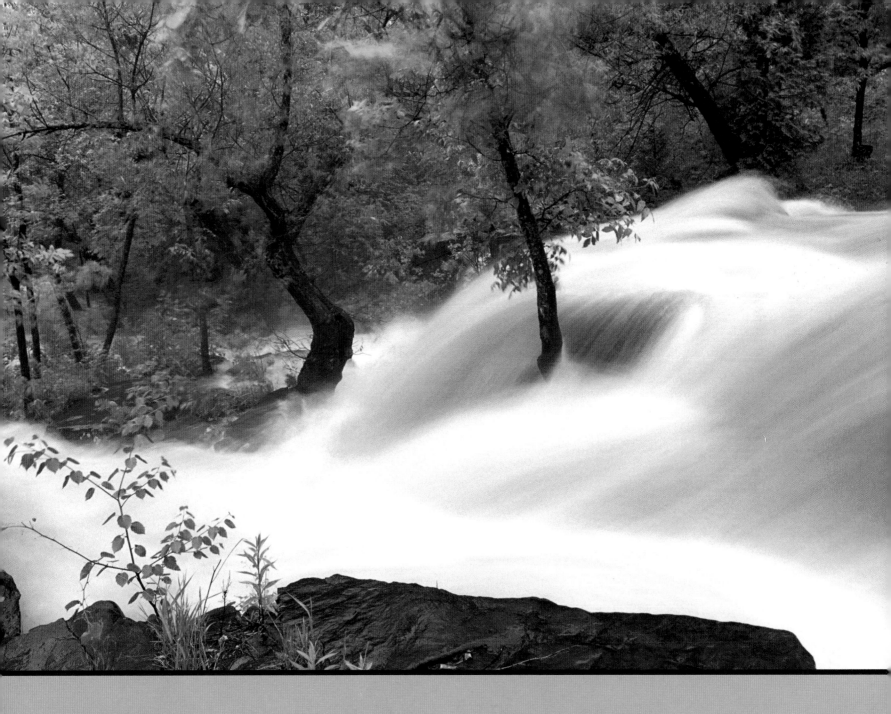

157. Miller Creek roils with spring run-off as it rushes through Lincoln Park.

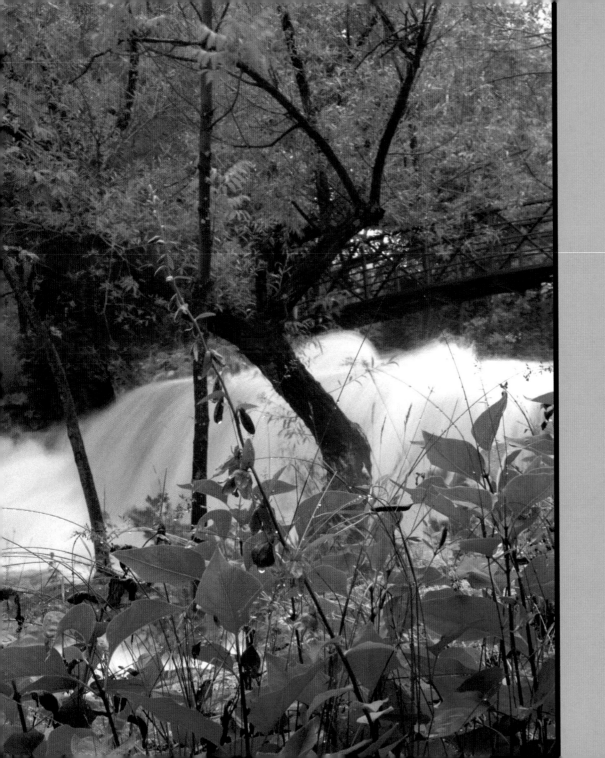

158.
Bluebells blossom
along Miller Creek in
Lincoln Park after a
late spring rain.

159. Bluebells in Lincoln Park.

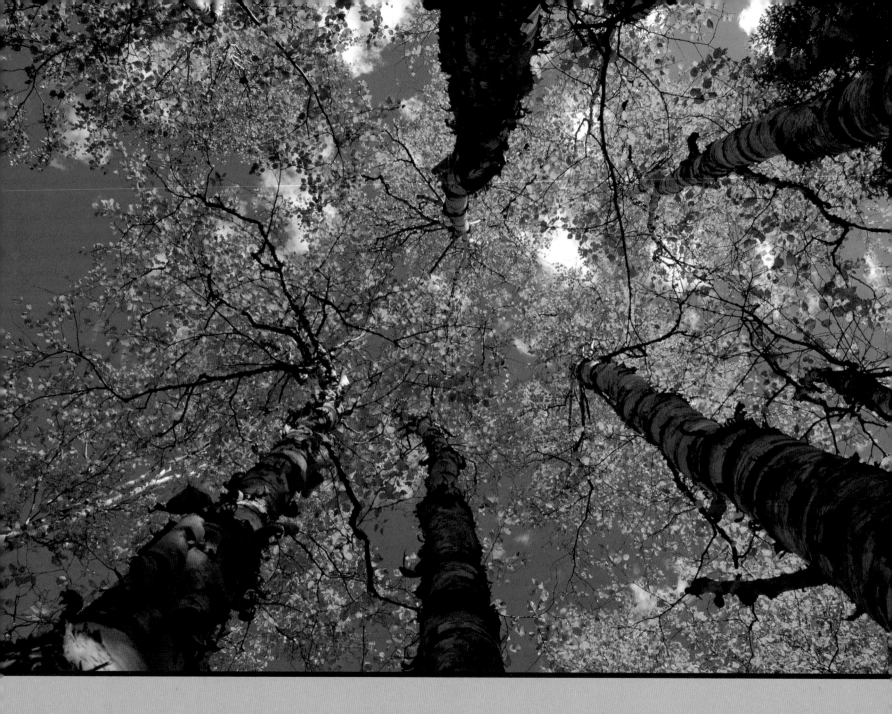

160. A small stand of birches in Lincoln Park, autumn.

5. Western Horizons

The Ore Docks to Fond du Lac Park

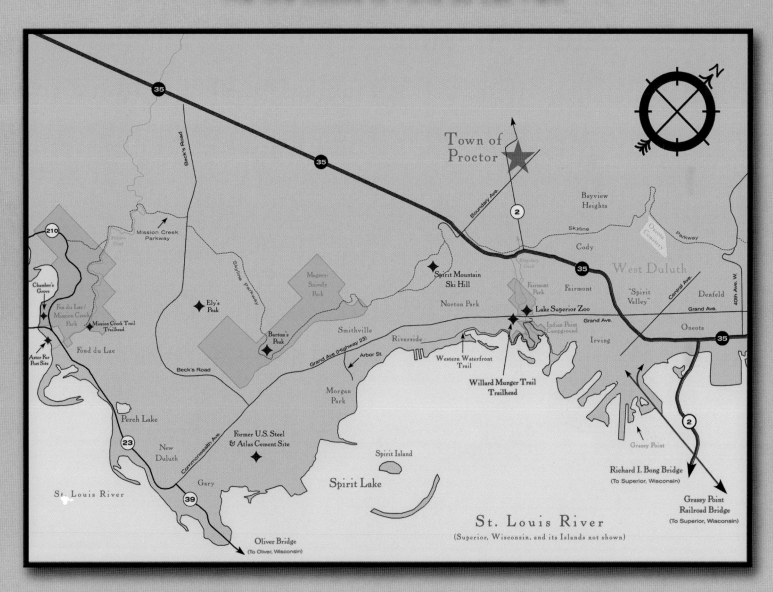

Town of Proctor

Bayview Heights

Oneota Cemetery

Skyline

Cody

West Duluth

Fairmont Park

Fairmont

"Spirit Valley"

Denfeld

Grand Ave.

Norton Park

Lake Superior Zoo

Grand Ave.

Irving

Oneota

Spirit Mountain Ski Hill

Indian Point Campground

Western Waterfront Trail

Willard Munger Trail Trailhead

Mission Creek Parkway

Skyline Parkway

Magney-Snively Park

Ely's Peak

Smithville

Riverside

Arbor St.

Barton's Peak

Grand Ave. (Highway 23)

Chamber's Grove

Fon du Lac / Mission Creek Park

Mission Creek Trail Trailhead

Fond du Lac

Astor Fur Post Site

Beck's Road

Beck's Road

Morgan Park

Perch Lake

New Duluth

Commonwealth Ave.

Former U.S. Steel & Atlas Cement Site

Gary

Spirit Island

Spirit Lake

Grassy Point

Richard I. Bong Bridge
(To Superior, Wisconsin)

Grassy Point Railroad Bridge
(To Superior, Wisconsin)

St. Louis River

Oliver Bridge
(To Oliver, Wisconsin)

St. Louis River

(Superior, Wisconsin, and its Islands not shown)

Boundary Ave.

Kingsbury Creek

40th Ave. W.

Central Ave.

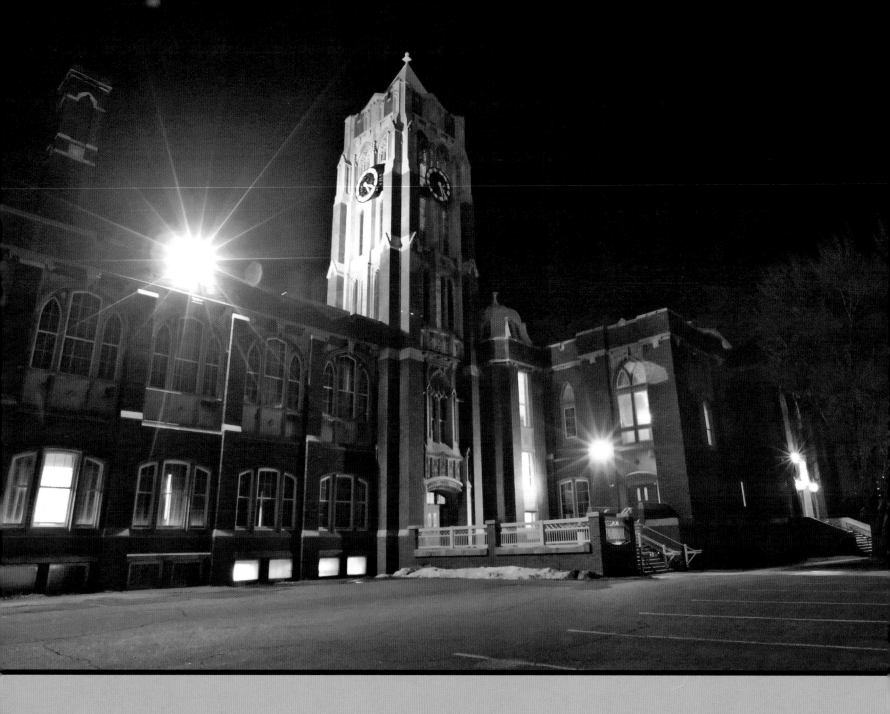

162. Denfeld Senior High School, 4405 West 4th Street (b. 1926; Abraham Holstead & William J. Sullivan, architects).

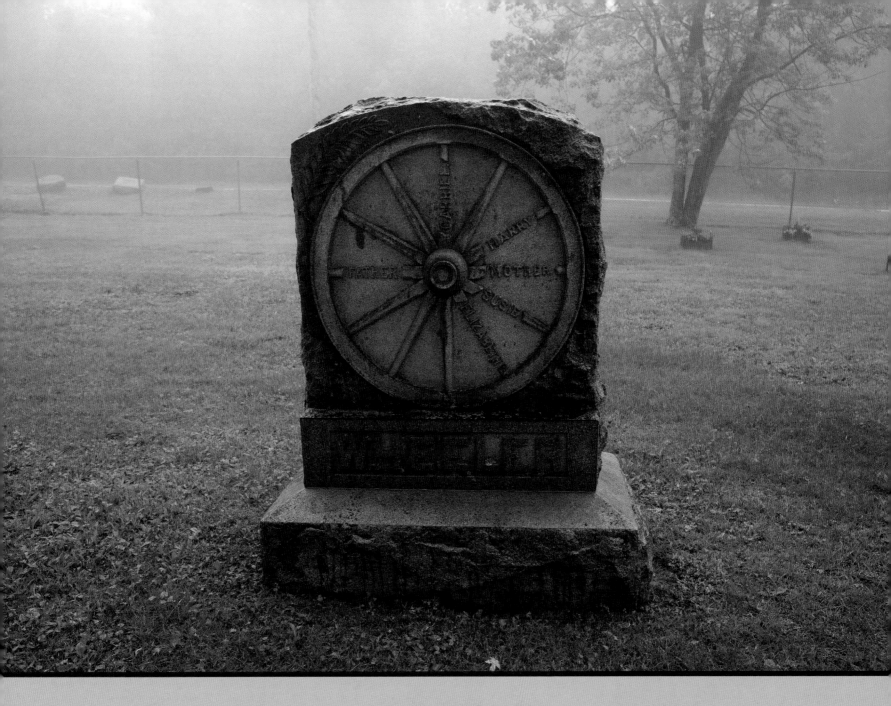

163. The Wheeler Family marker, Oneota Cemetery.

True Duluth pioneers, the Wheelers helped establish Oneota Township (later West Duluth) along with the Merritt Family of iron mining fame.

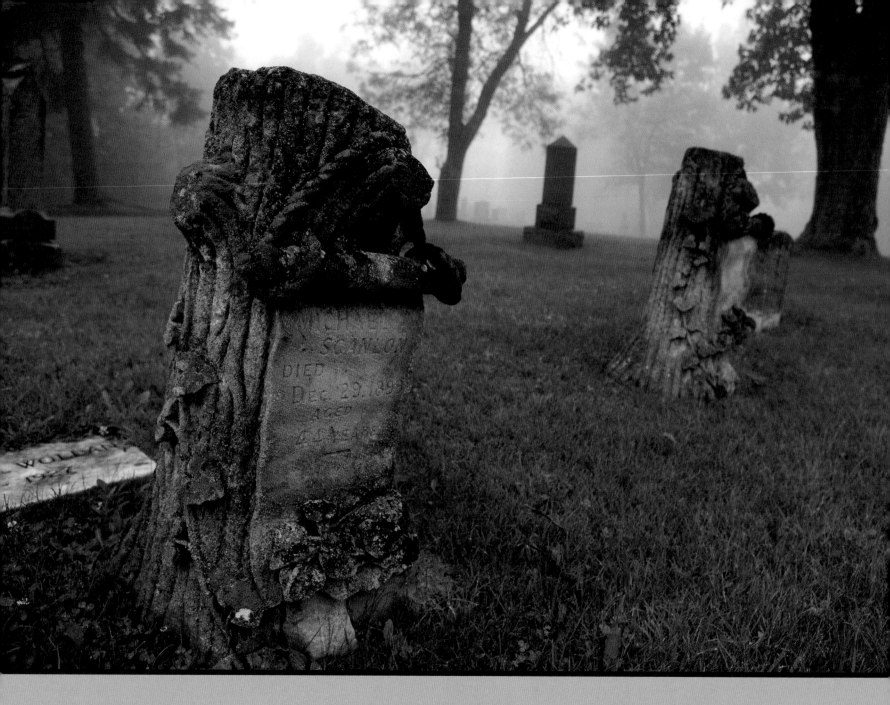

164. One of Oneota Cemetery's many "tree stump" grave markers.

Popularized in the late nineteenth century by the Woodmen of the World fraternal organization, the markers symbolized a life cut short.

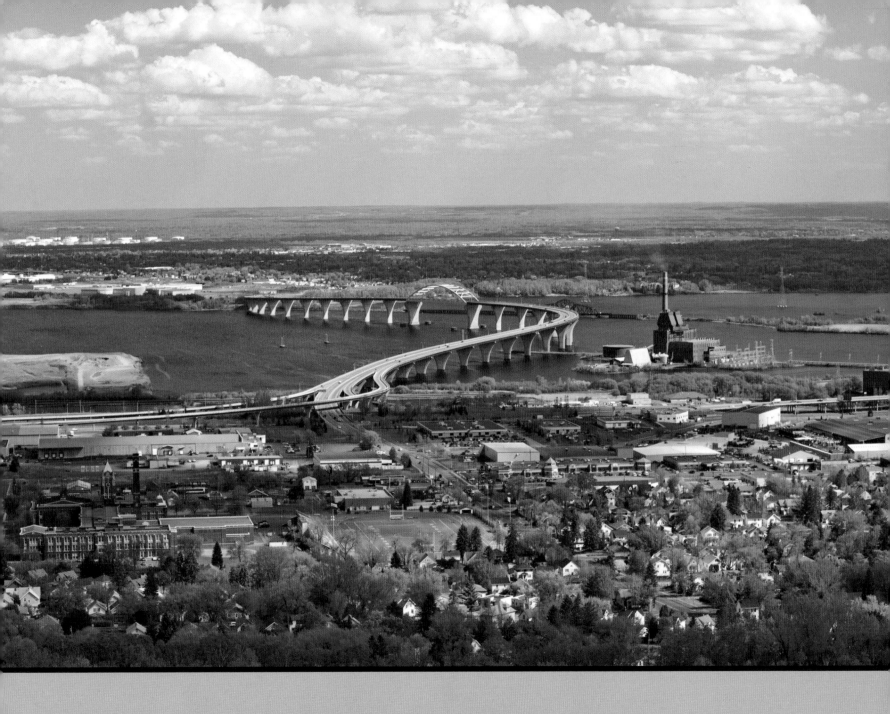

165. A view of West Duluth from Skyline Parkway, summer.

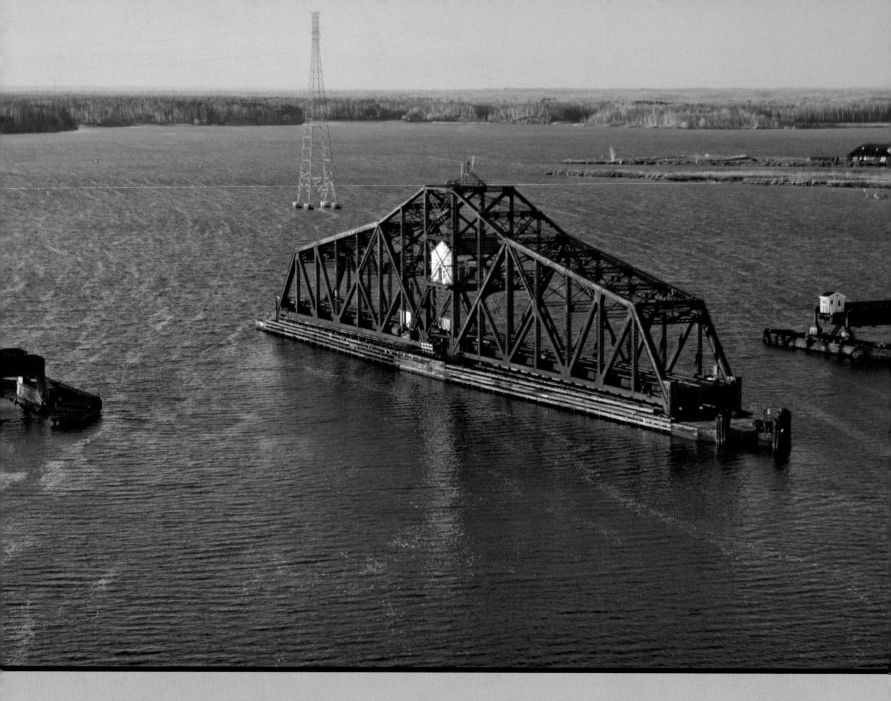

166. The St. Louis River Bridge at Grassy Point, a steel truss swing-span railroad bridge, in its open position to allow watercraft to pass through. The U.S. Army Corps of Engineers built the bridge in 1887 at the behest of the St. Paul & Duluth Railroad.

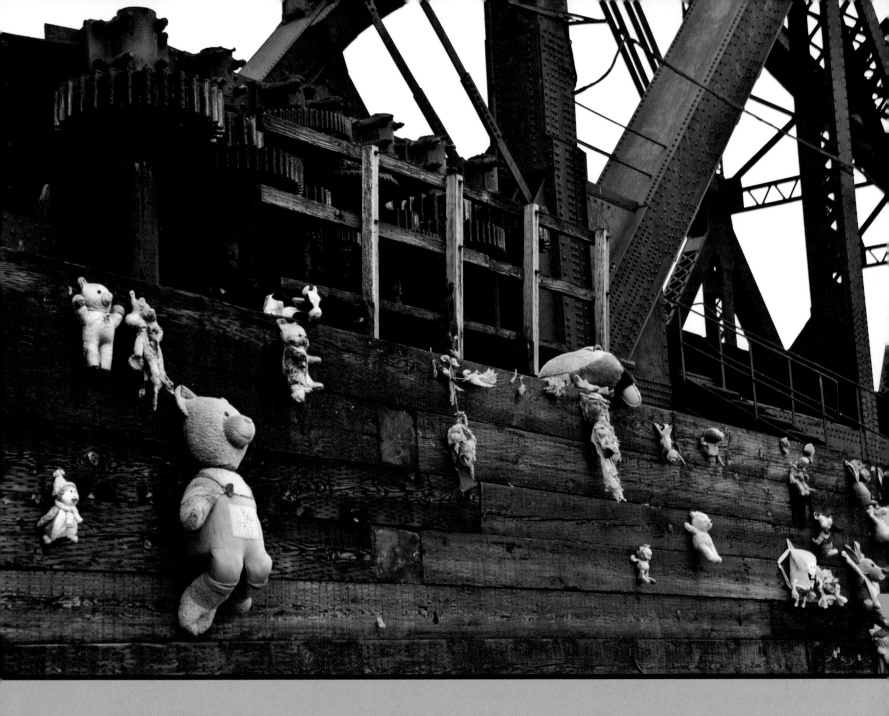

167. Close-up of the Grassy Point Railroad Bridge, which has become a canvas for a collage of stuffed animals, artist (or artists) unknown.

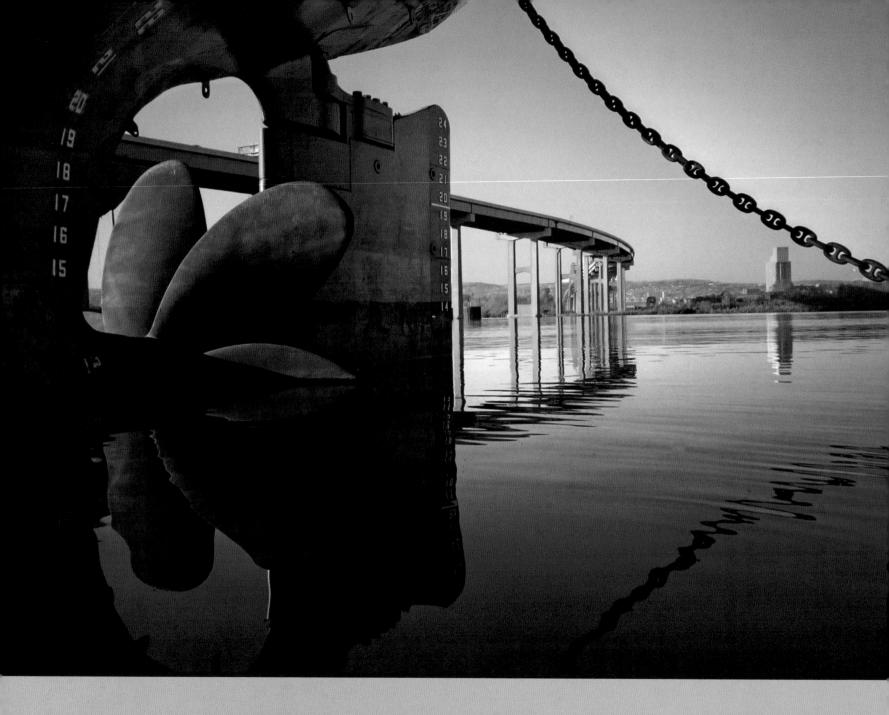

168. Propeller of an ore boat at anchor under the Blatnik Bridge in St. Louis Bay.

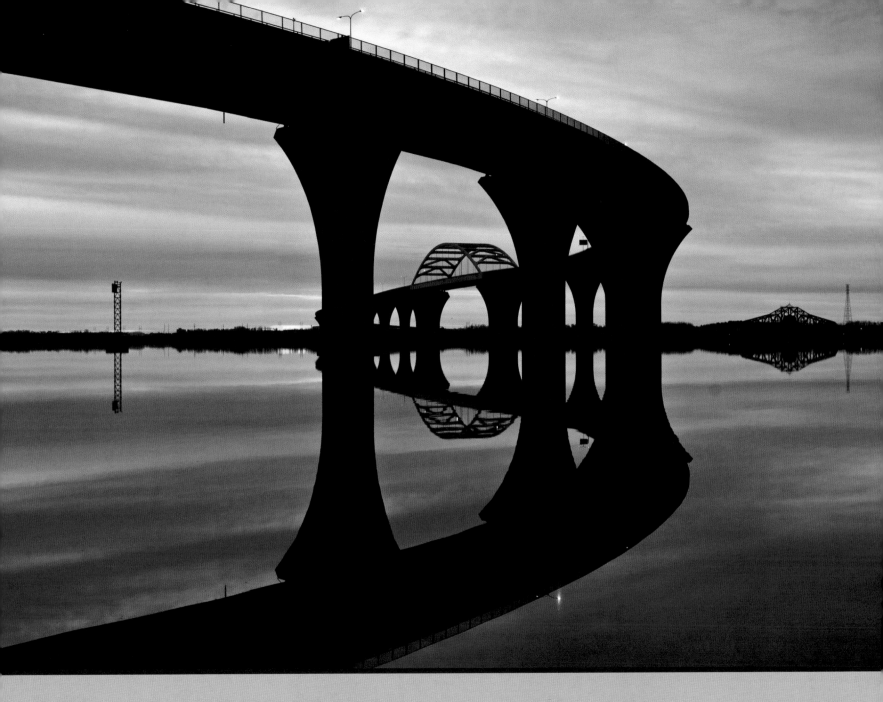

169. The Bong Bridge spans the St. Louis River from Duluth to Superior, Wisconsin.
The bridge is named in honor of World War II American flying ace Richard I. Bong, born in nearby Poplar, Wisconsin.

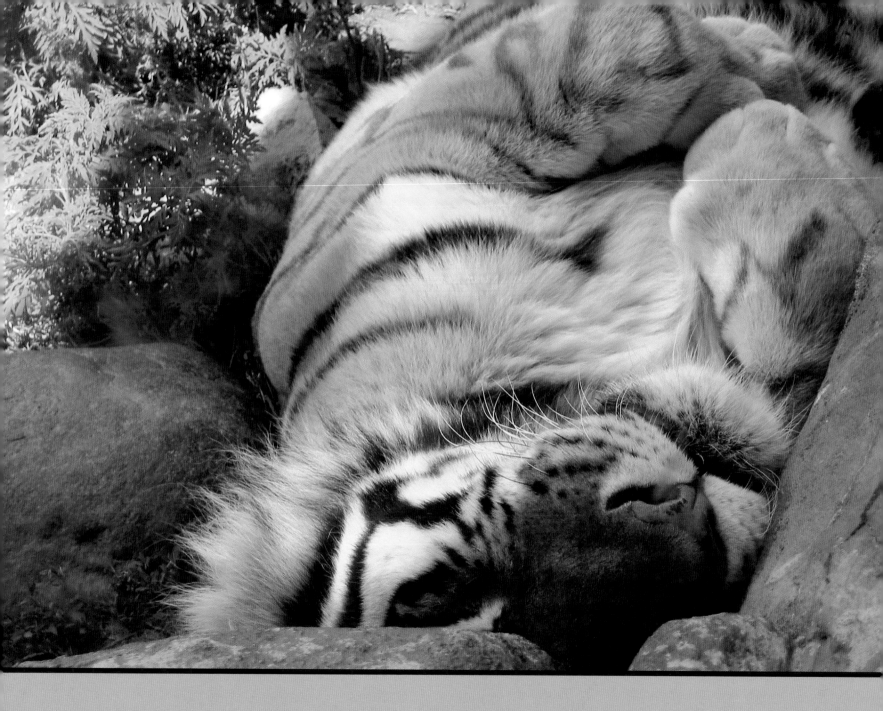

170. A Siberian tiger catches a nap at the Lake Superior Zoo, formerly the Fairmount Park Zoo, established in 1923.

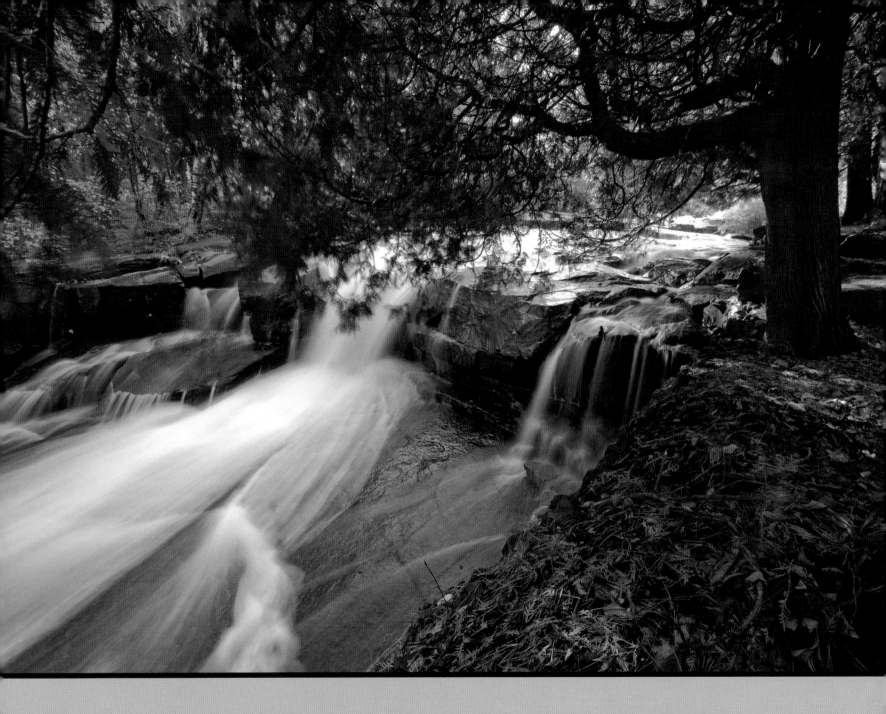

171. Kingsbury Creek cascading through Fairmount Park, summer.

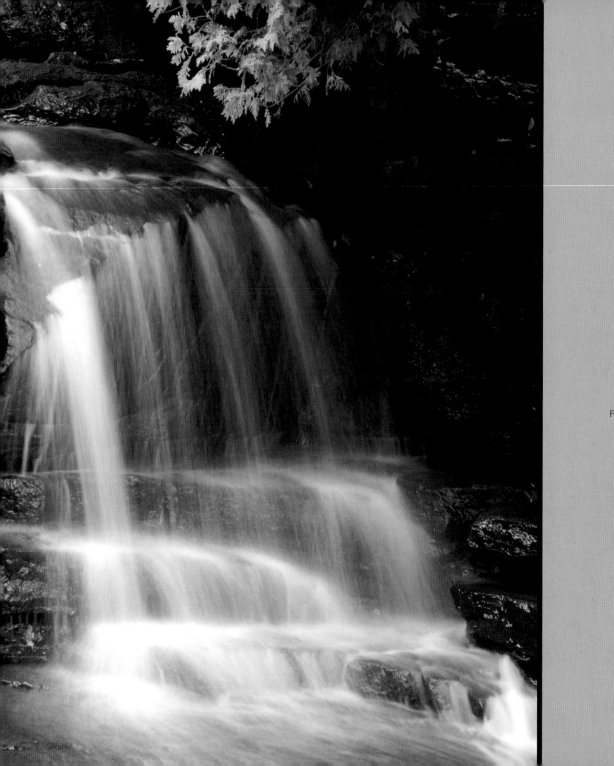

172.
Waterfall along
Kingsbury Creek,
Fairmount Park, autumn.

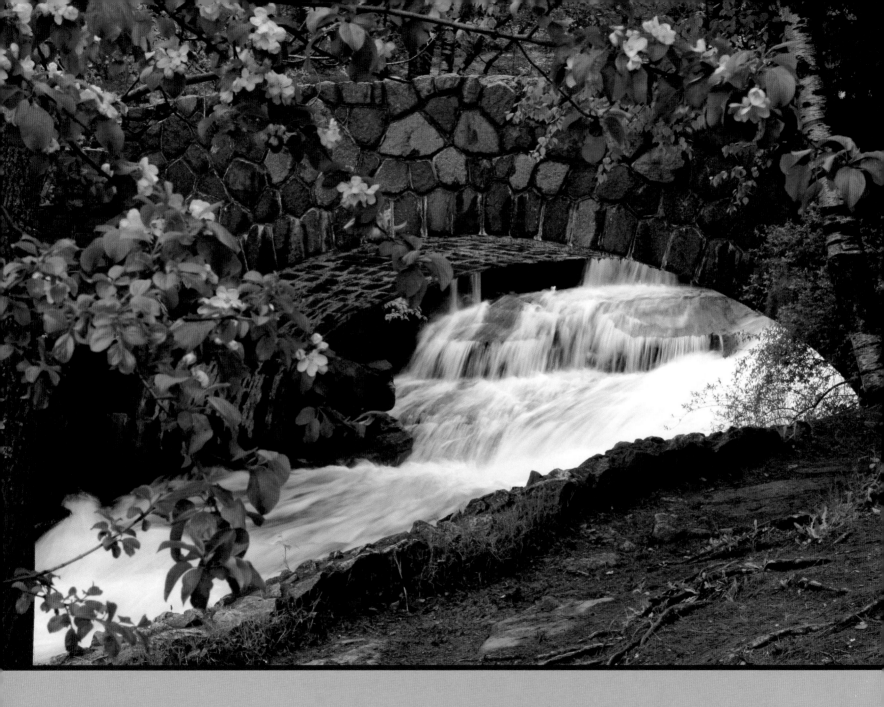

173. Kingsbury Creek flowing beneath a stone-arch bridge in Fairmount Park, late spring.

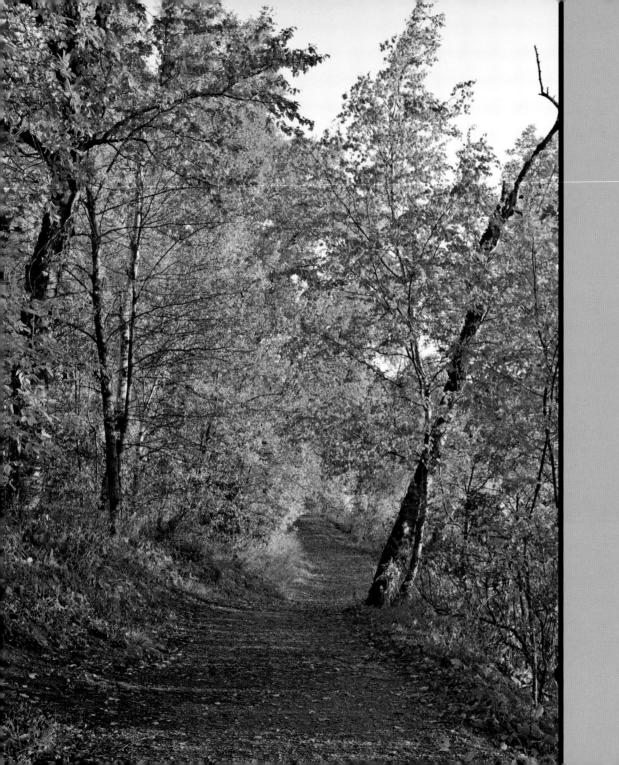

174.
The Western
Waterfront Trail,
autumn.

175. View from the Western Waterfront trail, autumn.

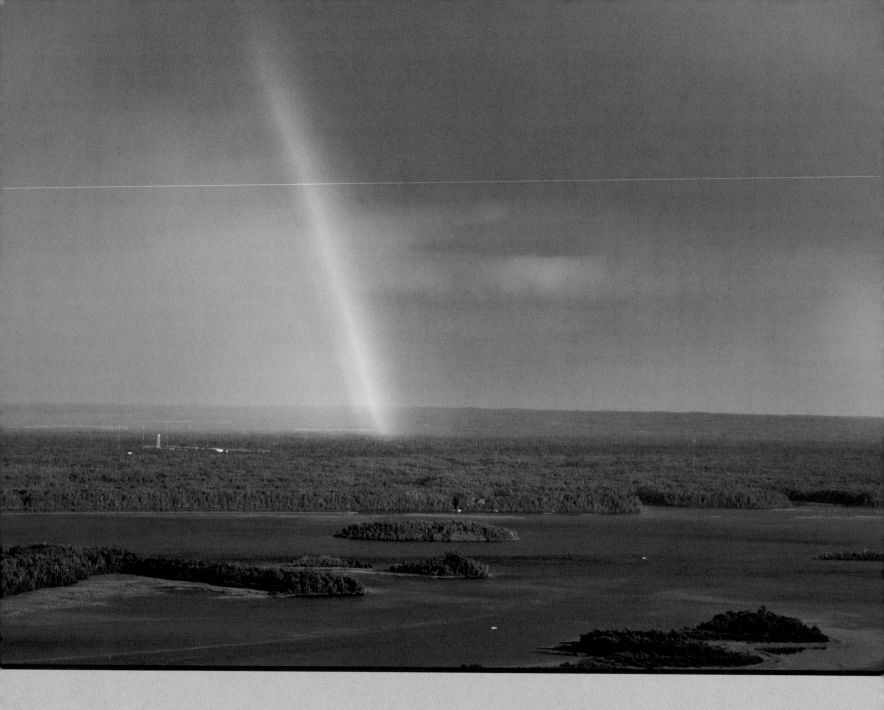

176. Rainbow over Spirit Lake and the St. Louis River as seen from Skyline Parkway, summer.

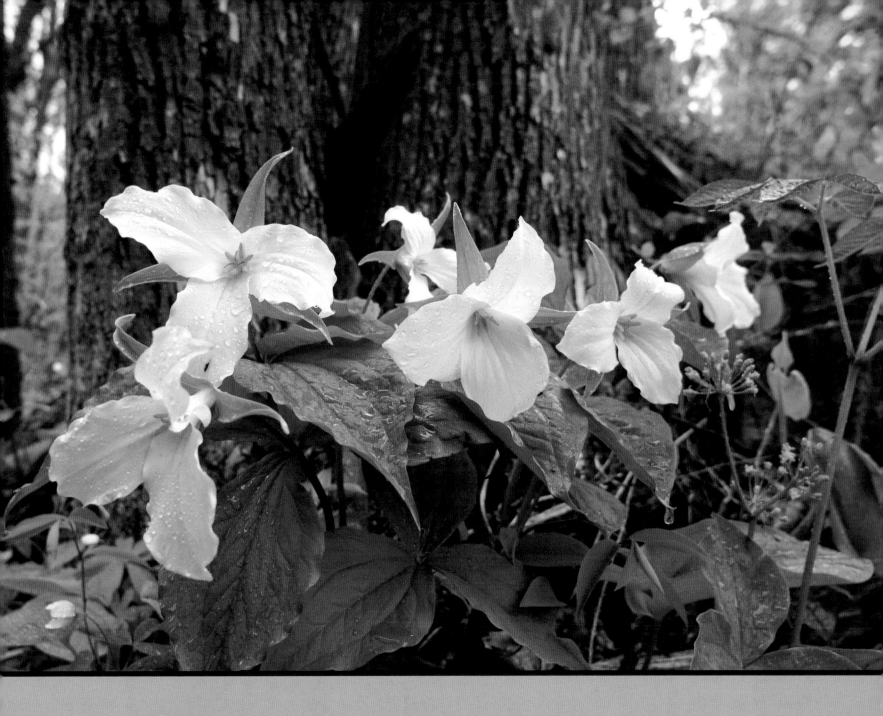

177. Trilliums on Spirit Mountain, summer.

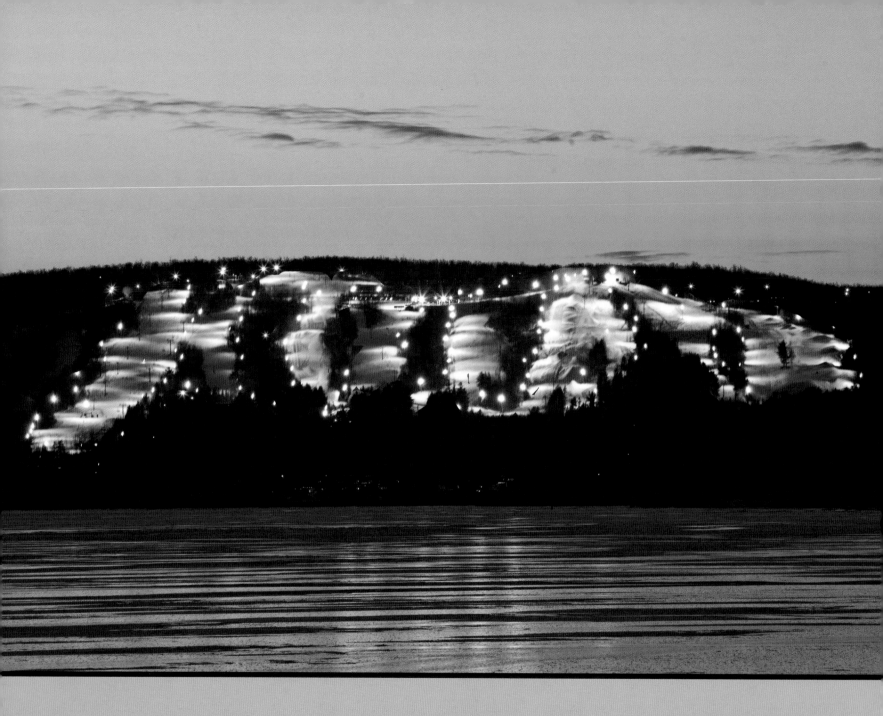

178. Spirit Mountain Ski Area lit up for skiers on a December night.

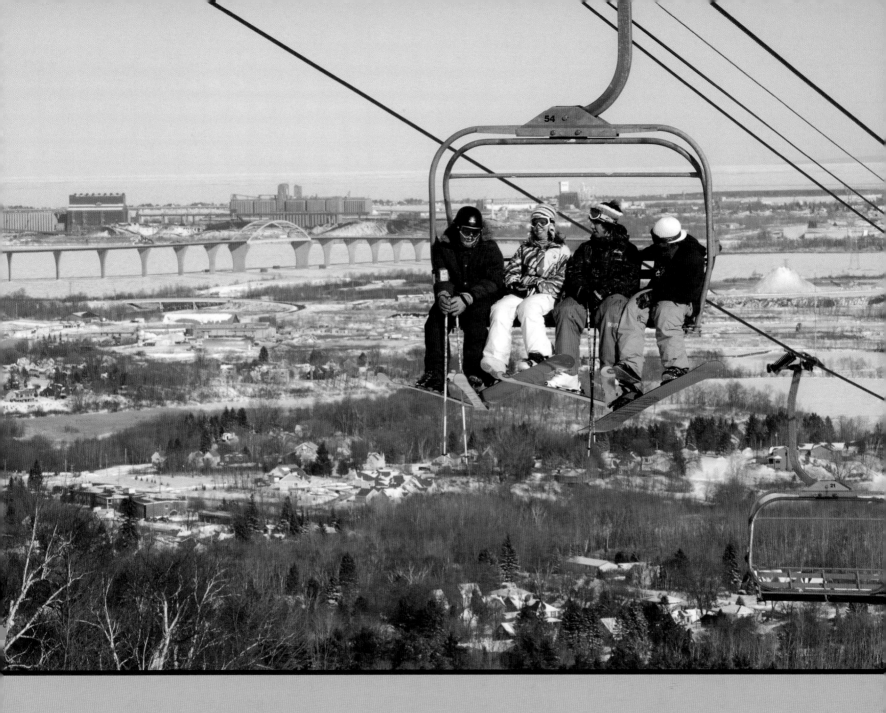

179. Riding the lift at Spirit Mountain Ski Area, winter.

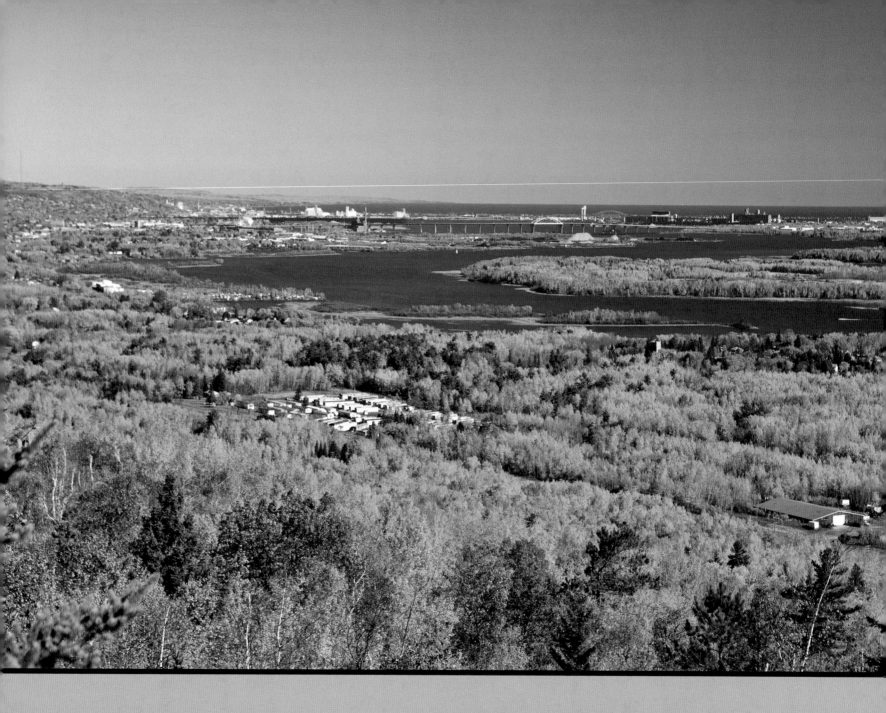

180. A view from Bardon's Peak above Skyline Parkway, autumn.

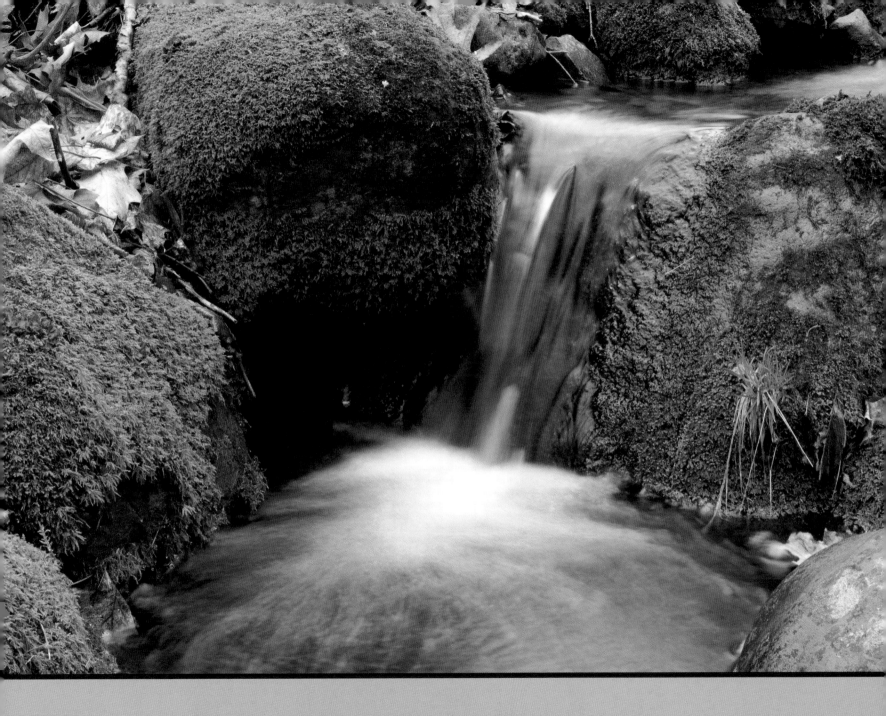

181. Mission Creek running through Magney-Snively Park, autumn.

182. Autumn leaves, Magney-Snively Park.

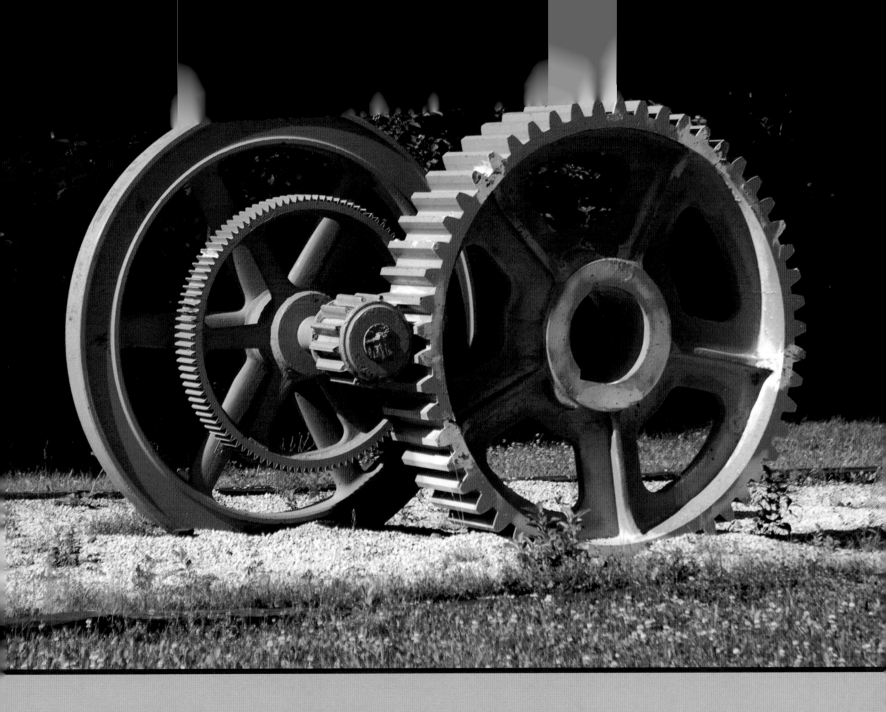

183. Gears from the U.S. Steel Plant mark the former entrance to the facility just west of Morgan Park, which operated from 1915 to 1971.

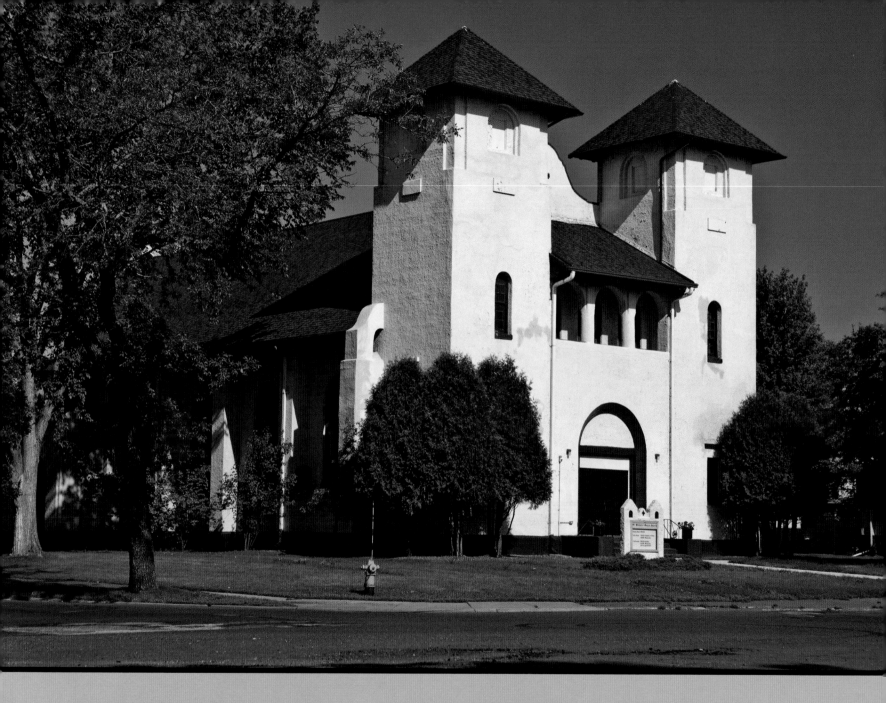

184. Church of the Blessed Mary Margaret, 1467 88th Avenue West on the western edge of Morgan Park (b. 1918; Dean & Dean, architects).
In 1922, Morgan Park built United Protestant Church on the eastern edge of the community to serve its non-Catholic Christians.

185. A residence in Morgan Park, a planned "company town" built by U.S. Steel to house the plant's employees and their families. The community was named in honor of U.S.S. President J. P. Morgan.

186. Another Morgan Park residence that, like nearly all of the original buildings in the community, was constructed of concrete block made at U.S. Steel's nearby Universal Atlas Cement Company.

187.
St. George
Serbian Orthodox Church,
1216 104th Avenue West
(1924; architect unknown).

The church was
founded by U.S. Steel to
serve the Serbian immigrants
who came to Duluth in the early
part of the twentieth century to
help build Thomson Dam on
the St. Louis River, which helps
provide Duluth with electricity.

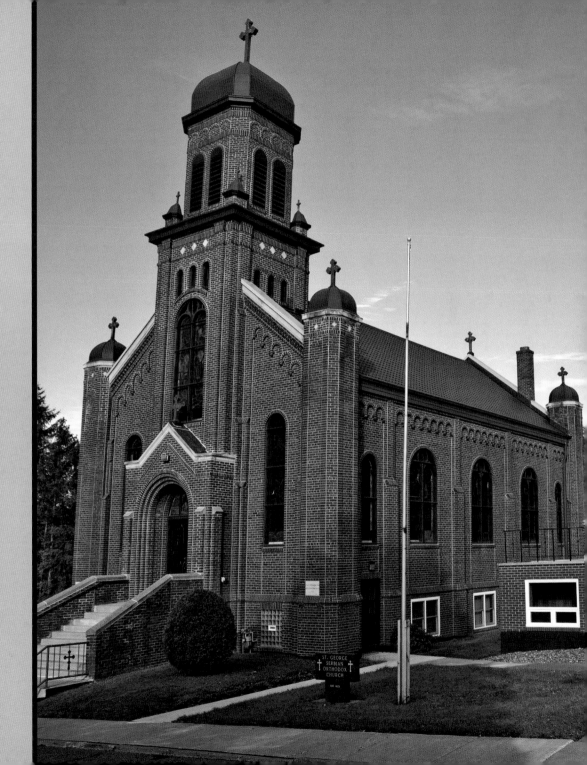

188.
Mission Creek
Park, summer.

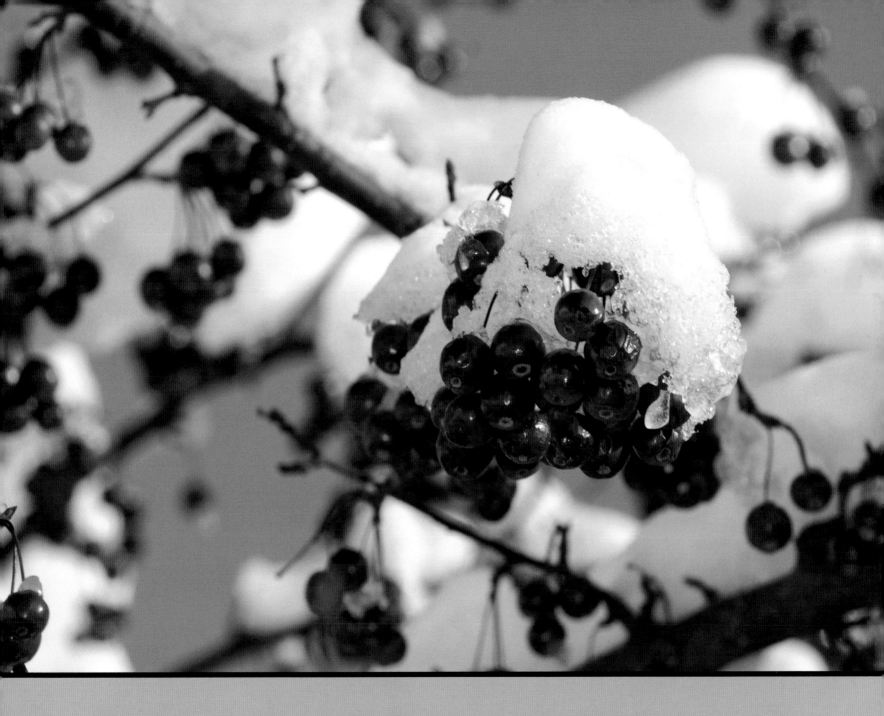

189. Mountain Ash berries under a blanket of snow in Mission Creek Park, winter.

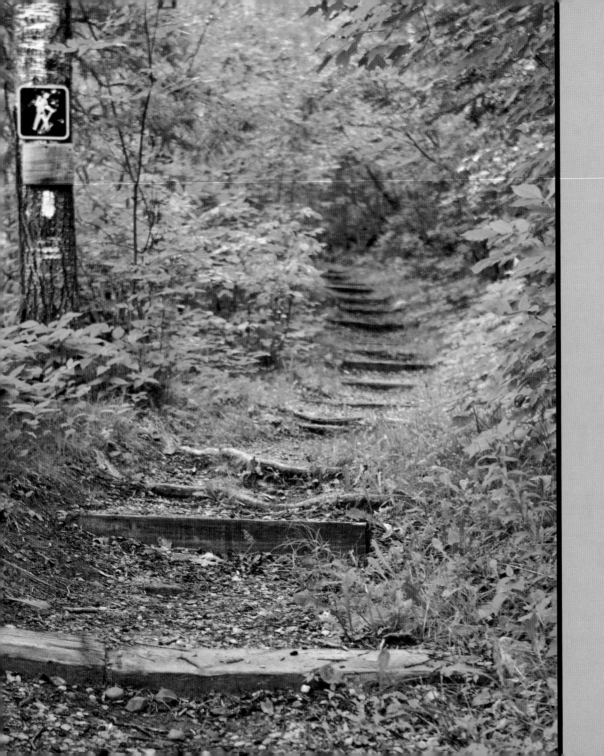

190.
Along the Mission Creek Trail,
Mission Creek Park, summer.

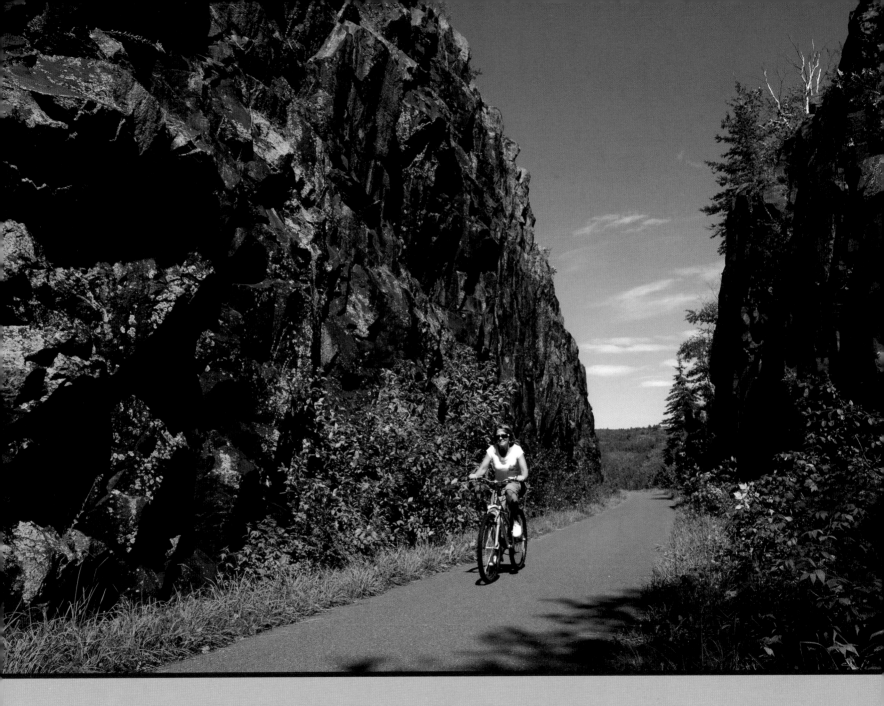

191. Biking along the Willard Munger State Trail, summer. The trail runs along the former
path of the Lake Superior & Mississippi Railroad, completed in 1870.

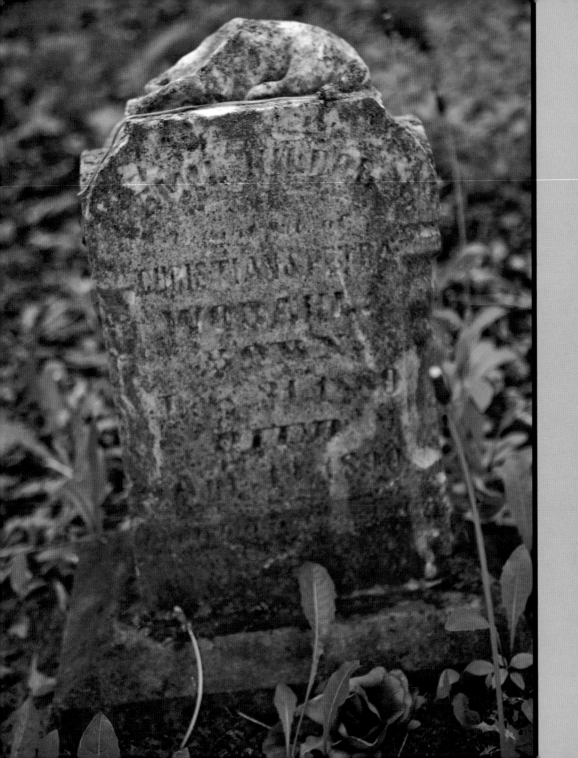

192.
Eroded grave marker in
Fond du Lac Park's
Pioneer Cemetery.

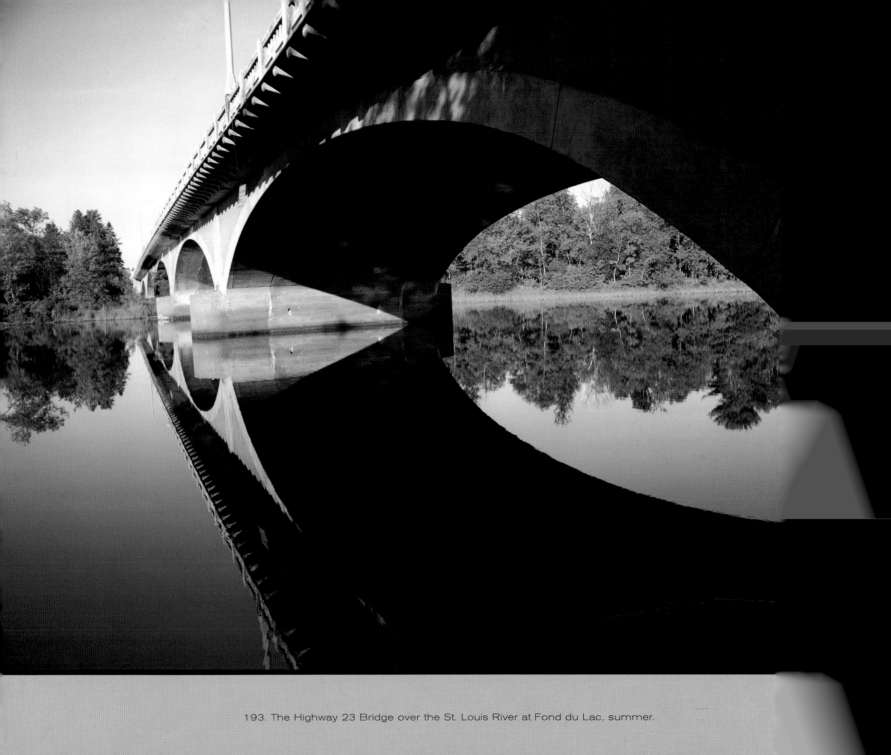

193. The Highway 23 Bridge over the St. Louis River at Fond du Lac, summer.

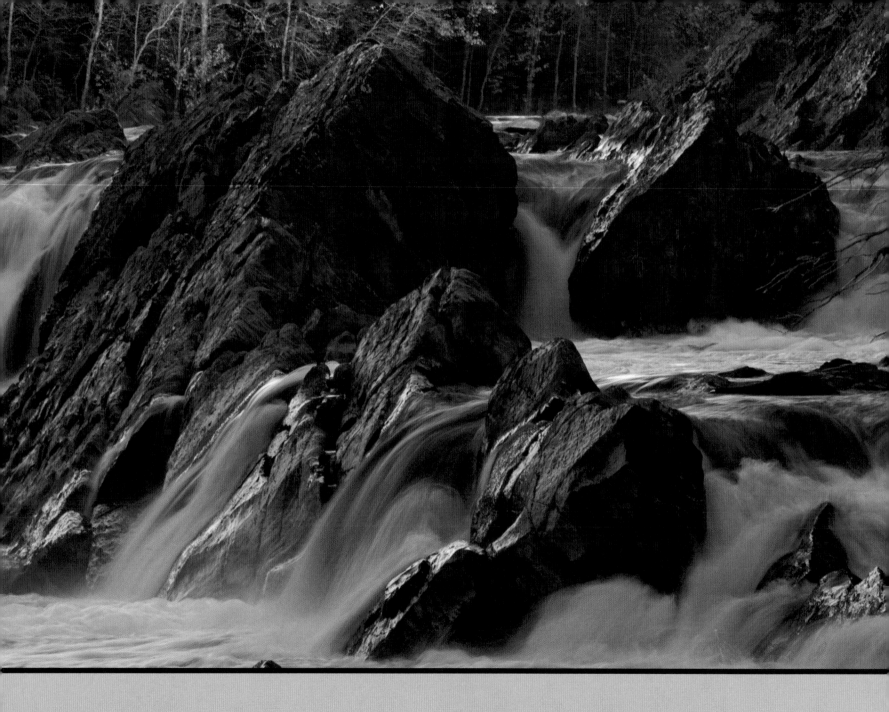

194. The St. Louis River between Fond du Lac Park and Jay Cooke State Park, autumn.

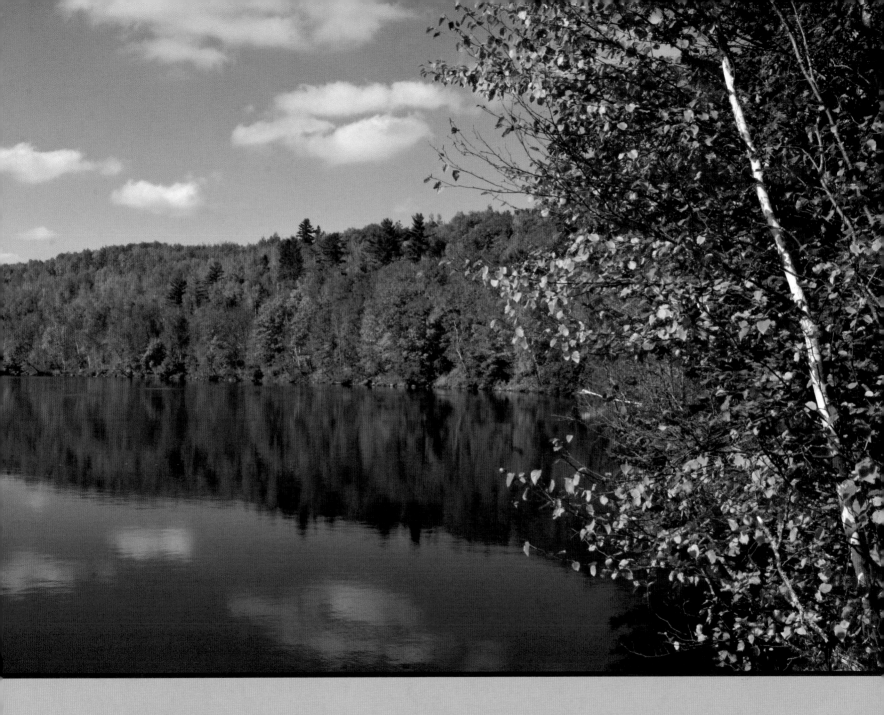

195. Fall colors along the St. Louis River.

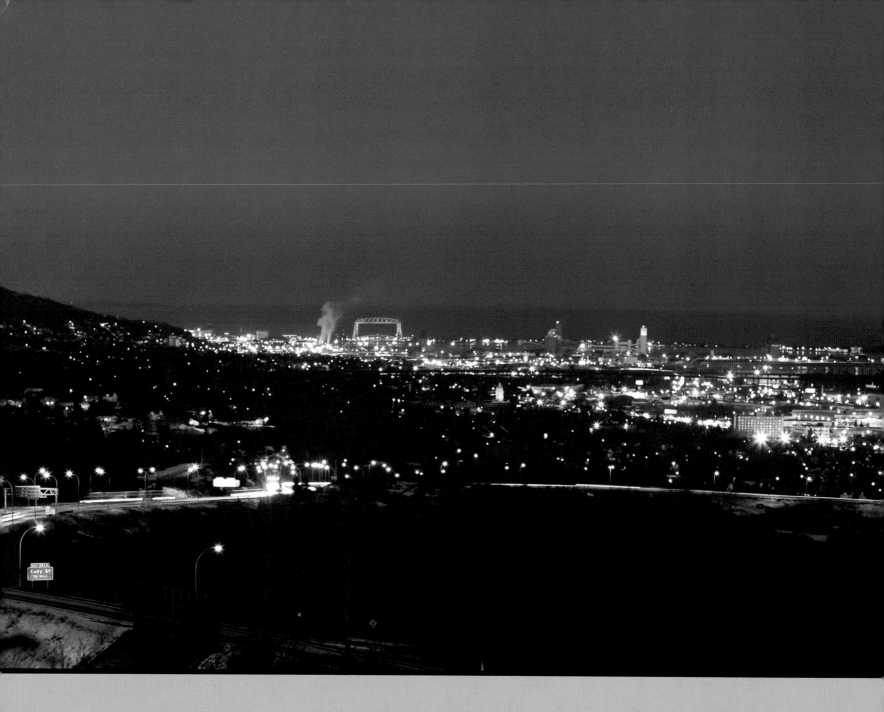

196–197. The view coming down Thompson Hill on I-35 at night, winter.

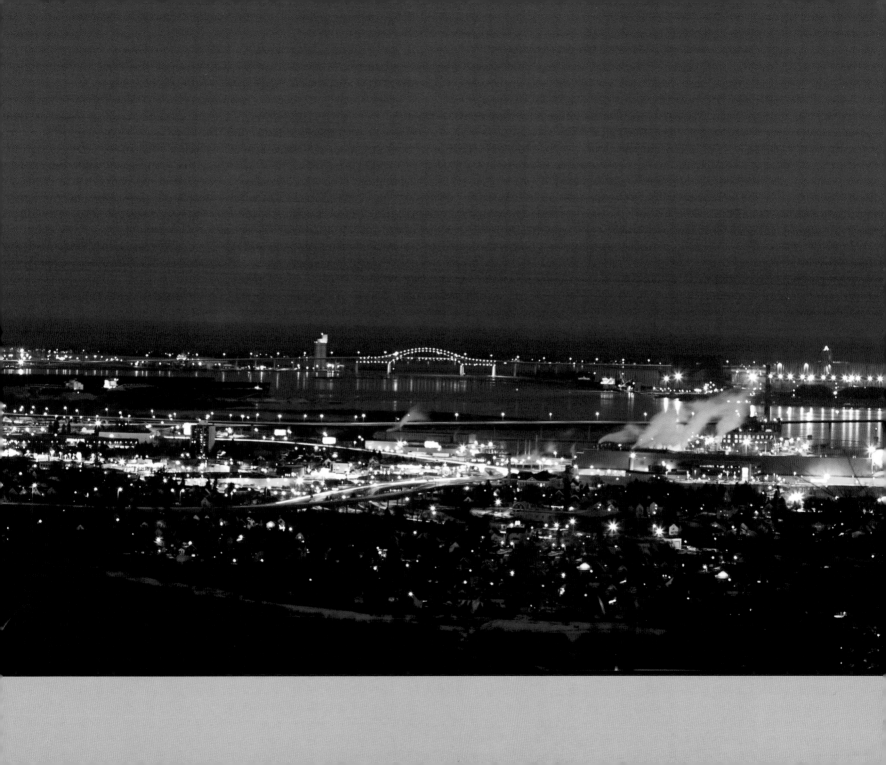

Photographer Dennis O'Hara

Duluth native Dennis O'Hara grew up in West Duluth, graduating from Denfeld Senior High School in 1971. He furthered his education at the University of Minnesota Duluth, earning a degree in industrial technology, and later studied photographic techniques through the New York Institute of Photography. Today Dennis resides at Caribou Lake just outside the city but keeps his eye on Duluth from his duluthharborcam.com Web site. He and his wife, Debby, are the proud parents of three children and four grandchildren.

Dennis's photography career started in the early 1970s when he operated a variety of cameras from the back seat of a RF-4C reconnaissance jet with the Duluth-based 148th Fighter Wing of the Minnesota Air National Guard. After retiring from the Air Guard in 1992 he stepped into nature photography as an avocation while employed as a Power System Operator at Minnesota Power. In May of 2006 he retired from that career and now devotes his time to photography as both a hobby and a business.

Over the years Dennis's work has appeared regularly in regional books, magazines, calendars, corporate publications, billboards, and print advertising—and of course at his own northernimages.com. Since its debut as a simple "picture of the week" Web site in the early days of the internet, the site has grown into a gallery of Dennis's extensive collection of work. Visitors to the site can download wallpapers and screensavers, and all of his images can be ordered as prints in a wide variety of sizes.